Women artists and the Parisian avant-garde

illustration facing see PLATE 14

Women artists
and the Parisian avant-garde

Modernism and 'feminine' art, 1900 to the late 1920s

GILL PERRY

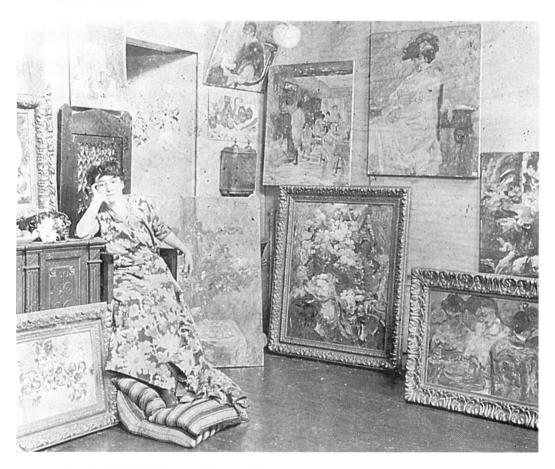

MANCHESTER UNIVERSITY PRESS
MANCHESTER AND NEW YORK
distributed exclusively in the USA and Canada by St. Martin's Press

Published by Manchester University Press
Oxford Road, Manchester M13 9NR, UK
and Room 400, 175 Fifth Avenue, New York, NY 10010, USA

Distributed exclusively in the USA and Canada
by St Martin's Press, Inc., 175 Fifth Avenue, New York NY 10010, USA

British Library Cataloguing-in-Publication Data
A catalogue record is available from the British Library

Library of Congress Cataloging-in-Publication Data
Perry, Gillian.
Women artists and the Parisian avant-garde / Gill Perry.
 p. cm.
Includes Bibliographical references (p. -).
ISBN 0-7190-4164-3 (hbk.). — ISBN 0-7190-4165-1 (pbk.)
1. Painting, French. 2. Painting, Modern—20th century—France-
-Paris. 3. Women painters—France—Paris. I. Title
ND548.P39 1995
759.4'361'082—dc20 94-42772
 CIP

ISBN 0 7190 4164 3 *hardback*
 0 7190 4165 1 *paperback*

First published 1995
99 98 97 96 95 10 9 8 7 6 5 4 3 2 1

Designed in Adobe Minion
by Max Nettleton FCSD
Typeset by Wyvern Typesetting Ltd, Bristol
Printed in Great Britain
by Redwood Books, Trowbridge

Contents

Plates

Colour plates

Acknowledgements

The preparation of this book in its various stages has taken over ten years, and has shifted and evolved in its focus. There are therefore many people (some of them sadly now deceased) to whom I wish to offer sincere thanks. Firstly, I would like to express my gratitude to the surviving family of Emilie Charmy. Before his death in 1988, Charmy's son Edmond Bouche provided me with invaluable information in the form of documents and personal memories of his mother and the artistic culture in which she participated. His son Bernard Bouche has continued this generosity of spirit, providing me with further information and research leads. Special thanks must also go to Patrick Seale, who first introduced me to the work of Charmy and who encouraged my earliest plans for a book on women artists. Throughout the lengthy production process he has continued to give generous support and encouragement. Marika Rivera Phillips also provided me with useful documents, details and memories of her mother Marevna and the artistic circles in which she lived and worked. Many other people were kind enough to answer queries and provide information, including Isabelle Rouault, Katia Granoff, Madame la Comtesse de Jouvencel, Liliane Caffin Madaule, Wendy Roche, Briony Fer, Tag Gronberg, Pauline Ridley, June Rose, Henriette Bessis, Sarah Wilson, Roger Benjamin and Christopher Green.

I have been furnished with information and references and given access to reserve collections by the staff of many museums and libraries. I am especially grateful to curators at the Musée des Beaux Arts de Lyon, Musée de Grenoble and the Centre Georges Pompidou. Danielle Molinari of the Musée d'Art Moderne de la Ville de Paris and Oscar Ghez of the Petit Palais, Musée d'Art Moderne, Geneva, both gave up valuable time to provide assistance and answer my queries. Tony Coulson of the Open University Library used his research skills to help me search for references and bibliographical material, and Margaret Cunningham was kind enough to check references for me in French libraries and museums.

I would also like to thank all those friends and colleagues who invited me to give papers on my research for the book, enabling me to discuss my ideas and benefit from the views of others. These include the Women in the Humanities Research Group at the Open University, Tamar Garb of University College, London, and Wendy Wassyng Roworth of the University of Rhode Island. Several people kindly commented or advised me on the manuscript in its various stages. Among them I

would like to offer special thanks to Clive Baldwin, Briony Fer, Patrick Seale and Ros Delanorol. Finally I would like to express my appreciation and gratitude to Katherine Reeve of Manchester University Press, who took on the book with enthusiasm, Denise Powers for patiently keying in and correcting the manuscript and David Batchelor for his advice and invaluable support.

For reasons explained in the text many of the works reproduced in this book are in private collections. I would like to convey my gratitude to all those collectors, galleries and individuals who both gave me permission to reproduce works in their collections and provided me with ektachromes and prints. They include the Bouche family, Patrick Seale, Marika Rivera Phillips, A. Kalman of the Crane Kalman Gallery, Oscar Ghez, Christiane and Guy de Aldecoa and the Kunsthaus Bühler, Stuttgart. I would also like to thank my brother, Mike Perry, for using his photographic skills to help provide me with reproductions of some hitherto little known works.

For my children, Nick and Sam

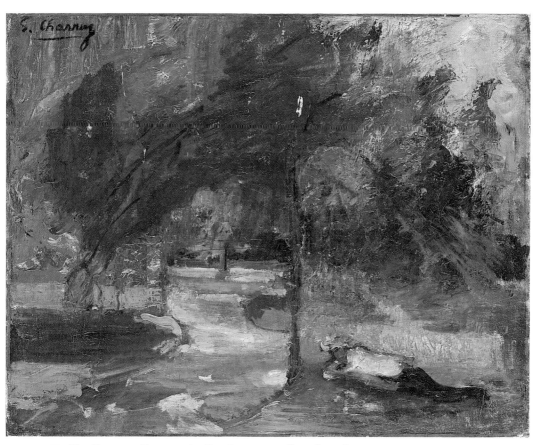

1 Emilie Charmy, *Siesta at St Cloud*, c. 1903, oil on board, 63 × 80 cm, private collection

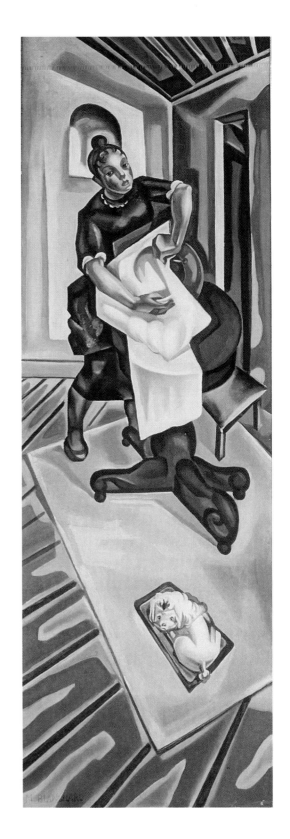

2 Maria Blanchard, *Washing*,
before 1921, oil on canvas,
211 × 70 cm, Musée d'Art
Moderne de la Ville de Paris

Introduction

'[Charmy] . . . sees like a woman and paints like a man'.

Thus wrote the writer and art critic Roland Dorgelès (PL. 1) in 1921 in a catalogue introduction to a major exhibition in Paris of the work of Emilie Charmy (1878–1974).[1] He was full of praise for her bold style and vigorous handling of paint. But underlying his division of her work into its 'masculine' and 'feminine' aspects was the notion that to paint boldly, using thick impasto heavily applied, was somehow inappropriate for a woman (COL. PL. 1). While some of the subjects which Charmy painted, such as

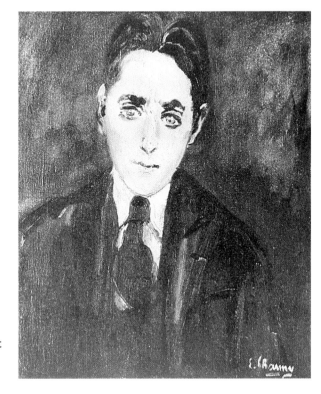

1 Emilie Charmy, *Portrait of Roland Dorgelès*, 1926 (exhibited in a show of Charmy's work introduced by Colette: *Quelques Toiles de Charmy – Quelques Pages de Colette*, Galerie d'Art Ancien et Moderne, Paris, 1926), private collection

flowers and portraits of women, and the subtle tones she employed, were seen as evidence of her 'feminine eyes', the manner in which she painted them was identified as 'masculine'. For Dorgelès, as for other contemporary critics who admired Charmy's work, the actual process of painting was implicitly gendered; in her bold painterly technique she was seen to be imitating the stronger, more vigorous skills of a male painter.

Charmy's work, like that of other women artists working in France during the first three decades of this century, among them Marie Laurencin (1883–1956) and Suzanne Valadon (1865–1938), was repeatedly reviewed and discussed in terms of its 'feminine' and 'masculine' characteristics, categories which, as I hope to show, were ideologically constructed, and have significantly affected the ways in which women's art has been assessed and valued in subsequent art history. It is partly in the construction of these categories that we may also find some of the reasons why some women artists have been found a place on the fringes of modern art history, while others who were working on the margins of so-called avant-garde movements have not.

While the work of Valadon and Laurencin is acknowledged, albeit briefly, in many post-war histories of modern French art, the work of most of the other women painters featured in this book is little known to both English- and French-speaking audiences.[2] Apart from Emilie Charmy these artists include Jacqueline Marval (1866–1932), Maria Blanchard (1881–1932), Alice Halicka (1895–1975), Marevna (1892–1984), Alice Bailly (1872–1938), Marie Vassiliev (1884–1957), Suzanne Roger (1899–1986) and Mela Muter (1876–1967). These are artists whose work does not even appear in recent surveys of 'women's art', which through the development of feminist art history have unearthed women artists previously ignored or marginalized by more traditional histories. It is also the case that many women artists from this period who worked both as painters and as decorative artists, among them Sonia Delaunay (1885–1979), are now better known for their applied or decorative art. The label 'decorative' in this context was often indexed to contemporary notions of predominantly 'feminine' forms of artistic production.

It seemed to me, therefore, that while various forms of feminist art history have helped to rewrite traditional representations of the art of the Impressionist period and the late nineteenth century, and the later Constructivist and Surrealist movements,[3] there was much work to be done on the artistic, cultural and social activities of women artists in France during the first quarter of this century, in particular those who were associated with the Fauve and Cubist groups, and with the loosely labelled 'School of Paris'. In the course of my research I became aware of the large numbers of interesting and original works by women artists which gather dust in the reserve sections of most of the major French public collections of modern

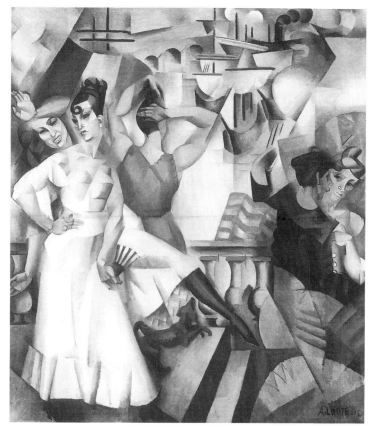

2 André Lhôte, *Port of Call*, 1913, oil on canvas, 210 × 185 cm, Musée d'Art Moderne de la Ville de Paris

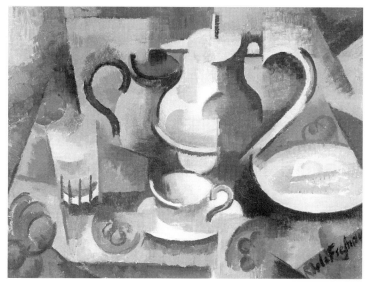

3 Roger de la Fresnaye, *Still-Life with Three Pitchers*, 1912, oil on canvas, 40 × 61 cm, Musée d'Art Moderne de la Ville de Paris

art. I also became aware of a recent growth of interest in some of those women artists who worked on the fringes of 'avant-garde' movements, and whose art has not been adequately represented (if at all) in comparison with that of many male artists who have achieved fame and publicity by virtue of their peripheral links with the Fauves or Cubists. For example, in the early 1990s the Musée d'Art Moderne de la Ville de Paris, which owns a substantial collection (largely stored in the reserve section) of work by women artists from this period, has devoted a small room to the exhibition of Cubist paintings by Maria Blanchard. Her figurative form of Cubism (COL. PL. 2; PLS 40, 41) has until recently been overshadowed by the work of better known figurative Cubists such as André Lhôte and Roger de la Fresnaye (PLS 2, 3) whose paintings also hang in the public galleries of this museum.[4] Clearly, there are complex social, political, institutional and aesthetic reasons for these shifts in interest. The growth of feminist culture in general and feminist art history in particular has been accompanied by the publication of *catalogues raisonnés* on lesser-known women artists,[5] and an increase in the numbers of women curators. This changing atmosphere has also encouraged (albeit in a limited way) revaluations of the works themselves and some of the problems of representation with which the artists were engaged. In this respect the reorganisation of Blanchard's work, alongside that of Lhôte and de la Fresnaye, speaks for itself.

I have chosen to write about the group of artists listed above, and the artistic culture in which they participated, not simply because they were women. I have chosen rather to focus on those women artists whose works were widely exhibited and regularly featured in the French art press and in surveys of modern art in the period from 1900 to the 1920s, but who (with the exception of Valadon and Laurencin) largely disappeared from the history books in the post-war period. This book seeks to unravel some of the complex cultural, aesthetic and economic reasons for these absences.

The work of Emilie Charmy forms an important (but not exclusive) focus of this account. Her career stands as an exemplar for the fate of many women artists working during the period, whose work was widely exhibited and reviewed in the 1920s and 1930s, but omitted from subsequent histories of modernism. Charmy was forty-three at the time of the 1921 exhibition cited above, which was held at the Galeries d'Oeuvres d'Art and helped establish her as a successful woman painter with a substantial following among the patrons of the established avant-garde. Born near Lyon in 1878, she spent most of her adult life working as a full-time, professional painter in Paris, and her works were widely exhibited and regularly featured in the French art criticism in the 1910s, 1920s and 1930s.

After a productive early period working in Lyon, Charmy moved to Paris

around 1903, where she developed a strong, brightly coloured style, close to that of Matisse and the Fauves in terms of technical innovation (COL. PLS 12, 13, 14, 15). Surprisingly, this period when she produced a series of bold, powerful paintings is rarely discussed in subsequent criticism. As I show in the following chapters, this was partly because, like most women artists at the time, she did not belong to, and exhibit with, the relevant modernist groups. In contrast, her work from the late 1910s onwards into the 1920s and 1930s, which became increasingly remote from avant-garde interests and closer to the various forms of 'naturalism' which are now identified with the 'School of Paris', was well-documented by contemporary critics. By 1921 the influential art critic Louis Vauxcelles described her as 'one of the most remarkable women [artists] of our time',[6] and praised above all her abilities as a 'sensual' colourist, an emphasis which was easily associated by Vauxcelles and his contemporaries with the idea of a 'feminine' style, and which, I believe, has contributed to subsequent critical misrepresentations of her work.

It is not my intention to establish rigid (alternative) criteria of value for assessing the work of the women artists discussed in the book. When researching for this study, I became especially interested in the work of Charmy in that it seemed to raise issues of interest to both feminist art history and art history in general. Her paintings provide rich and complex material for study, in that they reveal a shifting and often contradictory relationship to those styles and conventions associated with the male avant-garde, and to those associated with 'women's art'. Critics writing between the wars found it difficult to explain these shifts and contradictions. As a result her work, like that of many other women artists considered in the following chapters, has often been misrepresented, or forced into gendered categories which undermine serious analysis of some of the problems of representation which she sought to address. For similar reasons, I have also devoted some attention to the work of Valadon, although her work and the (feminist) debates which surround it are now better known. It is not my purpose to put forward conventional arguments for the 'greatness' of the artists in question, or for the 'rediscovery' of yet more forgotten women artists whose 'genius' went unrecognised. It is rather to seek to define the criteria of 'greatness' against which their works were assessed, thereby examining some of the categories of art history according to which these artists were first written into, and then written out of, the text books of modern art.

Modernism and representations of *les femmes peintres*

For Vauxcelles, as for Dorgelès, the value and meaning of Emilie Charmy's works were directly related to her gender. Reviews were written and

valuations made according to subtly different criteria from those applied to her male colleagues, criteria which were well-established in the traditions of late nineteenth- and early twentieth-century European art criticism, as may be seen, for example, in Walter Sparrow's *Women Painters of the World*, first published in 1905. One of the best-known publications of the period in English on the subject of women artists, it included contributions on various countries by eight different writers, two of whom were women. The overriding theme of the book was the need to divide art up into female or 'feminine' art practised by women and 'male' art practised by men. Sparrow's preface began:

What is genius? Is it not both masculine and feminine? Are not some of its qualities instinct with manhood, while others delight us with the most winning graces of a perfect womanhood?
... Why compare the differing genius of women and men? There is room in the garden for flowers of every kind and for butterflies and birds of every species.[7]

These separate criteria in fact define a feminine art which is implicitly inferior. It is a different sort of 'genius', which, in the language of Sparrow's book, is more 'emotional' and 'womanly'. It is defined according to a whole group of assumptions about the stronger qualities of 'instinct and manhood' which constitute the 'masculine'. Such assumptions about 'feminine' and 'masculine' styles have long and complicated histories. In broad terms they can be traced back to eighteenth- and nineteenth-century characterisations of women's roles, and the traditional (Academic) divisions of art into intellectual 'masculine' genres, as against 'feminine' or more decorative, superficial forms of artistic expression.[8] One of the aims of this book is to show how these associations were shifting and constantly renegotiated in the critical writings which surrounded the work and activities of both *les femmes peintres* and the (male) avant-garde during the first three decades of the twentieth century.

Writings about 'women's art' based on similar assumptions to those in Sparrow's work continued to appear in Britain and France during the period. With improved educational and exhibiting opportunities for women[9] increasing numbers were able to study and practise art, but there does not seem to have been a significant shift in emphasis on the forms of critical attention which they received. In fact some of the more journalistic accounts of the emancipation of the 'modern' woman which appeared at the beginning of the century reveal a misogynistic fear that the increase in the numbers of women painters would destabilise the profession. In his book *The Modern Parisienne*, first published in 1910, Octave Uzanne wrote:

We are at the dawn of a new era, which will give facilities to women for the devel-
opment as far as possible of their intellectual faculties. At no other epoch have their
talents for painting, sculpture, and above all, literature, been as considerable as at
the present day. Women authors, painters, and musicians have multiplied during
the last twenty years in bourgeois circles, and even in the *demi monde*. In painting
especially they do not meet with the violent opposition they endured in former
times. One may even say that they are too much in favour, too much encouraged
by the pride and ambition of their families, for they threaten to become a veritable
plague, a fearful confusion, and a terrifying stream of mediocrity. A perfect army
of women painters invades the studios and the Salons, and they have even opened
an exhibition of 'women painters and sculptors' where their works monopolise
whole galleries. The profession of a woman painter is now consecrated, enrolled,
and amiably regarded; the girl of a bygone age, who made her own dresses and hats,
who cooked jams, and attended to her devotions – the modest flower proposed to
candidates for matrimony; this young girl without fortune, educated by her mother
in excellent principles of order and economy, is now only to be found in distant
provincial places where good traditions still flourish.[10]

The work of women artists is featured in several important surveys of
modern French art which were published in the 1920s, of which the most
influential included Louis Vauxcelles, *L'Histoire générale de l'art français*,
vol. ii, 1922; Maurice Raynal, *Anthologie de la peinture en France – De 1906
à nos jours*, 1927; and Adolf Basler and Charles Kunstler, *La Peinture indépen-
dante en France*, 1929.[11] Of these three surveys, Raynal's *Anthologie*, written
as a series of fifty short monographs, is the only account which emphasises
the importance of Cubist artists in the history of modern French art, while
both Vauxcelles and Basler construct art historical narratives which privilege
more naturalistic post-Fauve schools of painting. Five of Raynal's fifty short
chapters are devoted to women painters: Valadon, Blanchard, Halicka,
Laurencin and Roger. The work of both Blanchard and Halicka is repre-
sented in terms of its relationship with Cubism; in other words their
associations with contemporary artistic 'avant-gardism' is clearly acknowl-
edged.[12] Basler acknowledges the work of many women artists, although they
rarely receive more than a brief mention, and devotes a short chapter in
volume ii to *les femmes peintres*. Vauxcelles's survey includes a longer chapter
titled '*Les femmes peintres d'aujourd'hui*' ('Women painters of today'). Both
authors then set up a separate category of *femmes peintres* distinct from the
explicitly male notion of *peintre*.[13]

While the critical discourses which represented 'women's art' of the
period were by no means homogenous, and progressive critics such as
Raynal appear to have been slightly less concerned with gendered categories
of artistic production, a critical tradition evolved which acknowledged what

Vauxcelles called a 'flowering' of women artists ('une copieuse floraison des femmes artistiques'), while continuing (explicitly or implicitly) to consign their work to a separate area of modern art. Although Vauxcelles's chapter opens with a comment on the dramatic increase in women's art in the preceding twenty years, he nevertheless draws a clear distinction between the characteristics of women's and men's art:

What many lady painters and sketchers call art, is often merely an art of pleasure ... Rare are those women artists who have understood that art is not merely an agreeable lie, but that through it one should express the most profound, the most intimate part of oneself, the sad and lofty dreams that one cannot pursue in life.[14]

Vauxcelles also claims to have identified the causes of 'women's inferiority in art'. He argues that, unlike men, women have had greater difficulty in freeing themselves from academic constraints, and are therefore less likely to arrive at a 'spontaneous, liberated vision'.[15] But what Vauxcelles identifies as a cause was, of course, a symptom of a social and educational system which had disadvantaged women artists, allowing them restricted access to academic facilities and professional opportunities. Moreover, Vauxcelles's category of masculinity implicit here is itself a reconstruction of notions of 'masculine' creativity in currency (as I suggested above) since the eighteenth century. The intellectual 'masculine' has now become inflected with post-romantic concepts of 'spontaneity' and 'liberation'. These qualities, according to Vauxcelles, are the absences in 'women's art'.

Running throughout Vauxcelles's account, then, is a concept of a separate feminine art, distinguished by its particular 'sensibility', 'softness' and 'refinement'. But his chapter does go on to discuss what he calls 'the exceptions' among women artists. The nineteenth-century artists Eva Gonzalès, Berthe Morisot, Marie Bracquemond and 'Miss Cassatt' feature prominently, followed closely by contemporary French artists whom Vauxcelles sees as women of 'real merit': Jacqueline Marval, Lucie Cousturier, Jeanne Simon, Alice Halicka, Marie Laurencin and Emilie Charmy. The list reveals something of Vauxcelles's personal tastes and prejudices – particularly in view of the absences of Suzanne Valadon and Maria Blanchard – but it also provides some indication of the relative status of these women artists as perceived by their contemporary audience. Apart from Laurencin, Vauxcelles's women of 'real merit' are barely known today.

Vauxcelles's emphasis on the 'spontaneous liberated vision' as a measure of aesthetic creativity was a crucial factor in his exclusion of women from certain categories of art. Like other contemporary critics, he evaluated paintings primarily in terms of the *profundity* of the emotions which they were

seen to express. And it was the apparent absence of this quality from most of women's art which, according to Vauxcelles's argument, excluded it from the main body of modern art history.

Vauxcelles's notion of creativity is associated with one aspect of a critical tradition which has been characterised retrospectively as 'modernist'. The critical traditions and dominant narratives which are now associated with modernism are by no means seamless, and have shifted and evolved from the late 1900s to the present, but it has tended to produce a somewhat exclusive, linear history tracing developments in art through the various 'major' movements of Post-Impressionism, Fauvism, Cubism, Purism, Constructivism, and so on, and excluding or marginalising other art practices, seen as less important.[16] Feminist art history has challenged the dominance of a canonical modernist narrative which either cannot accommodate women's art or relegates it to marginal positions.

The social and cultural reasons for the absence of women's art from the history of the key modernist movements have been well aired in the feminist literature of the last twenty years: restricted by domestic pressures and narrow educational opportunities, women could only rarely achieve the same professional status as men, and were less able to gain access to male-dominated 'avant-garde' groups.[17] It is a central argument of this book that the reasons for the absence of women's art include, but go beyond, these social and cultural disadvantages, and are inextricably bound up with the ways in which art history has been written. Moreover, my purpose is not simply to examine the exclusions, but also to reassess some of the histories which have placed most women artists so clearly *outside* the better known modernist movements of Fauvism and Cubism. The lack of historical material available and limited access to relevant works from this period have encouraged some misrepresentations of the complex relationships which many women artists negotiated both with 'avant-garde' groups and with the artistic styles and conventions associated with those groups.

In France in the 1920s no rigid criteria existed by which critics could determine which artists belonged to the avant-garde; the term could refer to a range of artistic practices and (political) interests. Broadly speaking, the label 'avant-garde' was used in art criticism of the period to refer to those artists whose work was recognised by their contemporaries as being self-consciously radical or up-to-date, as separate from the traditional or the normal.[18] My emphasis will reflect this broad (and sometimes shifting) notion of avant-gardism. The idea of the 'avant-garde', which is a central concept within modernist theory (although not necessarily synonymous with 'modernism'), poses some problems for the study of women artists during the early twentieth century. The majority of women artists worked

in different spheres from, or on the fringes of, male exhibiting groups, and were thus less likely to pursue those 'progressive' styles so highly valued in modern art history. As I have suggested, however, these 'absences' are at least partly to do with the way in which art history has been written.

Thus my title, *Women artists and the Parisian avant-garde*, has not been chosen merely to describe the protagonists' negative relationships with the male avant-gardes of their time. Rather, it is a means of pin-pointing some of the contradictions and shifts both in the work of these women artists and in the interests and allegiances of those contemporary critics who wrote about their painting. For example, the close relationship between Charmy's work in the early years of the century and the Fauve group has been ignored – or overshadowed – by some of her interests in the 1920s, and by the contemporary tendency to group her work, along with that of other women artists, with the more traditional wing of the School of Paris. Similarly, the Cubist works produced by Blanchard, Marevna and Halicka during the 1910s (COL. PLS 2, 17, 18, 22, 23) have (until relatively recently) been less well represented in art criticism than their more marketable naturalistic forms of painting. The absence of work by each of these women artists from relevant Fauve or Cubist exhibiting groups has made some important areas of art historical information especially difficult to recover.

In this book, then, I am concerned to make visible (through reproduction) many works which are currently little known outside France, a large number of which are still in private collections or the reserve sections of public galleries. I am also concerned to unravel some of the complex reasons why so many of these works remained outside the main exhibiting groups and collections which would have helped to ensure historical durability. In the following chapters I therefore examine some of the ways in which works by these women artists were exhibited, patronised, publicised, marketed and supported. The role and writings of Berthe Weill (1865–1951), one of the few women dealers working at the beginning of the century, form a focus of study throughout this book, and inform my exploration of some of the constructions of femininity which affected both the production and the patronage of work by women artists. Drawing on Weill's published and unpublished writings, I will argue that her role was crucial in the early exhibition and promotion of the work of many women painters, including Marval, Halicka, Valadon and Charmy.[19]

Gender and biography

As is suggested by my title, my intention is not to produce a series of biographical monographs. Feminist art history in particular has provided a

critique of the form of the biographical monograph in that it tends to repro-
duce a traditional form of narrative applied to individual male artists. As a
genre, the monograph is now often associated with histories of creative male
artists whose life stories are constructed to illuminate their artistic person-
alities and avant-garde 'genius'. Thus the lives and activities of women artists
do not usually fit the expectations aroused by the conventions of this genre.
Moreover, the biographical mode has become increasingly devalued with the
growth of social histories of art and post-structuralist approaches to visual
imagery, in which the meanings of art-works are seen as part of a broader
network of representational practices and visual ideologies.

However, through the influence of psychoanalytic theory within feminist
art history, the study of identity has become an important theme in the
reconstruction of subject positions. Questions which concern me in the
following chapters include: how are masculine and feminine subjectivities
constructed within the artistic culture of the period, and how are these
mediated (if at all) through the art works? To attempt an answer to such a
difficult question we need access to biographical material, while always being
aware of how historically mediated that material will be.

Moreover, as many of the artists featured in this book are little known I
have included some biographical material on each in my attempt to recon-
struct a picture of how various women artists negotiated their professional
and personal lives, and how these forms of negotiation could be seen to have
affected their art. Much of the information on Emilie Charmy,[20] and to a
lesser extent Valadon, Laurencin and Marevna, is provided within the main
text, while short biographical accounts of all the women artists whose
work is mentioned and/or illustrated can be found in the appendices. Such
material also provides important information on the collective condition of
women artists, in particular the complicated relationship of their work and
interests to contemporary perceptions of *les femmes peintres*.

By the second decade of the twentieth century the conditions and cir-
cumstances of artistic production for women were changing. With improved
opportunities for exhibiting, work by women painters was increasingly
becoming visible on the margins of various modernist groups. As I hope
to show, by the 1910s the 'spaces of femininity'[21] represented and inhabited
by women artists had shifted and evolved from those identified with
women's art in the late nineteenth century. Some of the categories and
paradigms which feminist art history has used to investigate art practices
by women in the nineteenth century need adjusting to accommodate the
complex iconographical, formal, and historical shifts in the various codes
of representation adopted. As I shall argue, the female nude, an important
theme in the work of most of the women discussed in this book, features

prominently in this crisis of representation. The work of many of these women artists suggests that there was a *fringe modernist* space in which women could position themselves, and if they were sufficiently astute, in which they could achieve certain limited forms of success and artistic recognition. Charmy's work, along with that of Valadon and others, seems to have occupied a fragile space in which notions of 'masculine' and 'feminine' art could intersect, and could be negotiated in relation to the codes of artistic value of contemporary modernism. This fragile space was written out of the art history of the post-Second World War period.

Notes

1 R. Dorgelès, *Emilie Charmy*, Galeries d'Oeuvres d'Art, 1921.
2 Valadon and Laurencin have also been the subject of monographs in both French and English. Please see Bibliography for detailed references.
3 The work of Tamar Garb, Kathy Adler and Griselda Pollock on women artists of the late nineteenth century is now well known. See also the work of Whitney Chadwick on women and the Surrealist movement, and Christina Lodder and Briony Fer on women and Russian Constructivism. Please see Bibliography for references.
4 The public hanging of Maria Blanchard's work in this prestigious collection also coincided with the publication of the first *catalogue raisonné* of her work: Liliane Caffin Madaule, *Maria Blanchard*, 2 vols., published (in French) by Liliane Caffin Madaule, London, 1994. I am grateful to Liliane Caffin Madaule for the information which she provided on Blanchard's work.
5 Apart from the recent catalogue on Blanchard, Laurencin's graphic and painted work has now been catalogued by Daniel Marchesseau (see Bibliography and biographical entries).
6 *Éclair*, 23 June 1921.
7 Walter Sparrow, *Women Painters of the World*, London, 1985 (Preface).
8 For consideration of notions of 'feminine' and 'masculine' forms of expression in eighteenth-century art and culture see G. Perry and M. Rossington (eds.), *Femininity and Masculinity in Eighteenth-Century Art and Culture*, Manchester University Press, Manchester, 1994. The construction of the 'feminine' in the discourses of nineteenth-century art history has been examined by T. Garb in 'L'Art Féminin: The Formation of a Critical Category in Late Nineteenth-Century France', *Art History*, 12:1, March 1989.
9 These are discussed in more detail in Chapter 1.
10 Octave Uzanne, *Parisiennes de ce temps*, Paris, 1910; translated as *The Modern Parisienne*, Heinemann, London, 1912, p. 129.
11 Louis Vauxcelles, *L'Histoire générale d l'art français de la Révolution à nos jours*, 2 vols., Librairie de France, Paris, 1922; Maurice Raynal, *Anthologie de la peinture en France – De 1906 à nos jours*, Editions Montaigne, Paris, 1927; Adolf Basler and Charles Kunstler, *La Peinture indépendante en France*, 2 vols., Editions G. Crès & Cie, Paris, 1929.
12 Raynal also refers to the work of several other women artists in his review of the modern movements in the introduction. These include Berthe Morisot, Emilie Charmy and Beatrice Appia.
13 Vauxcelles, *L'Histoire générale de l'art français*, vol. ii, p. 320ff.
14 *Ibid.*, p. 320.
15 *Ibid.*, p. 313.

16 Debates around and discussions of modernist theory and practices are now well aired in recent art historical literature. The category 'modernist' and some of its meanings has been the subject of two Open University published courses: *Modern Art and Modernism* (A315) first published by the Open University in 1983, and *Modern Art, Practices and Debates* first published in four volumes by Yale University Press, New Haven and London, 1993. Perhaps one of the first explicit (and more sophisticated) uses of the label 'Modernist' (with a capital 'M') to describe the specific preoccupations of modern painting was by Clement Greenberg in his essay *Modernist Painting* of 1956 (*Art and Literature*, 4, Spring 1965, pp. 193–201). He wrote 'the essence of Modernism lies, as I see it, in the use of the characteristic methods of a discipline to criticize itself'. He identified flatness as the quality unique to painting, arguing that for this reason Modernist painting orientated itself to flatness as it did to nothing else. Parallel (although perhaps cruder) preoccupations can be found in the earlier writings of the English critics, Roger Fry and Clive Bell. Both were influential proponents of critical approaches which we now define as 'Modernist'. Bell, for example, identified a quality of 'significant form', that is 'lines and colours combined in a particular way, certain forms and relations of forms stir our aesthetic emotions' ('The Aesthetic Hypothesis' in *Art*, Chatto and Windus, 1931, pp. 3–30; first published in 1914).

17 Surveys of women's art which have engaged with these issues include: Eleanor Tufts, *Our Hidden Heritage: Five Centuries of Women Artists*, London, 1974; Anne Sutherland Harris and Linda Nochlin, *Women Artists: 1550–1950*, Los Angeles County Museum of Art, 1976; Karen Peterson and J. J. Wilson, *Women Artists: Recognition and Reappraisal from the Early Middle Ages to the Twentieth Century*, Harper Colophon, New York, 1976; Donna Bachman and Sherry Piland, *Women Artists: An Historical, Contemporary and Feminist Bibliography*, Metuchen, New Jersey and London, 1978; Elsa Honig Fine, *Women and Art: A History of Women Painters and Sculptors from the Renaissance to the Twentieth Century*, Montclair, New Jersey, 1978; Germaine Greer, *The Obstacle Race: The Fortunes of Women Painters and their Work*, Secker and Warburg, London and New York, 1979; Roszika Parker and Griselda Pollock, *Old Mistresses: Women, Art and Ideology*, Routledge and Kegan Paul, London, 1981.

18 Debates around the aesthetic, cultural and political meanings of the avant-garde have featured prominently in art history and criticism of the seventies, eighties and nineties. In the *Theory of the Avant-Garde*, Peter Bürger investigates the concept, arguing that developments in French and German art and literature of the 1920s produced genuinely avant-garde movements in that they questioned the bourgeois notion of an autonomous art, and represented a radical break with Modernist tradition (Manchester University Press, 1984). Raymond Williams looks at the relationship (and distinctions) between modernism and the avant-garde in his chapter 'The Politics of the Avant-Garde' in his book *The Politics of Modernism: Against the New Conformists*, Verso, London, 1989.

19 I have drawn heavily on Weill's memories of the early years of her gallery as expressed in her book *Pan! Dans l'œil! Ou trente ans dans les coulisses de la peinture contemporaine 1900–1930*, Lipschutz, Paris, 1933, and on unpublished manuscripts and letters in the private collection of the Bouche family. I am very grateful to Bernard Bouche and his family for allowing me access to many pieces of personal correspondence.

20 In seeking to represent the activities and artistic interests of Charmy I have interpreted the limited biographical information available. Unfortunately there are few documents written by Charmy herself: she rarely wrote letters and there is no surviving diary. Some of the material I have drawn on comes from the recollections and writings of friends and relatives, and in particular from her son Edmond Bouche, who, until his death in 1988, lived at Marnat in the Auvergne. My effort to reconstruct a picture of some of her personal and professional

relationships has inevitably been influenced by the different impressions and attitudes of the people who knew her well, and for obvious reasons, her surviving friends tend to be those who knew her in the second half of her long life. Information on the early part of her life is scarce, and I have therefore tried to avoid speculative generalisations.

21 Griselda Pollock's arguments on the 'spaces of femininity' are discussed in Chapter 1, p. 24ff.

Professionalism, training and 'the spaces of femininity'

The appeal of Paris

According to modern art history, most of those artist's groups which have become the focus of European modernism before the war, such as the Post-Impressionists, the Fauves, or the Cubists, consisted almost exclusively of male artists who exhibited together in the 'independent' salons[1] or in smaller private galleries. Their activities were largely tied to the professional and commercial structures of the Parisian art world. The seeds of such progressive groups were sown within art institutions or exhibiting societies, through which male students and artists got together to pursue their shared radical interests. The prestigious *École des Beaux Arts*, where many a student established a career in fine art, excluded women until 1897.[2] And many of those artists who went on to identify themselves with progressive interests, scorning an academic education, had initially sought out the professional qualifications which such an institution offered, as is illustrated by Matisse's persistent attempts to gain entry to the *École des Beaux Arts* in the 1890s.[3]

Yet as Tamar Garb has shown, in the Parisian art world of the 1890s many women were negotiating roles as professional artists, although these often involved membership of separatist groups, such as the *Union des Femmes Peintres et Sculpteurs*. Founded in 1881, this organisation worked to promote women's art and access to exhibiting space, and held annual exhibitions from 1882. Although officially sanctioned, the Union did not have permanent premises and could not compete with the exhibiting groups organised by the exclusively male *cercles*, or the status accorded the prestigious, state-patronised annual *Salon des Artistes Français*. As Garb has argued: 'Catering for the needs of women in an environment which was at best neglectful, at worst hostile, the *Union* drew from a range of possible institutional prototypes, forming a hybrid which could go some length in catering for the needs of women within a particular historical context. Only by initiating an independent exhibition forum, with its own complex institutional infrastructure, did Mme Bertaux [the first president] and her colleagues believe that

they could begin to compete with their contemporaries, ensure exposure for their work, and at the same time create a supportive environment for the encouragement of younger female talent, vital for the creation of a vibrant feminine culture'.[4]

By 1900, however, the cultural and political context for women's artistic training was changing, and the pattern of professional 'exclusions' was less rigidly applied. According to a reviewer in *The Studio* of 1903, women artists were flocking to Paris around the turn of the century,[5] for despite the constraints, the city offered them a stimulating artistic environment and better opportunities for exhibiting and training than those available in many provincial French towns, or indeed in some other European art centres. Paris attracted many women students from other parts of Europe who subsequently settled in France. These include Alice Halicka and Mela Muter from Poland and Marevna, Sonia Delaunay and Marie Vassiliev from Russia. Maria Blanchard came to Paris from Spain in 1909 and spent most of her subsequent career working there, and in 1904 Alice Bailly left Switzerland for Paris where she lived and worked for the next ten years.

There were also many women artists from Europe and America who came to Paris for shorter periods to work and/or study and exhibit, among them the better known names of Paula Modersohn-Becker, Käthe Kollwitz and Gabriele Münter from Germany, Gwen John from Britain, and Natalia Goncharova and Liubov Popova from Russia. This group is beyond (although related to) the scope of this book, and forms part of a broader international artistic culture, shared by both male and female artists, for whom Paris had become an undisputed international centre with a seemingly magnetic appeal.[6]

The role of the private academies: an education for women?

Until the late 1890s the only state-funded art school for women in Paris was the *École Nationale pour les Jeunes Filles*, which encouraged pursuit of decorative and applied art, rather than participation in what was seen to be the more 'masculine' arena of 'high art'. Most women, therefore, who sought a training which would prepare them for a career as professional artists went to one of the many private academies, the *académies libres or académies payantes* which provided (often segregated) classes for female students and which were notoriously expensive. For example, the famous *Académie Julian*, founded in 1868, provided separate studios for women, and was one of the few places where women could study from the nude, but its fees for female students were twice those of the male students. It is hardly surprising then that most of the women artists discussed in this book and who received an art education in the 1890s, enjoyed the economic and educational advan-

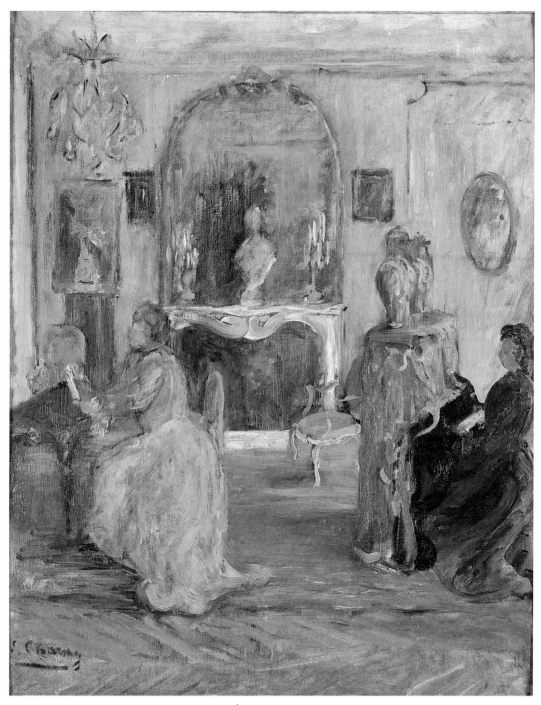

3 Emilie Charmy, *Interior at Saint-Étienne, c.* 1897, oil on canvas, 82 × 64 cm,
private collection

4 Emilie Charmy, *Lyon Interior with Jacques Martin, His Wife and a Model*,
late 1890s, oil on canvas, 84 × 90 cm, private collection

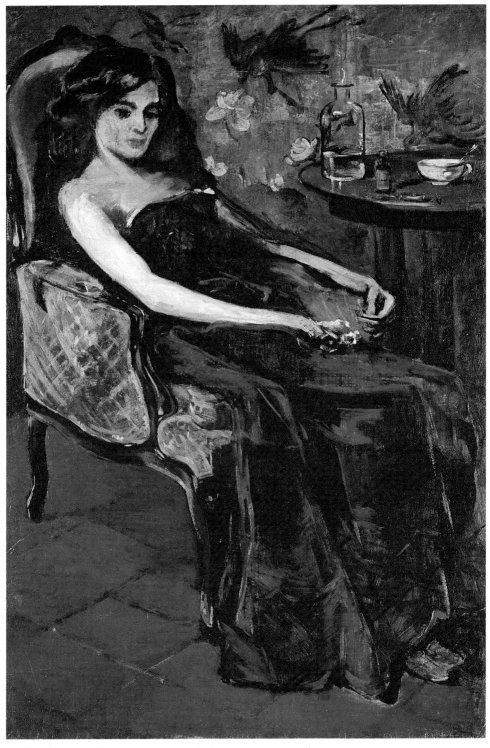

5 Emilie Charmy, *Woman in an Armchair*, c. 1897–1900, oil on canvas,
130 × 89.5 cm, private collection

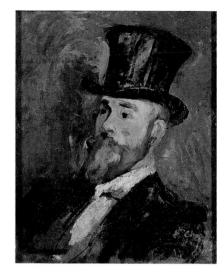

6 Emilie Charmy, *Portrait of the Artist's Brother,*
c. 1900, oil on board, 60 × 70 cm,
private collection

7 Emilie Charmy, *La Loge*, 1902–3, oil on board,
72 × 71 cm, private collection

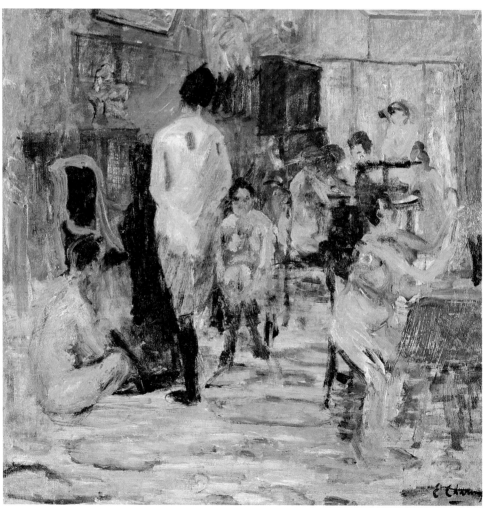

tages of a middle-class background. Without the resources to finance an art education, a professional career in art was virtually out of the question for women. The remarkable case of Suzanne Valadon who, despite her impoverished working-class background, managed to short-circuit the more conventional route to professional status, is considered in Chapters 3 and 4.

Partly as a result of the dogged campaigning by members of the Union, and the wider popular debate on the question of women's admittance to the professions, the state-funded *École des Beaux Arts* finally opened its classes to women in May 1897, but on special conditions which excluded them from the *ateliers*.[7] Such exclusions affected any claims for full professional status. These *ateliers* were finally opened to female students in January 1900. Within the fierce debates which preceded this development the contemporary critical, legal, philosophical and political battles over what could be seen to constitute a 'feminine' art were very much to the fore.[8]

As I hope to show, such debates, and the gendered forms of criticism involved, were reworked in the discourses which surrounded the activities of many women painters in the 1900s and 1910s, when the focus of critical attention seems to have shifted towards the status and role of 'women's art' in the more commercial arena of the private galleries and exhibiting societies. As I have suggested, to 'paint like a man' in this context could signify an artistic radicalism which increasingly became a focus of interest for the private art dealer. What it could have meant to paint 'like a woman', however, is sometimes more difficult to decode. Social and critical constructions of masculinity in the artistic sphere were increasingly subject to both renegotiation *and* re-affirmation. The appearance of growing numbers of women artists on the margins of the professional art world at the beginning of the twentieth century encouraged an awareness of both the critical potential, and the dangers, of gendered notions of artistic production. One response to this debate was to defeminise practices by women which were seen to compete with those of established (and highly valued) male painters. The expression 'to paint like a man' could thus carry with it a currency of meanings associated not just with technique, but also with professional training, creativity and 'avant-gardism'.

By the time the *École des Beaux Arts* admitted women, its dominance in the world of artistic training was on the wane. For those aspiring artists of both sexes who were interested in pursuing more 'progressive' forms of art which might feed the growing network of private dealers and galleries, the many private Parisian academies were an important training ground. Between 1900 and 1914 the private academies, most of which admitted women and increasingly offered mixed classes, seem to have been particularly buoyant, drawing a large source of income from foreign students, among

them many of the artists discussed in the following chapters. By 1900, the *Académie Colarossi* was competing with the *Académie Julian* as one of the most popular academies for women students,[9] and was soon established as an important international centre for art training. In her autobiography, published in 1962, Marevna (PL. 4) recalled her impressions of a life-class at Colarossi's which she joined one evening in 1912:

One evening, however, it happened that I had gone to work at drawing at the Colarossi Academy, in the rue de la grande Chaumière. The crowd there was thicker still: the building was filled with a whole army of young students of all nationalities, and all the rooms were packed. In the one where we were drawing from the nude the air was stifling, because of an overheated stove. We were positively melting in an inferno permeated by the strong smell of perspiring bodies mixed with scent, fresh paint, damp waterproofs and dirty feet; all this was intensified by the thick smoke from cigarettes and the strong tobacco of pipe smokers. The model under the electric light was perspiring heavily and looked at times like a swimmer coming up out of the sea. The pose was altered every five minutes, and the enthusiasm and industry with which we all worked had to be seen to be believed.

 The clothed models, men, women and children, were often Italian, dressed in the Neapolitan fashion.[10]

4 Marevna in 1912 with her fiancé Jura, just
 before her departure for Paris. She later
 broke off the engagement to Jura

By 1910 mixed classes were available in most of these academies, which also provided contexts in which women art students first became associated with male artists who were members of early modernist groups and artistic networks. For example, after moving to Paris in 1905, Sonia Delaunay studied at the *Académie de la Palette*, where her teachers included Ozenfant and Dunoyer de Segonzac. In 1912 Alice Halicka attended the *Académie Ranson*, where the teachers included Paul Sérusier and Maurice Denis. And after studying at Matisse's school, the *Académie Matisse* in 1908,[11] the Russian painter Marie Vassiliev actually founded her own art school, the *Académie Vassiliev* in 1909 (the canteen of this academy became a famous meeting place for artists and is mentioned in Marevna's autobiography). Maria Blanchard was a pupil here after moving to Paris in 1909. Blanchard also studied at the *Académie Vltii* under Van Dongen and the Spanish painter Angalda. The *Académie Russe*, a special school founded for Russian art students in Paris, attracted many Russian women, including Marevna, who worked there alongside other Russian emigrés including Soutine and Zadkine. While the growth of private academies helped expand the educational alternatives for those women who could afford it, it also increased the possibilities for acquiring less 'academic' forms of art training.

Paris and the provinces: social and artistic contexts and conflicts

The Parisian art world exerted a strong pull on many aspiring artists from the French provinces around the turn of the century. The commercial and professional networks of the French art world were heavily centralised, despite the growth of municipal museums and private galleries in some provincial centres such as Lyon. The capital provided more possibilities for women who had chosen careers as artists. It was also seen by many painters (both male and female) as providing working spaces in which progressive attitudes towards both artistic and social conventions could flourish. The myth of an artistic 'bohemia' with its associations of *déclassement* and sexual freedom was thriving in pre-war Paris and focused around the studios and café-communities of Montmartre and Montparnasse. The extent to which such bohemian spaces, and the anti-bourgeois attitudes which they nurtured, actually offered greater freedoms to women artists will be considered in Chapters 2 and 3.

Both Emilie Charmy and Jacqueline Marval left provincial towns to settle and work in Paris.[12] Both came from middle-class backgrounds and had previously trained as school teachers, one of the few acceptable professions for a respectable single woman in the late nineteenth century, but chose instead to pursue the riskier option of a career as an artist.

5 Jacqueline Marval, Paris, *c.* 1907

Marval, who came from Quaix near Grenoble, left behind a broken mar-
riage when she moved to Paris in 1895. Several accounts have emphasised
her provincial outlook at the time, when she has been described (somewhat
patronisingly) as 'this young provincial woman'[13] She moved in with the
painter Jules Flandrin, and apart from an unhappy period working as a
waistcoat-maker, sought out an appropriate art training. Thus Marval's
decision to pursue a career in art took place after she had moved to the
capital. In the late 1890s she attended Gustav Moreau's studio at the *École
des Beaux Arts* where she befriended Matisse, Marquet and Rouault, and
began submitting works to exhibiting groups including the *Salon des
Indépendants*. By the early 1900s Marval (PL. 5) was already establishing a
reputation as a *femme peintre* of merit, albeit a reputation separated (as we
shall see) from that of the avant-garde.[14] Charmy also submitted to the
Indépendants after moving with her brother from Lyon to a house in Saint
Cloud, Paris, in 1903. In contrast with Marval, Charmy had already estab-
lished herself as a serious professional artist before moving to Paris, a deci-
sion that was made easier by the necessary financial support from her family.
Her provincial bourgeois background, and the security which it afforded her
as an aspiring artist, provided some crucial influences on later developments
(and conflicts) in both her personal and professional life, and on the nature
and content of her art.

Academic debate has flourished around the shifting social and economic

backgrounds signified by the label 'bourgeois' in nineteenth-century French culture. During the 1870s and 1880s broad divisions were still recognised between the *grande* (or *haute*), *moyenne*, and *petite bourgeoisie*.[15] Born in 1878 in Saint-Étienne, an industrial town near Lyon, Emilie Charmy's social and educational background was rooted in a fusion of the *grande* and *moyenne* bourgeoisie. While her grandfather, who was Bishop of Toulouse, gave her family roots in the *grande bourgeoisie*, her father was the owner of an iron foundry, an industrial base associated with the *moyenne bourgeoisie*. However, by the end of the century distinctions between strata within the bourgeoisie were becoming increasingly blurred. While political power had previously been largely in the hands of the *grande bourgeoisie*, with the coming of the Third Republic many professionals and industrialists began to enter Republican political careers and widen the sources and areas of political and social influence and educational opportunities within the bourgeois class. This shift brought with it a growth of liberal philosophies and an increased awareness of political debates around the status of women in society. The sometimes uncomfortable co-existence of traditional with more liberal social values which this background involved is echoed in some of the seemingly contradictory interests later evident both in her work and her personal life. As a woman artist and a mother who (as we shall see) conspicuously avoided images of maternity, and a passionate seeker after professional success and social status who disdained some of the commercial channels available to her, her history does not encourage any simple or stereotypical representation of what it might have meant to be *une femme peintre*.

The early years of Charmy's life are the least well documented. She was the youngest of three children and from family records we know that she spent her first four years boarded out with a wet nurse in the village of St-Priest en Jarez, near her parents' home in Saint-Étienne where the family business was based. Despite the contemporary influence of Rousseauesque ideas on child rearing and the need for more 'natural' family relationships, it was still quite common in mid-nineteenth-century provincial France for children born into well-off families to spend their first years in the care of wet nurses, where they would not interfere with respectable bourgeois life. Over thirty years later, when such forms of child rearing were increasingly out of fashion for middle-class mothers, Charmy sent her own son Edmond into the care of wet nurses and carers for most of the first fourteen years of his life. Some of the social, psychological and artistic implications of this rejection of a conventional maternal role will be considered in later chapters.

Education was an important distinguishing feature of bourgeois life

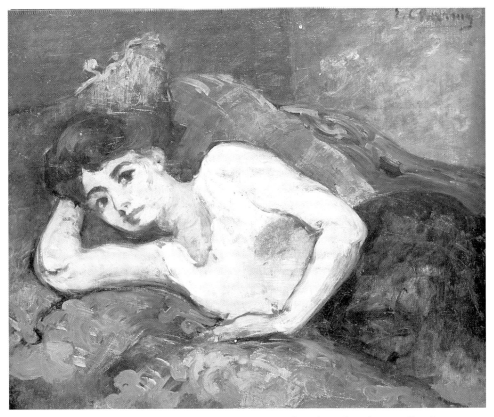

6 Emilie Charmy, *Reclining Woman*, c. 1900, oil on board, private collection

in late nineteenth-century France, and was crucial in the growth of a
politically powerful middle class which had emerged from the ranks of the
moyenne bourgeoisie. Attendance at a *lycée* or private college was socially
exclusive, more widely available to male students, and virtually impossible
for those on low incomes (free education at secondary level was not intro-
duced in France until 1929–33). Before 1880, when a law was passed intro-
ducing state-controlled *lycées* and schools for female students, the education
of young women (at both primary and secondary levels) was almost exclu-
sively controlled by the church.[16] Throughout France around the turn of
the nineteenth century educational debates focused on the secularisation
of education, a policy which was widely supported by Republican political
groups.

 These changing educational philosophies directly affected public percep-
tions of women's social roles; in eroding the control of the (largely) Catholic
Church from the education of young women, the State was also calling into

question the dominance (though not necessarily the value) of religious imperatives in contemporary constructions of femininity. Most primary schools for girls controlled by the Church had placed more emphasis on teaching religious values and 'virtuous' moral codes in family life, than on the acquisition of knowledge. Learning was more heavily emphasised in schools for boys.[17] Increasing demand, particularly from middle-class parents, for an education for girls which would prepare them for vocational or professional work led to an expansion of secondary education which trained pupils to gain teaching certificates.[18]

Despite these social changes around the turn of the century, the educational aspirations of this expanding provincial bourgeoisie were still conditioned by gendered priorities. A state-recognised 'professional' qualification for a woman was largely restricted to a teaching qualification. In this respect Emilie Charmy's education followed a familiar pattern for women of her class. After attending a private Catholic school for girls and an *École Supérieure*, she qualified as a teacher. But Charmy also had early ambitions to be a painter, which were not discouraged by her family. She turned down the offer of a teaching job and in the late 1890s (the exact date is unknown) entered the studio of Jacques Martin (1844–1920), a well-known Lyon painter.

Although information from this period is scarce, it seems that little pressure was imposed on her to pursue the more respectable option for a single woman. This may have been partly to do with the unconventional and tragic circumstances behind the polite façade of her early family life. One of her elder brothers died of an appendicitis at the age of nine. Both parents died in the 1890s, and during his last painful years her father had become addicted to morphine. Charmy was orphaned by the age of fourteen, when she and her elder brother Jean went to live with relatives in nearby Lyon. By the turn of the century the city of Lyon and its surrounding area had become the industrial and commercial centre of the southern half of France. Although less provincial than Saint-Étienne, the growth of the city's wealthy middle class had been built on the expansion of some of the same heavy industries.[19] By the early twentieth century, the city could boast a prestigious *École des Beaux Arts*, one of the largest municipal museums in France, a buoyant local art market and a growth in demand for art education. In fact Lyon was one of the few regional centres in which there had been some municipal provision for prospective women art students in the late nineteenth century. The artist and teacher Joseph-Benoit Guichard (who taught Berthe Morisot in Paris)[20] helped organise and direct a municipal art course in drawing and painting in Lyon from 1868 until his death in 1880. Charmy's family took the common option for middle-class daughters – private tuition.

Images of bourgeois life: Charmy and the representation of 'feminine' space

Charmy's earliest surviving canvases from the Saint-Étienne and Lyon periods, many of which are still in the collection of her family, show that this was one of the most interesting periods of her work (COL. PLS 3, 4, 5, 6, 7; PLS 6, 8, 9, 10). This group of work raises some difficult questions about both the social and sexual differences represented in women's artistic production at the time, and the relevance of a Paris-based modernism to a privately trained provincial (woman) artist. Much work has now been done on the deconstruction of 'masculinist myths of modernism' and the alternative 'spaces of femininity' which are represented (both as locations and as discourse) in the work of late nineteenth-century women artists such as Berthe Morisot (PL. 7) and Mary Cassatt. In her important and influential essay 'Modernity and the Spaces of Femininity', Griselda Pollock has looked at the work of these two women Impressionists showing how various gender power relations were inscribed in their artistic practices and the social spaces which they represented.[21] She argues that given the restrictions of class and gender, women's experiences of modernity would not have been the same as those

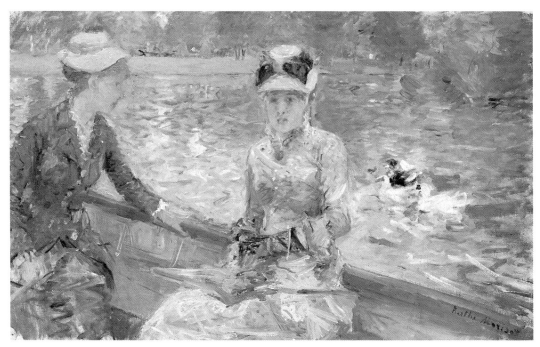

7 Berthe Morisot, *On a Summer's Day*, 1880, oil on canvas, 46 × 75 cm, National Gallery, London

of contemporary male artists. Those urban spaces, such as the brothel, the café-concert and the bar, which have come to be seen as the iconographic signifiers of modernity, were inaccessible to middle-class women. The representation of such spaces invokes the spectator as masculine.

In contrast the spaces (as locations) represented in the work of Morisot and Cassatt are largely those of bourgeois leisure and domestic activities. In this respect many of Charmy's earliest canvases from her Lyon period seem to invoke a sense of domestic confinement consistent with bourgeois codes of femininity. Her *Interior at Saint-Étienne* of c. 1897 (COL. PL. 3) shows an affluent interior in which one woman reads while another plays the piano. Her early interiors often include references to the accomplishments and interests of her family, such as music, reading, playing cards, sewing and painting, and are inhabited largely by women (PLS 8, 9). In some of these images it is not clear from the dress whether the subjects are family or women servants, thus blurring a traditional distinction between polite bourgeois life 'above stairs' and the more manual forms of labour 'below stairs' and, perhaps, revealing that such distinctions were not rigorously imposed in her household. These canvases also show that despite her provincial education, Charmy was developing a style influenced by both Impressionist and Post-Impressionist techniques. The loose brushwork, light tones and ambiguous sense of spatial depth of works such as *Interior at Saint-Étienne* reveal that her interests were closer to those of a Paris-centred early modernism than those of her tutor Jacques Martin, who was best known for his portraits and allegorical works (PLS 11, 12). In many of Charmy's works from this period both iconographical and spatial ambiguities are themselves suggested through the techniques adopted. The looseness of the brushwork in *Interior at Saint-Étienne* reduces the female figures to anonymous faceless objects. The content and space of the room is suggested rather than carefully described, with an expanse of carpet between the figures and the foreground. As spectators we are therefore distanced from the subject matter, both spatially and through the means of representation. This contrasts with the kind of spatial intimacy and compression of the picture space which has been identified by Pollock in works by Cassatt and Morisot,[22] and which constitutes an important visual illustration of the 'spaces of femininity' argument. Rather than force the viewer into a kind of confrontation or critical engagement with a foreground space in which a woman pursues an activity such as sewing, as in for example, Cassatt's *Lydia at a Tapestry Frame*,[23] in the Charmy the viewer is, so to speak, refused admittance to the space.

Was the artist consciously using this pictorial device to distance both herself and the spectator from this constricted form of bourgeois life? While

such a reading may seem dangerously close to a form of reflection theory, there is evidence that Charmy did dissociate herself from the narrow provincialism of her early life in Saint-Étienne, seeing the pursuit of a career in art, and the escape to Paris which it involved, as a form of liberation. Whether or not she was prepared to acknowledge it, this 'liberation' was to involve a confrontation with the constraints of both her class and her gender.

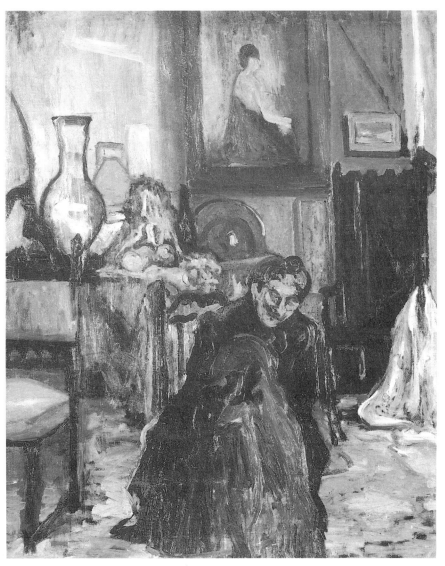

8 Emilie Charmy, *Interior at Saint-Étienne*, 1890s, oil on canvas, 96.5 × 78 cm, private collection

Of course, without evidence of artistic intention, we can only speculate on the extent to which she used her painting to express these social desires.

However, from the evidence of her surviving work, it is also difficult to retrieve a clearly defined self-image as artist during this early Lyon period. The closest that Charmy comes to painting herself as an artist is her *Lyon Interior: The Artist's Bedroom*, from around 1902 (PL. 10). But this is an image of an *absent* female artist. Although the loosely applied brushwork and the darker tonal areas inhibit a clear reading of the subject matter, there are many clues to suggest that this is the artist's bedroom which doubles as her studio. Her bed in the corner, items of clothing and a piano are juxtaposed with the tools of her trade: a plaster cast, an easel, a still-life arrangement. The portrait of the artist at work in (his) studio was a genre largely reserved

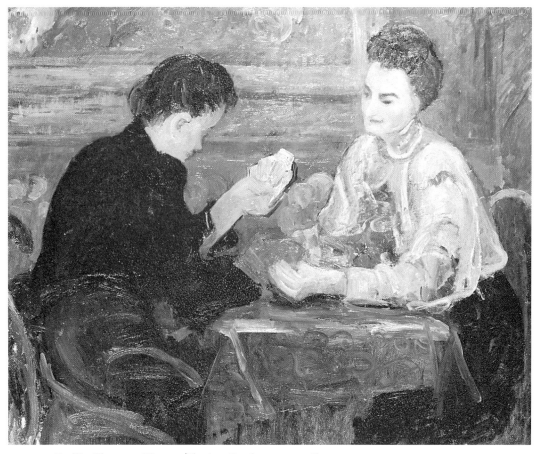

9 Emilie Charmy, *Women Playing Cards*, c. 1898, oil on canvas, 76 × 95.5 cm, private collection

for those successful male artists who could use the theme to display their professionalism. Without that established status, and the studio which went with it, a self-portrait as artist could be more ambiguously coded, or was at least more likely to be read as a representation of 'amateur' status. When Jacques Martin painted a portrait of his pupil, *Portrait of Charmy in the Studio of Jacques Martin*, late 1890s (PL. 11), there are no clear references to her own role as artist. She is depicted in Martin's studio with *his* canvases stacked behind her. She is dressed in virginal white and assumes a conventional 'feminine' pose with her body turned modestly to one side.

Around the same time, Charmy painted a contrasting image of her teacher at work in *Interior with Jacques Martin, his Wife and a Model*, c. 1900 (COL. PL. 4). Martin, wearing his familiar artist's beret, is shown sketching (or painting?) from a model, in surroundings which look like those of a middle-class interior, but which may be one of the studio reception rooms which he used for painting portrait commissions. Unlike some of the surviving studio photographs of Martin (PL. 12) which show him somewhat theatrically posed amidst the grease and grime, artistic tools and canvases of his trade, this portrait shows him working in a context more appropriate for 'feminine' portraiture, a domestic interior. Charmy also represents this artistic activity in terms of what we might call a 'viewing chain'. The relationship between artist and model is not the intimate one suggested by the popular early twentieth-century theme of self-portrait of artist and model (as painted by the male artist).[24] On the contrary, the relationship is shown as a small-scale spectacle observed by both the artist's wife, and by another male figure who is probably the husband of the sitter. And this chain of observers, and its gendered implications, are further extended by our knowledge that the artist is female. This canvas then could be read both as an image of male artistic production mediated through 'the spaces of femininity', and as a representation of artistic practice as a middle-class spectacle in which the portrait commission is the main currency of exchange. What is interesting is that this form of exchange has been recorded, and objectified, by a woman artist. I would suggest that Charmy's somewhat ambiguous position as a woman on the fringes of the professional activity which she depicts, enabled her to observe these relationships from a distance, to place herself further down the 'viewing chain'.

There are several works from around 1900 in which the viewing positions suggested seem more clearly to call into question some of the social divisions implied in the 'spaces of femininity' inhabited by many nineteenth-century women artists. Unlike that of Morisot or Cassatt, Charmy's subject matter was not always within the bounds of middle-class propriety. In

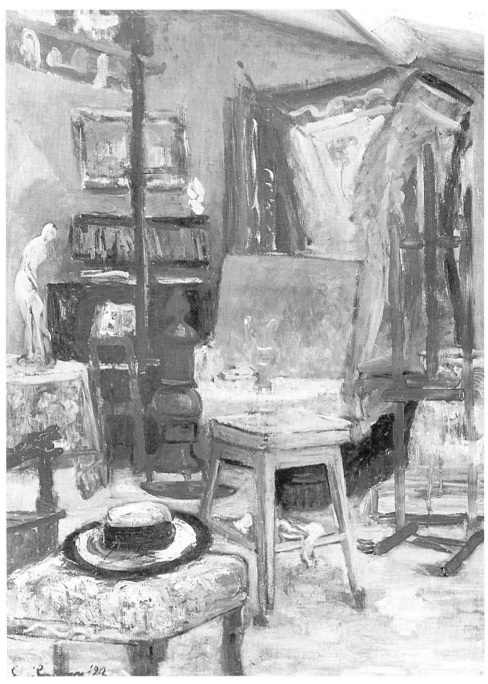

10 Emilie Charmy, *Lyon Interior: the Artist's Bedroom*, c. 1900, oil on canvas on
 board, 90 × 67 cm, private collection

11 Jacques Martin, *Portrait of Charmy in the Studio of Jacques Martin*, late 1890s, oil on canvas, private collection

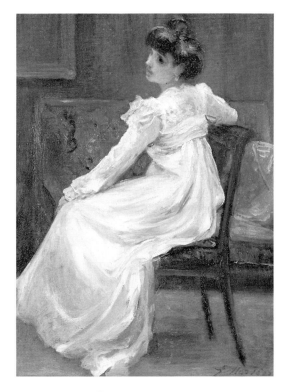

12 Jacques Martin in his Studio in Lyon, 1890s, with examples of his allegorical nudes hanging on his studio wall

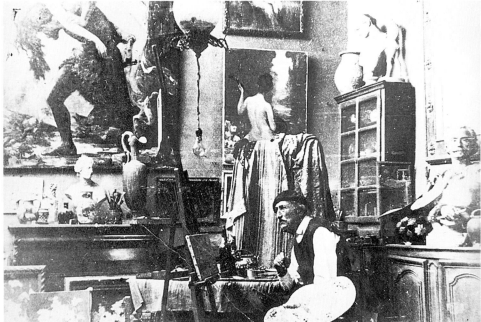

Woman in an Armchair, from the late 1890s (COL. PL. 5) she depicts another young woman in a middle-class interior, seated in front of a decorated screen. But this protagonist is slumped in her chair in evening dress, with dishevelled hair and a brooding expression, she seems to clasp a handkerchief. Next to her on the table is a tisane, a syringe and a medicine bottle. This is most likely a somewhat morbid image of female morphine use – or perhaps addiction, a theme with which Charmy would have been familiar from her father's addiction, and perhaps from contemporary literature which addressed the problem.[25] In this respect the image can be seen as failing to conform to the representation of respectable bourgeois femininity. Such a reading could be reinforced (both for a contemporary and modern audience) through the visual effects of the painted technique. In places the work appears deliberately unfinished and sketchy. For some contemporary observers this would have signified a technical incompetence; for others it could signify a break with convention, a 'modern' technique. In the context of her other works from this period, it seems likely that the artist intended this sketchiness to reveal her involvement with 'modern' techniques. But the painting also reveals an engagement with a 'modern life' theme, a post-Baudelairian preoccupation with the seedier aspects of a woman's life, more often associated with the late nineteenth-century work of male painters such as Degas, Manet or Toulouse-Lautrec.

Representing the brothel: woman as subject and object

Shortly before she moved to Paris in 1903, Charmy was working on a canvas which her family have politely titled *La Loge* (Artists' Dressing Room), 1902/3 (COL. PL. 7). Despite the loose, fluid brushwork, there are many visible clues which indicate that the subject matter was chosen to suggest, if not clearly to depict, the interior of a brothel. Naked women are shown sitting around in groups, talking, reading and apparently waiting. Several are naked apart from knee-length black stockings, items of clothing which had become recognisable symbols of the trade of prostitution.

This choice of subject matter by a woman artist suggests that by the early twentieth century the boundaries between women's and men's experiences of modernity are less easy to define. Yet the origins of Charmy's chosen image are difficult to unravel. Given her background, it is extremely unlikely that she would have visited a brothel. Within the provincial bourgeois culture of Lyon, merely to enter such a space as an observer would have threatened 'feminine' codes of behaviour. As a pupil in the studio of Jacques Martin, she studied from and observed the nude models he employed for his allegorical works. Although her earliest interpretations of this theme

were nurtured by Martin's teaching, she consistently rejected the allegorical and mythological conventions, in which women's bodies are often displayed in powerless, captive poses, or as symbolic of abstract virtues, for which her teacher became renowned (PL. 12). Her interest in reworking the theme would have been further encouraged after her move to Paris with her older brother in 1903. Despite the protective attitudes of her brother, her participation in the *Salon des Indépendants* and the *Salon d'Automne* gave her some access to the work of progressive artistic groups involved with these Salons, and to the bohemian culture with which such groups were associated.

It has been suggested by Charmy's family that studio sessions in which Martin worked with several models may have provided the original inspiration for *La Loge*.[26] In contemporary polite society, women who worked as artist's models were often associated with the world of prostitution. And the composition clearly evolved from a studio study into a larger grouping of women which suggested the salon, or waiting room of a brothel. The theme of the legally supervised brothels in France, known as *maisons closes or maisons de tolérance*, which were not abolished until 1946,[27] was depicted in the work of many late nineteenth- and early twentieth-century male

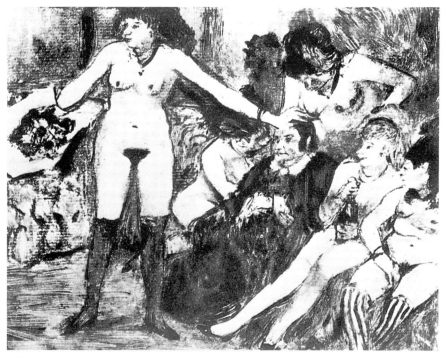

13 **Edgar Degas, *The Madam's Birthday* (brothel monotype), *c.* 1880, whereabouts unknown**

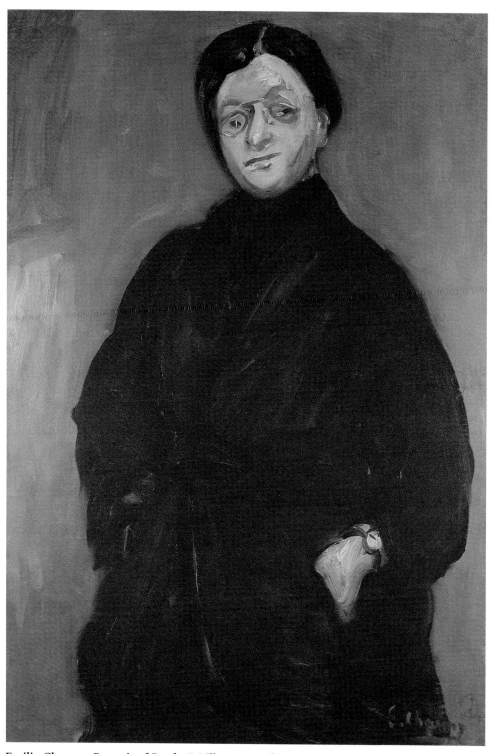

8 Emilie Charmy, *Portrait of Berthe Weill, c.* 1917, oil on canvas, 90 × 61 cm, private collection

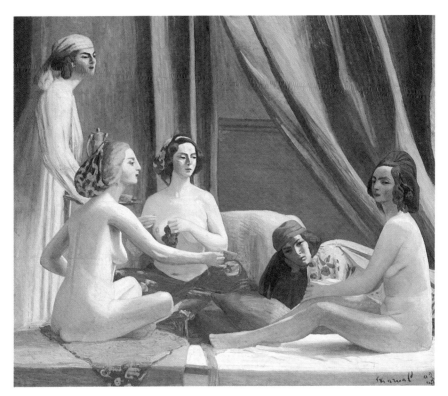

9, 10 Jacqueline Marval: *Les Odalisques*, 1902–3, oil on canvas, 194 × 230 cm,
Musée de Grenoble; *Portrait of Charles Verrier*, 1905–6, oil on canvas,
89 × 116 cm, private collection, London

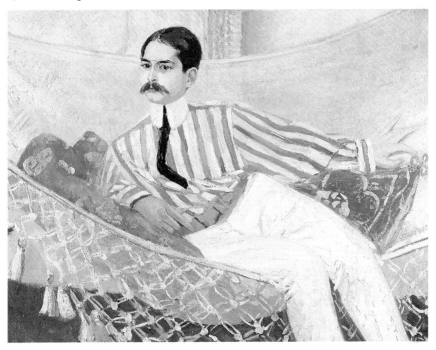

painters, among them Toulouse-Lautrec and Degas, and have come to be seen as one of the exclusively 'masculine' spaces of modernity. Charmy would have had access to reproductions of the theme in art magazines and journals, and through exhibitions of 'modern' art which travelled to Lyon. As I suggested earlier, by the turn of the century Lyon had become one of the most important centres of the French art world.

Does *La Loge* then represent a private voyeurism in which Charmy merely participates in a contemporary (male) artistic obsession with female sexuality as a commodity? This seems to be too simplistic a form of explanation. Although the artist occupies a traditionally 'masculine' space, she has also appropriated the genre for herself. She has become the subject to woman as object, and in the process has adjusted her focus. In common with her other works from this period the paint is loosely applied and the figures are ill-defined. These figures are not overtly sexualised or eroticised in the manner, for example, of a Degas brothel monotype, in which the women are often lined up across the picture space with their pubic areas emphasised (PL. 13). In *La Loge*, as in other works by Charmy from this period, the technique and the foreground space establishes a

14 Emilie Charmy, surrounded by her work in Saint Cloud, Paris, 1906

distance between the viewer and the groups of figures. Any suggestion of available female sexuality is absent; the artist seems to have separated herself, and the viewer, from a representation of woman as a sexual commodity.[28]

There is also evidence that the work was intended for public view, rather than perceived by the author as a form of private voyeurism. It is one of several works displayed in a photograph of the artist with her work taken in Paris in 1906 (PL. 14) and was later sold. This photographic record belongs to a tradition of studio photographs which we saw exemplified in the photo-graph of Jacques Martin, and represents a claim for professional artistic status. But in view of the forms of painting displayed around Charmy in *her* studio, her photograph is also a claim for recognition as a (Paris-based) *modern* artist, whose subject matter ranges from still-lifes to everyday domestic themes and nudes, and whose painting techniques have a visibly bold and free appearance, albeit through a black and white reproduction.

Charmy's adaption of a theme which has become an icon of late nineteenth-century modernity was, I would argue, part of a broader his-torical shift in the art of the early twentieth century, in which women artists increasingly engaged with themes traditionally associated with the male avant-garde. As I shall argue in Chapter 4, the theme of the female nude, in its various iconographical variations, became an important focus for many women artists struggling with problems of representation both out-side and on the fringes of the 'modern' movements. It is perhaps partly a lack of historical information and inadequate access to relevant works which has encouraged a tendency to see the female nude as a genre which was rarely adopted by women artists at the beginning of this century.[29]

My own work suggests a rather different picture, in which many of those women artists seeking professional recognition on the fringes of the avant-garde, such as Charmy, Marval, Valadon, Blanchard, Halicka and Marevna, were involved in reworking and developing the iconography of the female nude. For example, around the same time that Charmy was painting *La Loge*, Marval was working on *Les Odalisques* (COL. PL. 9), a large work which she submitted successfully to the *Salon des Indépendants* of 1903. Marval's canvas is a strange reworking of the nineteenth-century oriental 'odalisques' or harem theme, which Apollinaire later described as realising 'an important work for modern painting'.[30] Unlike Charmy's *La Loge*, Marval's interpretation of the odalisque theme provides little evidence of a woman artist deliberately transforming a 'masculine' language of looking. At the same time it does provide further evidence of women participating in forms of artistic production and iconographies more often associated

with better-known male artists. (It is worth noting here that Matisse's controversial reworking of the bathers theme, *Luxe, calme et volupté*, 1904–5 appeared in the *Salon des Indépendants* two years later.)

By the early twentieth century, then, the growth in professional and educational opportunities for women artists brought with it a slow erosion of some of the social divisions in male and female bourgeois roles, and a growing involvement by women in 'modern' artistic practices. Women were increasingly tackling both the themes and techniques of modernity. While some approached the theme of the (modern) nude in conventional ways, others, such as Charmy, have produced some ambiguous versions of a popular contemporary theme. In adopting a contradictory viewing position (that of a woman viewing female sexuality) she inscribes some of these differences in her work. The representation of these contradictions involves a kind of marginal 'space' in which women artists could work with these themes. It also signals the development of a physical marginal space, beyond those more clearly defined categories of 'femininity' and 'masculinity', in which women artists could practise and exhibit their work.

Notes

1 These are discussed in Chapter 2.
2 For a full discussion of the campaigns to have women admitted into the *École des Beaux Arts*, see Tamar Garb, *Sisters of the Brush: Women's Artistic Culture in Late Nineteenth-century Paris*, Yale University Press, New Haven and London, 1994; especially chapter 4, 'Reason and Resistance: Women's Entry into the *École des Beaux Arts*, p. 70ff. For a discussion of changing facilities for women art students at this time see also Diane Radycki, 'The Life of Lady Art Students: Changing Art Education at the Turn of the Century', *Art Journal*, Spring, 1982.
3 For biographical details on Matisse's art training see Alfred H. Barr, *Matisse, His Art and His Public*, Secker and Warburg, London, 1975.
4 Garb, *Sisters of the Brush*, p. 41.
5 Clive Holland, *The Studio*, Dec. 1903, pp. 225–30.
6 The international appeal of Paris as an avant-garde centre is taken up in Chapter 3.
7 The conditions for women's admittance to the *École des Beaux Arts* are discussed in Garb, *Sisters of the Brush*, p. 102.
8 These debates are addressed in *ibid.*, especially chapters 4 and 5.
9 The better-known women artists who studied at the *Académie Colarossi* include Paula Modersohn Becker (in 1900 and 1903), Mela Muter in 1901 and Marevna and Jeanne Hébuterne in the 1910s (see biographical information in Appendix 1). In his article in *The Studio* of 1903 (cited above n. 5) Clive Holland describes how women artists in Paris were mostly attached to the classes of the *Académie Julian* or the *Académie Colarossi*. He writes: 'The life of the schools is intensely interesting, often amusing, and sometimes even tragic. The stronger natures among the girl students will probably decide on attending one of the mixed classes, and there they will work shoulder to shoulder with their brother art students, drawing from the costume or the living model in a common spirit of studenthood and camaraderie'. Apart from the private studio, some free schools and classes were

available to women students. Octave Uzanne describes these and life in the private studios in a quotation from a 'Mme Romieu': 'If the girl', she says, 'is too poor to attend a studio, free schools and all kinds of classes for her art are open to her. But the studio really forms the artist. For the sum of twenty-five or thirty francs per month, the pupils can spend the whole day at the studio. They arrive at eight or nine in the morning, and stay until four or six in the afternoon. The master, generally a painter of merit, visits his pupils twice or three times in the week. He examines the work of each in turn and makes his comments. He has no sort of control over them, and does not even live in the house in which his studio is situated. The pupils gain most of their experience from each other. A studio is a kind of mutual school and, in spite of the lack of supervision, it is very orderly. The pupils answer (as it were) for each other's conduct. As pupils are of all ages, there are not the same drawbacks that might arise were they all young girls. There are married women, young girls, and children. A child of ten or twelve years sits next to a woman of thirty. As to the social position of the women, there are daughters of artisans, of business men, of tradespeople; often daughters of retired military men, and girls of a higher class whose parents have the good sense to send them where they can study with professional artists. Young girls of position and fortune are more or less numerous, according as the studios are more or less fashionable' (Octave Uzanne, *Parisiennes de ce temps*, Paris, 1910; translated as *The Modern Parisienne*, Heinemann, London, 1912).

10 Marevna Vorobëv, *Life in Two Worlds*, Abelard-Schuman, London and New York, 1962, p. 122. Please see Appendix 3 for the full extract from which this quotation is taken.

11 For information on the *Académie Matisse*, see Barr, *Matisse*, pp. 116–19. Matisse himself had studied at the *Académie Carrière* in 1900, where he met Derain, Puy and Laprade. According to Puy's biographer, of the fifteen or so students enrolled in 1900, five or six were women (Petit Palais, Geneva, *Jean Puy*, undated, p. 13).

12 Laurencin and Roger were both born in Paris and Valadon moved to Paris from Bessines in the Haute Vienne when she was five. She came with her mother Madeleine who was in search of work as a cleaner, and in 1870 they settled in the boulevard Rochechouart in Montmartre. See biographies in Appendix 1.

13 François Roussier, *Jacqueline Marval 1866–1932*, Didier Richard, Grenoble, 1987, p. 7.

14 The importance of the *Salon des Indépendants* as an exhibiting platform for women painters and some of Marval's submissions to that Salon are discussed in Chapter 2.

15 See, for example, the discussion in E. Cahm, *Politics and Society in Contemporary France 1781–1971*, Harrap, London, 1977, p. 374ff; and R. Pernoud, *Histoire de la bourgeoisie en France*, vols. i and ii, Editions du Seuil, 1962. According to Cahm, the *grande bourgeoisie* consisted of those who had accumulated the greatest wealth or who occupied the highest positions in the civil service, the church, the law and the professions, and therefore constituted the ruling class. The *moyenne bourgeoisie* were the less wealthy property owners or those who occupied lower ranks in the professions, while the *petite bourgeoisie* were the small tradesmen and clerical workers (Cahm, *Politics and Society*, p. 374).

16 For useful information on the education of women and the control of the church in the late nineteenth century in the region around Saint-Étienne, see Mathilde Dubesset and Michelle Zancarini-Fournel, *Parcours de femmes – Réalités et représentations: Saint-Étienne 1880–1950*, Presses Universitaires de Lyon, Lyon, 1993. In the municipality of Saint-Étienne in 1870, before a concerted campaign for secularisation had taken place, there were 2,500 boys attending 17 non-denominational schools, and 1,750 boys at congregationalist schools. In contrast 1,313 girls attended 15 non-denominational schools and 2,050 congregationalist schools. See Dubesset and Zancarini-Fournel, *Parcours de femmes*, p. 30.

17 For example, in 1861 an inspector of primary schools produced a report on girls' schools in the area of Saint-Étienne, pointing out that: 'les populations se montrent généralement moins disposées pour l'éducation des filles que pour celle des garçons ... Les villes ont confié la direction des écoles communales à l'ordre de Saint-Charles ou de Saint-Joseph ... Elles n'oublient pas [les religieuses] qu'elles sont appelées à former des mères de famille vertueuses et dévouées ... Les bonnes méthodes ne sont pas toujours appliquées avec toute l'intelligence désirable; les progrès sont lents mais incontestables, et les élèves ne quittent les classes qu'après avoir acquis des notions solides sur les principes de la religion' (Archives Nationales, AN F17 9347, Rapport de l'inspecteur primaire, 31/1/1861; cited in Dubesset and Zancarini-Fournel, *Parcours de femmes*, p. 13).

18 Notably in the development of the *École Normale* and the *École Supérieure*. And as Mathilde du Bresset and Michelle Zancarini-Fournel have shown, this increased demand for vocational forms of training was especially pronounced in the provincial municipality around Saint-Étienne, a growing area of middle-class wealth generated in part by heavy industries such as mining (*Parcours de femmes*, p. 35ff).

19 By 1900 Lyon had become an important centre for the chemical industry and for a number of early automobile manufactures. The town had been well established as the centre of the local silk industry since the eighteenth century, and the mid nineteenth century saw a growth in banking and commerce in the area, including the founding of the famous Crédit Lyonnais in 1863.

20 See Katherine Adler and Tamar Garb, *Berthe Morisot*, Phaidon, London, 1987, p. 13.

21 See 'Modernity and the spaces of femininity', chapter 3 in *Vision and Difference: Femininity, feminism and histories of art*, Routledge, London and New York, 1988, p. 50ff.

22 *Ibid.*, p. 63. Kathleen Adler has developed further arguments about the suburban 'spaces' which Morisot inhabited and the ways in which she represented them in her art. See K. Adler, 'The Spaces of Everyday Life', in T. J. Edelstein (ed.), *Perspectives on Morisot*, Hudson Hills, New York, 1990, pp. 35–44.

23 Cassatt's *Lydia at a tapestry frame* (c. 1881), Flint Institute of Arts, is discussed and reproduced (fig. 3.8) in Pollock's chapter 'Modernity and the spaces of femininity'.

24 The gendered implications of this relationship as it has been represented in early twentieth-century avant-garde art have featured in much feminist writing of the last thirty years. See, for example, Carol Duncan's famous essay 'Virility and Domination in Early Twentieth-Century Vanguard Painting', first published in *Artforum*, Dec. 1973, pp. 30–9.

25 Morphine addiction was quite common at the time, and it had become something of a 'society' drug. The depressing and socially damaging effects of addiction were popular themes in contemporary literature.

26 Charmy's grandson, Bernard Bouche, has suggested to me that she would have observed models waiting to sit for Martin's compositions, and these could have provided the initial inspiration for this painting.

27 For a discussion of the history of prostitution in France see Neil Philip, *Working Girls: An Illustrated History of the Oldest Profession*, Bloomsbury, London, 1991, chapter 4, 'They order these things better in France', p. 62ff.

28 Although this is purely speculative, there may also have been some more personal (unconscious?) psycho-sexual reasons for Charmy's early interest in the theme. Later in life she was probably bisexual, and her enduring interest in the theme of the female nude may be rooted (as I suggest in chapter 4) in some complex (and shifting) attitudes to her own sexuality.

29 See, for example, Patricia Matthews's discussion of the theme of the nude in the work of Suzanne Valadon in 'Returning the Gaze: Diverse Representations of the Nude in the Art of

Suzanne Valadon', *Art Bulletin*, 63;3, Sep. 1991, pp. 415–30. This article and some of the issues it raises are discussed in Chapter 4.

30 *Chronique des Arts*, 5 Apr. 1914. And an article in *La Plume* of April 1903 described the painting as having 'simple colours which were muted and gracious like *gandourahs* in the sun'.

'In the wings of modern painting':
women artists, the Fauves and the Cubists

As if by magic, my shop took on an imposing appearance, and we painted in big letters above the shop front: '*Galerie B. Weill*'. The first gallery of painting by *Young People* was born.[1]

In November 1901 Berthe Weill (COL. PL. 8) officially opened her small gallery dedicated to showing the work of 'young' artists, at 24 rue Victor Massé. The inaugural exhibition opened on 1 December and although nothing sold, it attracted many visitors and was declared by Weill 'a significant moral success'.[2] As a dealer she was seriously under-capitalised and continually dogged by financial problems. But her commitment to promote the work of young and little-known artists contributed to the mythology, if not the economic success, of many members of the early twentieth-century avant-garde, most of whom went on to sign contracts with better financed dealers. She was the first Parisian dealer to sell the work of the young Picasso in 1900, and hers was one of the first galleries to exhibit and sell the work of Matisse and some of his friends before they won themselves the group label '*les fauves*' (the wild beasts) in 1905.[3] Weill's commitment to 'Young People' also involved the patronage of many little-known women artists who were seeking commercial outlets for their work in the 1900s and 1910s. As can be seen from Weill's exhibition lists reconstructed in Appendix 2, these included Marval, Charmy, Laurencin, Valadon, and Halicka among others.[4] In this chapter I am concerned with the ways in which such women artists positioned themselves and their art in relation to the activities of early twentieth-century avant-garde groups. I am also concerned with the forms of art which these women practised, and the contemporary critical responses which their work evoked.

Although many of these women artists were taken up by more successful dealers (as I show in Chapter 3), Weill's early patronage and active support seems to have involved a sense of indignation against the forms of critical and professional discrimination they suffered for their sex. As a woman in a profession dominated by men, her writings reveal a strong sense

of the problems faced by women seeking careers, whether in art or business. In her autobiographical account of the first thirty years of her gallery, *Pan! dans l'œil! Ou trente ans dans les coulisses de la peinture contemporaine 1900–1930 (Splat in the Eye! Or thirty years in the wings of modern painting 1900–1930)*, she makes frequent references to the problems and obstacles she faced as a woman trying to operate within the art market[5] and to some of the prejudices held towards women painters by male critics. In her account of 1903, she describes the negative criticism on the *Salon des Indépendants* of that year made by Arthur Cravan, a professional boxer, writer and patron of the art world who became notorious for his outspoken views on contemporary art. She writes that in his magazine *Maintenant,* Cravan took every opportunity to hurl scurrilous insults at the women artists in the show, especially Valadon and Laurencin.[6] Cravan's review had in fact attacked many artists in the show, and by some strange coincidence he appeared in her shop shortly afterwards. She records the following exchange:

WEILL: Ah, it's you the so and so Cravan! the insulter of women? you're doing a really dirty job there.
CRAVAN: Lets see! (he said to me laughing) . . . You're a feminist, I suppose?
WEILL: Certainly!
CRAVAN: Ah, so! that's the equality of men and women; well, I take no more issues with women than with men.
WEILL: Oh! you contrive that to cover yourself, for you are evasive once it's a question of taking responsibility. There is, sir, a way of doing things in France, one respects women and the individuality of each person . . . I'll say it again, you're playing a dirty game.[7]

According to Weill, many of the male artists attacked in his review challenged *le boxeur* to meet them in the 'Salle Champollion' in order to fight out their disagreements in public. Not surprisingly, Cravan did not turn up. His dismissive review had targeted one of the most important contemporary exhibiting spaces for lesser known artists, among whom were many women.

Exhibiting spaces

Since its foundation in 1884 the *Salon des Indépendants* had provided opportunities for artists whose work did not meet with the (broadly speaking) more traditional forms of work exhibited and selected in the official *Salon des Artistes Français,* or the slightly more liberal *Salon du Champs-de-Mars* (also known as the *Nationale*). Unlike most other exhibiting societies, the *Indépendants* was open to anyone. The absence of a jury system encouraged submissions from women artists who might otherwise have encountered

some professional prejudice. Catalogue lists from the first two decades of the century show that this society became one of the most important exhibiting outlets for women. Marval, Charmy, Valadon, Laurencin, Alice Bailly and Mela Muter (PLS 15, 16) all showed there regularly during this period,[8] and most of the women artists associated with the Cubist movement, including Sonia Delaunay (PL. 17; COL. PL. 19), Halicka, Marevna and Blanchard began to submit to the *Indépendants* during the 1910s. Valadon was one of many outspoken defenders of the institution and its 'open' exhibiting policies, although in an article of 1921 she deplored its decline in the later 1910s.[9]

Annual exhibitions, which often included retrospectives of better-known artists, were held in the Spring, and for a small fee two paintings could be exhibited (although larger numbers of submissions were allowed). By 1900, the *Indépendants* had become a recognised forum for the promotion of new artistic developments and was closely watched by the critics. It was here that Paul Signac and other Neo-Impressionist painters established a reputation, that Matisse and his friends were able to exhibit some of their earliest Fauve canvases, and that Picasso and the Cubists later made their mark.[10] Cravan's attack then threatened the very fabric of more permissive exhibiting policies. If the quality of most of the work exhibited by the *Société des Artistes Indépendants* was in doubt, its status as a national forum for new forms of artistic production was also open to scrutiny. During the first two decades of the twentieth century debates about the status of the *Indépendants* continued to rage, and its reputation often rose or fell in direct relationship to the fortunes of those controversial groups who showed under its auspices.

From the earliest days of her gallery, Berthe Weill scouted for talent at the *Indépendants*, where many of her artists were first exhibited. Marval, who first showed with Weill in 1902, made regular submissions to the *Indépendants* from 1901. The catalogues show that in some years she showed as many as nine canvases, and her reputation was well established with the success of *Les Odalisques* (COL. PL. 9) in 1903, which was subsequently included in the much publicised New York Armoury Show of 1913. Charmy showed at the *Indépendants* from 1904, and it was through this exhibiting society that she probably first became friendly with Matisse, Camoin, Marquet and other members of the Fauve circle. Weill first noticed Charmy's works at the 1905 *Salon des Indépendants*, which was dominated by the *succès de scandale* of Matisse's *Joy of Life* (PL. 18).[11] Weill records:

This year the Salon des Indépendants will definitely put in motion a progressive movement towards *la jeune peinture*; the interesting retrospectives of Seurat and Van Gogh are certainly capable of shutting the mouths of the most recalcitrant; if the amateur still doesn't value much, the artists are very enthusiastic . . .

It was this year that I noticed the paintings of a young girl who I didn't know, and who had not yet shown me her work. I sensed there was something of a personality there. I wrote asking her to bring me one or two paintings, which she did. I sold one of these during the course of the shows which followed [the *Indépendants*]. Since them Mlle Charmy has become my best friend.[12]

Another important exhibiting outlet for lesser-known and 'progressive' artists was the *Salon d'Automne*, founded in 1903. Weill described its opening as a 'sensational event', and closely followed its annual shows, scouting in her inimitable way for up-and-coming artists. Like the *Indépendants*, the *Salon d'Automne* encouraged submissions from 'beginners', a category which often included women artists. A significant difference from the *Indépendants* was that the *Salon d'Automne* controlled admissions through an elected jury, and soon came to be seen as a more prestigious institution. It was founded by a group of painters and writers, including Renoir, Huysmans, Rouault and Vuillard, and its first president was the architect Franz Jourdain.[13] Jourdain has described his ambitions in founding the Salon as follows:

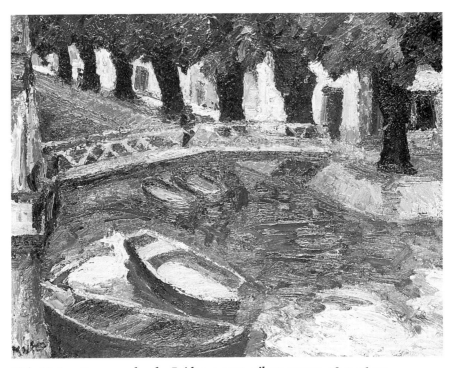

15 Mela Muter, *Barges under the Bridge, c.* 1901, oil on canvas, 38 × 46 cm, Musée Petit Palais, Geneva

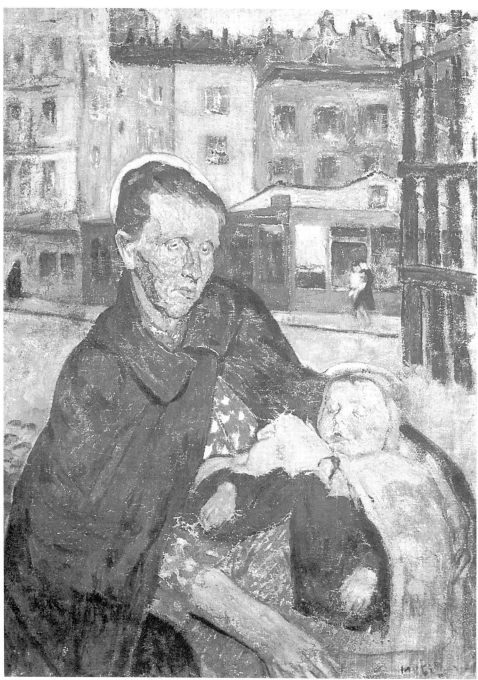

16 Mela Muter, *Mother and Child with Haloes, c.* 1910, oil on canvas, 60 × 81 cm,
Musée Petit Palais, Geneva

I was obsessed with the idea of grouping together those modern artists who found it so difficult to gain the publicity they deserved. By offering the beginners, the misunderstood, the rebellious, a way of putting themselves on an equal footing with the ambitious and the pundits, there's a chance of shortening the sad and humiliating probation periods imposed on the innovators.[14]

The avant-garde and the 'misunderstood beginners' were regularly exhibited alongside more established artists and thereby given a more acceptable context in which to promote their work. Weill noted a similar exhibiting strategy in her comments quoted above on the retrospectives of Seurat and Van Gogh in the 1905 *Indépendants*. In the same year the *Salon d'Automne* included retrospectives by Ingres and Manet, thereby helping to legitimise the display of works by less established artists. Among these were exhibits by Matisse, Derain, Vlaminck, Marquet and Rouault in the controversial gallery seven or *cage centrale*, which caused the critic Vauxcelles to first use

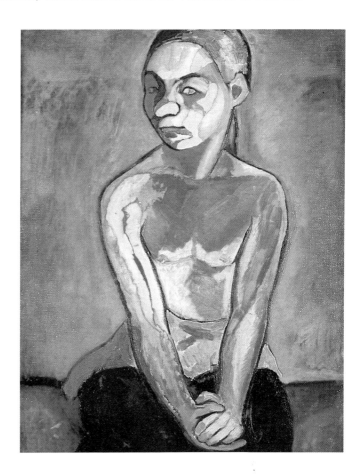

17 Sonia Delaunay, *Young Finnish Girl*, 1907, oil on canvas, 80 × 64 cm, Musée d'Art Moderne de la Ville de Paris

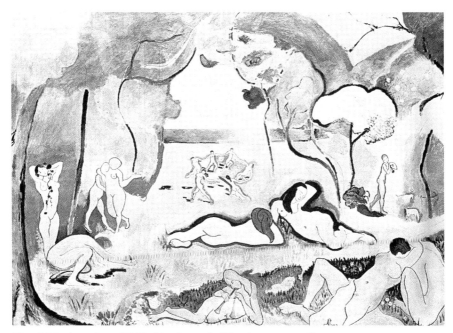

18 Henri Matisse, *Joy of Life (Bonheur de Vivre)*, 1905–6, oil on canvas, 171 × 234 cm

the label *les fauves* to describe the loosely painted, brightly coloured style of some of their work.[15] The critical publicity generated by these paintings has tended to overshadow art historical discussion of the content of much of the rest of the exhibition, which numbered nearly two thousand exhibits. Although Marval's work was becoming known and was beginning to feature in contemporary criticism, there is relatively little evidence from contemporary reviews to tell us that the 1905 show also included several exhibits by women artists whose work has (subsequently) been associated with *les fauves*, including Charmy and Muter.

Les femmes peintres and the 'wild beasts': gendered themes and techniques?

Histories of Fauvism tend to see the exhibits in 1905 and 1906 by Matisse and his friends in the *Indépendants* and the *Salon d'Automne* as marking the crucial years of the movement. The critical consternation and outrage which greeted their daring, violently coloured works has helped to consolidate a radical or avant-garde status for Fauvism. I have argued elsewhere that we must be cautious of overplaying the myth of an outrageous group of 'wild beasts' (*les fauves*) bursting onto the artistic scene. Many of the

characteristics of painting which we now identify as Fauve had been in
evidence before the shows of 1905 and 1906, and the critical reception of
these exhibitions was by no means exclusively 'outraged'.[16] However in such
large-scale exhibitions, the critical coverage (whether enthusiastic or nega-
tive) tended to be selective, and more often than not focused on exhibits by
artists already known, or who had already generated controversy. Moreover,
the representation of these controversial artists as 'wild beasts' carried with
it connotations of bestial, violent or savage behaviour more often associated
with a male artist. According to this notion the creative process itself
involved a 'wild' or instinctive form of expression. It is hardly surprising then
that exhibits by Marval and Charmy in the now notorious salons of 1905
and 1906 either escaped any significant critical mention or were represented
as preoccupied with entirely separate concerns from those of *les fauves*.

In the 1905 *Salon d'Automne* Marval showed *Spring*, and Charmy two still-
lifes listed in the catalogue as *Dahlias* and *Fruit*. In the same Salon of the
following year Marval showed *The Sleep of the Graces* and *Portrait of
Charles Verrier* (COL. PL. 10) and Charmy showed five flower paintings and
one titled *Prunes*. In the same exhibition, the so-called Fauves were well
represented with exhibits by Matisse, Marquet, Manguin, Puy, Vlaminck,
Derain, Dufy, Friesz, Van Dongen, and Rouault, although critical reactions
to these works were somewhat overshadowed by the fuss surrounding
Matisse's *The Joy of Life* in the *Indépendants* earlier in the year.[17]

Charmy's exhibits in the *Salon d'Automne* of 1906 have proved difficult to
trace, as has Marval's *Sleep of the Graces*. However, the title *Sleep of the Graces*
suggests that this painting belongs to a series of compositions of women and
bathers in nature (PL. 19) which Marval was producing around 1904–7. These
show a loose application of paint and bright colours similar to that
of 'fringe' Fauves such as Von Dongen (PL. 21). Despite these parallels
Marval's work from this period was more often associated in contemporary
criticism with a sub-Impressionist style of painting influenced by the
work of Vuillard and Bonnard,[18] thus clearly separating it from the more
'innovative' techniques employed by the Fauve group.

Charmy's exhibits in the 1906 show would have been similar in style to
the still-lifes from the same period illustrated in COL. PL. 11, PLS 24, 25 and
26 displayed in the photographs of the artist surrounded by her canvases in
Saint Cloud in 1906 (PLS 22, 23). Such works were often characterised by
thick paint, almost brutally applied, a style of painting which was to become
her hallmark, and which would confound those critics who identified bold
brushwork with supposedly 'masculine' techniques. Similar techniques had
encouraged Vauxcelles to use the label 'wild beasts' to describe the work of
Matisse and his group in the 1905 *Salon d'Automne*. In her still-lifes from

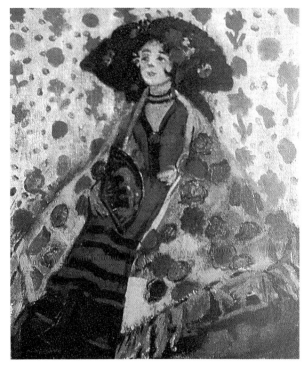

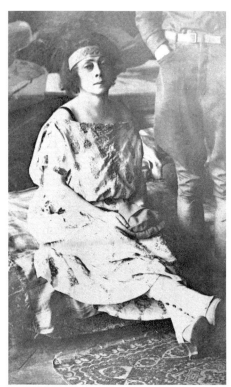

19 Jacqueline Marval, *L'Espagnole, c.* 1904,
 oil on canvas, 55 × 46 cm, private
 collection, London

20 *upper right*
 Jacqueline Marval, *c.* 1918

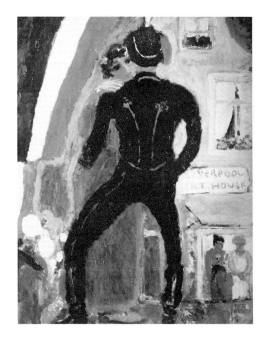

21 Kees Van Dongen, *Liverpool Lighthouse,*
 Rotterdam, 1907, oil on canvas, 100 ×
 81 cm, Fridart Foundation, Rotterdam

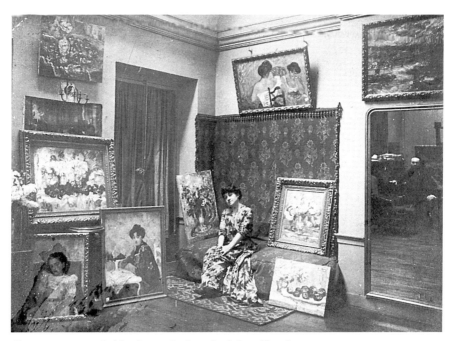

22 Charmy surrounded by her paintings in Saint Cloud, 1906

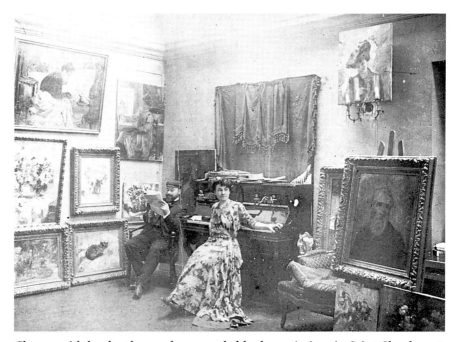

23 Charmy with her brother, and surrounded by her paintings in Saint Cloud, 1906

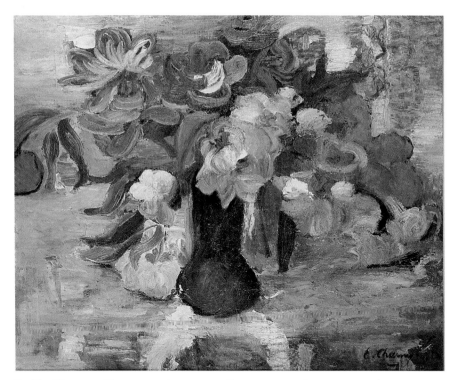

11, 12 Emilie Charmy: *Flowers, c.* 1897–1900, oil on canvas, 58 × 70 cm, private
collection; *Piana, Corsica,* 1906, oil on board, 54 × 65 cm, private collection

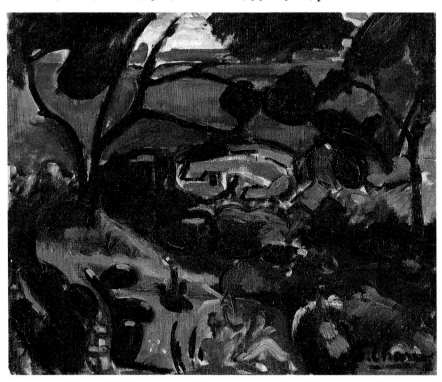

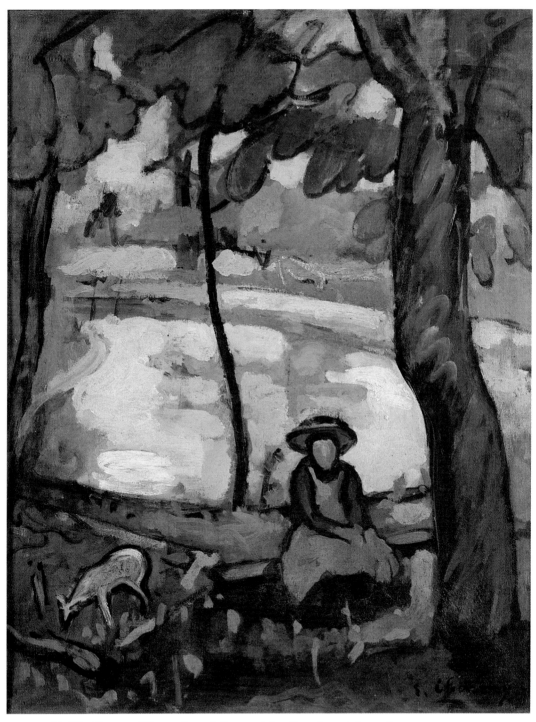

13 Emilie Charmy, *Woman by a Lake*, 1906–8, oil on board, 80 × 63 cm,
private collection

14, 15 Emilie Charmy: *The Bay of Piana, Corsica*, 1906, oil on canvas,
17 × 26 cm, private collection; *Woman in a Japanese Dressing
Gown*, 1907, oil on canvas, 81 × 62 cm, private collection

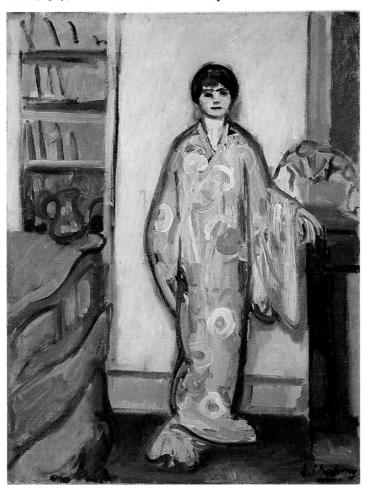

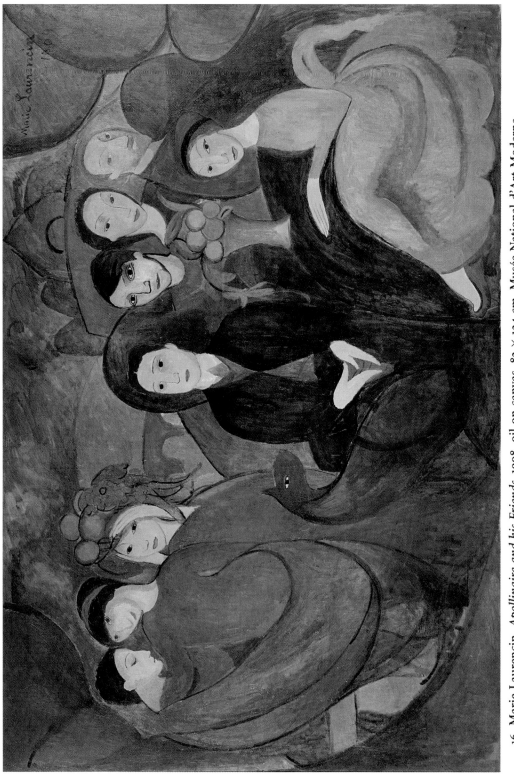

16 Marie Laurencin, *Apollinaire and his Friends*, 1908, oil on canvas, 82 × 124 cm, Musée National d'Art Moderne, Centre Georges Pompidou, Paris

this period Charmy also often followed the Fauve practice of leaving large areas of the canvas unpainted, and of employing strong rich colours with dark outlines (COL. PLS 8, 12, 14, 15, 24). In view of these characteristics it seems remarkable that her canvases passed relatively unnoticed in the *Salon d'Automne* of 1905 and 1906.[19] But these submissions were hung separately from those of Matisse's group. Exhibits were often hung five or six deep, and lesser-known artists were usually given less favourable positions. If Charmy's works had been included in the notorious *cage centrale* in 1905, they might have provoked some critical interest. They were also the work of a woman painter and, therefore, stood less chance of being acknowledged critically in the same category as the avant-garde. Access to better hanging space could also be helped by having friends, or by being involved oneself, on the relevant Salon committees. It is significant then that in 1905 Matisse was chairman of the hanging committee of the *Indépendants*, which included Camoin, Manguin, Marquet and Puy. In 1905 Matisse was also on the committee of the *Salon d'Automne*.[20]

As the label 'Fauve' was not coherently adopted by Matisse and his circle, and was a critical concept imposed (initially by Vauxcelles) upon them, it is dangerous to generalise about the nature and organisation of such an exhibiting group. However, the evidence from exhibition catalogues and reviews does suggest that the so-called 'Fauve' circle was organised into a recognisable exhibiting group largely by Matisse, and that the self-image of these 'radical' artists involved a sense of predominately masculine professional and creative roles. That is to say that women painters who adopted similar styles were rarely included in the group hanging space and collective studio activity,[21] and were not mentioned in critical representations of the 'wild beasts'. Such exclusions did not necessarily involve conscious decisions to keep women out of masculine spaces. It was rather the case that access to such space was rarely sought by artists such as Charmy or Marval, for whom a marginal relationship with their male professional colleagues was seen as the cultural norm. Although (as we shall see) women's names become more visible in the Cubist group shows, women artists were more often expected to gain access to avant-garde circles through their personal (rather than professional) relationships with better-known male artists. The different ways in which women exercised, challenged and reinforced these marginal roles is a central theme of this book.

Charmy's salon exhibits during the years 1905–6 were almost exclusively flower paintings and still-lifes, and this genre itself may also have separated her work off from what were perceived to be the most 'modern' aspects of the Fauve movement. To a certain extent she was following established and marketable conventions. Such subjects, which were popular with middle-class

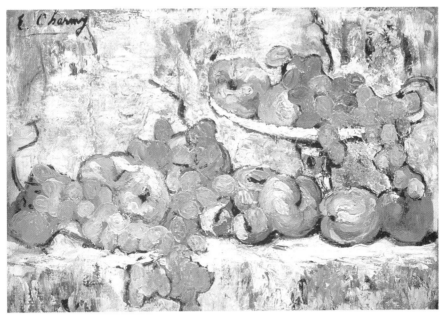

24, 25 Emilie Charmy: *Still-Life with Fruit*, 1900–2, oil on canvas, 38 × 55 cm, private
collection; *Flowers on a Balustrade*, 1899–1900, oil on canvas, 63 × 79 cm, private
collection

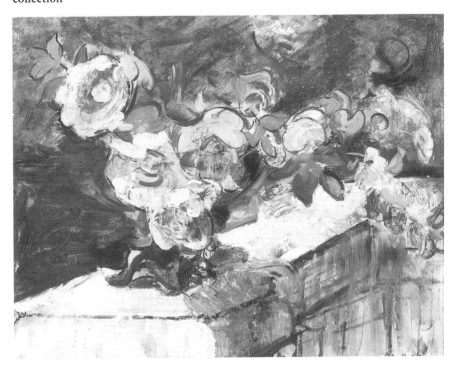

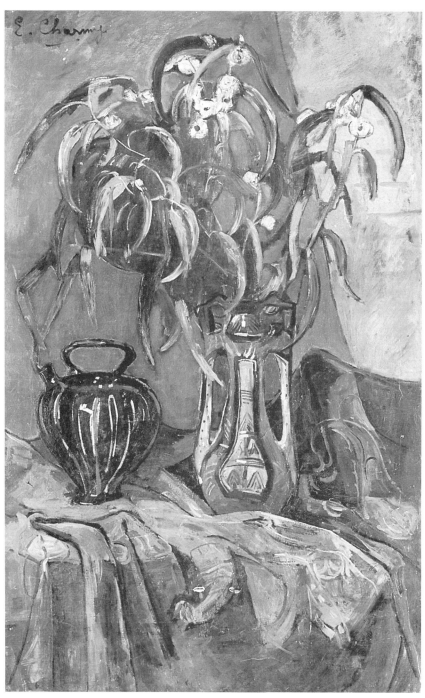

26 Emilie Charmy, *Large Still-Life, c.* 1900–3, oil on canvas, 151.5 × 93 cm, private collection

patrons, were common on the walls of the *Salon d'Automne* and the *Salon des Indépendants* at the time, and had been the stock-in-trade of some early Fauve painters. Before 1905 Matisse, for example, often showed such works: in the *Indépendants* of 1902 four of his six exhibits were flower pieces. By 1905, however, much of the critical attention was focusing on his portrait and landscape subjects, paintings to which the label 'Fauve' was more likely to be attached.

However, the genre did have associations which were more likely to affect the reception of the work of women painters. For at least the last three centuries, flower painting (as a branch of still-life painting) has often been identified by Western art historians and theorists as a 'lesser' genre which involved less intellectual skill than historical or allegorical subjects and some forms of portraiture. This lower status of flower painting was well established in Academic theory in eighteenth- and nineteenth-century France and Britain, and the subject was long regarded as an important province for women painters whose supposedly unintellectual sensitivity was thought to be ideally suited to the genre. The imagery of flowers therefore often became associated with a specific notion of sensitive femininity, a more decorative form of artistic production.[22] Some more adequate historical reasons can, of course, be found for the importance of the theme for women painters of the last three centuries. As a consequence of their limited access to traditional forms of art education, they have inevitably been restricted in the forms and genres of painting which they have been able to practise. For example, virtual exclusion from the life-class in most European Academies until the late nineteenth century denied them a central aspect of contemporary art training, which (in Academic circles at least) would qualify them to develop the skills of history painting. Moreover, the generally smaller, more intimate size of still-life paintings made them easier to produce by artists who did not have large-scale studio space.

While the 'flower theme' was of special importance for Charmy (COL. PL. 11; PLS 24, 25, 26), it also appears frequently in the work of Marval, Valadon (PL. 27) and Laurencin. It is hardly surprising then that critical responses to the theme in the work of these women artists were often inscribed with a language of difference. In Basler and Kunstler's chapter '*Les Femmes Peintres*' in their survey of early modern French paintings of 1929, Charmy, Valadon, Laurencin and Marval are mentioned as belonging to a group of women artists 'who with their gentle hands weave garlands of delicate flowers in modern art'.[23] The image was intended both literally and metaphorically, as a reference to both a 'feminine' subject matter and a 'feminine' mode of painting.

Yet there are contradictions in this association between women artists and flower painting. It was also an important theme for male artists at the time.

Charmy's early interest in flower painting was nurtured in the context of the predominantly male professional Lyon art world. Her teacher Jacques Martin was one of several established Lyon painters, including Louis Carrand and François Vernay, who had won local reputations as artists skilled in the painting of colour and atmospheric affects, as was exemplified in their distinctive style of flower painting, a theme long associated with the Lyon school (PL. 28). In Basler's and Kunstler's survey of 1929, this group of artists are named 'the lonely artists of Lyon' because of the lack of attention given to them in Parisian circles. They are singled out for the passionate sense of colour and subtle hues of their flower paintings.[24] Basler's notion of 'independant' painting is rooted in a concept of (supposedly) anti-academic art which is painterly, individualist and can be traced back to what he saw as the 'exhuberant individualism' of the Impressionists. Thus his view of the development of French painting, which was shared (as we shall see) by many other critics writing in the 1920s, puts special emphasis on artists such as Vuillard, Bonnard, Matisse and the Fauves, whom he believes to have developed these painterly effects, and to have been preoccupied above all with colour and paint texture. He sees the members of the Lyon school as neglected early exponents of such artistic interests.

Within this school in the late nineteenth century, flower paintings were perceived as a continuation of a respected seventeenth-century Dutch tradition of flower (and still-life) painting which, although it could not claim the status of history painting, was replete with symbolic and allegorical meaning. The 'modern' painterly techniques of this group of Lyon painters (as perceived by Basler and Kunstler) were thus combined with a worthy art-historical pedigree. This pedigree seems to have become mysteriously disengaged in the criticism which saw flower painting by women as an essentially 'feminine' pursuit.

For a male painter working around the turn of the nineteenth century the genre could carry contradictory, even avant-garde associations. Basler and Kunstler's sense of the pre-Fauve 'modern' techniques adopted by the male painters of Lyon is not undermined by their choice of subject. With a growing contemporary interest in everyday themes which signalled the break-down of Academic hierarchies, a flower painting could also signify a lack of narrative meaning; as subject matter it could be seen as a vehicle for the communication of painterly effects, for the expressive trace of the artist's brush. Thus Van Gogh's *Sunflowers* or *Blue Irises* are now seen as exemplary works of early modernism. In the work of women artists, however, the theme was more likely to be seen as evidence of 'feminine' eyes.

Such critical assumptions are, of course, fraught with contradictions. In their chapter '*Les Femmes Peintres*', Charmy is singled out according to Basler

and Kunstler's criterion of modernism; she is described as a 'talented
colourist'. But this label was used to identify her both with a modern tradi
tion, *and* with a group of women 'weaving delicate garlands of flowers'. An
element of such inconsistency can be explained by the way in which early
twentieth-century perceptions of the role of colour in artistic production
were shifting and unstable in artistic discourse. The Academic legacy was
still evident in some forms of art criticism. As Anthea Callen has shown, the
theoretical writings which accompanied the activities of the French Academy
in the nineteenth century had often involved the perception of drawing as
'masculine', as against colour as a 'feminine' interest.[25] Despite the break-
down of some nineteenth-century Academic conventions, colour was often
identified in some early twentieth-century art criticism as the less intellec-
tual, more 'feminine' sphere of art.

 With the emergence of a (male) avant-garde group for whom colour was
of central importance, the critical languages shifted and evolved to revalue

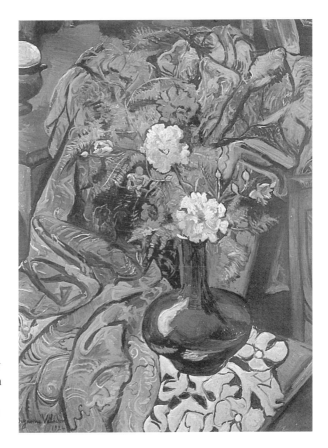

27 Suzanne Valadon,
 *Still-Life with Bouquet
 of Flowers*, 1924, oil on
 canvas, 80 × 60 cm,
 Musée d'Art Moderne
 de la Ville de Paris

and appropriate colour as a masculinised element in painting. Thus Vauxcelles's use of the metaphor of 'wild beasts' to describe the boldly applied, seemingly unfinished areas of bright colour in canvases by Matisse, Derain and their friends, carried with it connotations of violent *masculine* force. This was the process implicated in the suggestion that Charmy paints 'like a man'. As a woman she was seen to appropriate, rather than participate in, a 'masculine' language of artistic production. If that language was seen as the prerogative of the avant-garde, the claims of a woman painter for avant-garde status (should she seek such status) could easily be thwarted. The critical value of a (masculine) language of Fauve painting was exalted beyond a concern with colour by critics such as Basler and Kunstler who sought to give these developments a quasi-spiritual status. Basler and Kunstler wrote that the generation which emerged from Cézanne and culminated in Matisse and the Fauves inaugurated 'a style with a universal tendency. Thus was born a highly spiritual aesthetic'.[26]

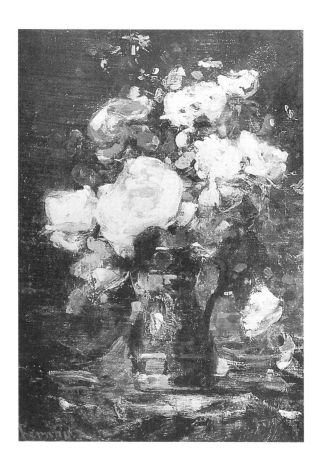

28 François Vernay, *Bouquet of Roses*, 1880s? (undated), oil on canvas, Musée des Beaux Arts, Lyon

While such levels of critical approbation did not greet Charmy's exhibits from the years 1904–c. 1907 (which were mainly still-lifes), during this period she also produced many boldly painted landscapes and figure compositions which, in their innovative techniques, could have qualified for the much trumpeted status of 'wild beasts'. Many of these works were little known as they remained in her collection or were sold privately. Apart from a series of views of her garden at St Cloud from c. 1904, characterised by loose brush-work and rich impasto (COL. PL. 1), she produced many landscapes between 1905 and 1909 in which she adopted bright colours and bold outlines. In paintings such as *Woman by a Lake c.* 1906–8 (COL. PL. 13), she simplifies the outlines of her subject matter, emphasising their rhythmic forms. In the process, her seated female figure is dehumanised, reduced to areas of colour as part of the overall decorative design. In common with the work of the Fauve group, her canvases reveal the influence of the Nabi group, especially the work of Vuillard, Bonnard and Gauguin, in her interest in decorative and highly coloured surface. In many other works from the period, these interests are combined with a consistent concern with the surface texture of the brushwork, with the use of rich impasto, as in her series of landscapes painted in Corsica in 1906 (COL. PLS 12, 14).

Charmy spent the summer of this year in Corsica with the painter Charles Camoin, with whom she had a relationship lasting several years. Working largely around Ajaccio and Cassis, she produced a remarkable series of Corsican landscapes, characterised by a tension between the decorative distortions (flattened areas of bright colour and bold outlines) and the loose, suggestive brushwork loaded with thick paint. Camoin was one of the so-called Fauve group who exhibited in the *Salon d'Automne* of 1905, and there was undoubtedly an exchange of ideas between the two artists. There is even evidence that they worked together in Charmy's studio in the Place Clichy around 1904–6.[27] Like Camoin, Charmy often uses dark outlines, or bold dark strokes of paint in her compositions. But most of her canvases appear to be more freely painted than those of her companion; they are less tightly organised with less attention to detail, as is evident from the many portraits of Charmy, some of them in intimate surroundings, which were painted by Camoin during this Corsican holiday (PL. 29).[28] It was not the case, as Charmy's absence from histories of Fauvism might suggest, that she was merely following the example of a better-established male painter.

There are other works by Charmy from this period which are very close in technique and subject matter to those of the core Fauve group. In her *Woman in a Japanese Dressing Gown c.* 1906/7 (COL. PL. 15), she adopts a theme which also appears in works by Matisse, Camoin, Derain and Marquet in 1905 (PL. 30), shortly after Matisse's wife had purchased a

29 Charles Camoin, *Woman in a White Dress (Emilie Charmy)*, Corsica, 1906–7, oil on canvas, 73.5 × 57.5 cm

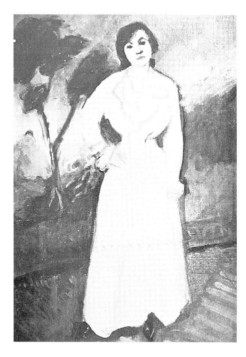

30 Charles Camoin, *Mme Matisse Doing Needlework*, 1905, oil on canvas, 63.5 × 80 cm, Musée de la Ville de Strasbourg

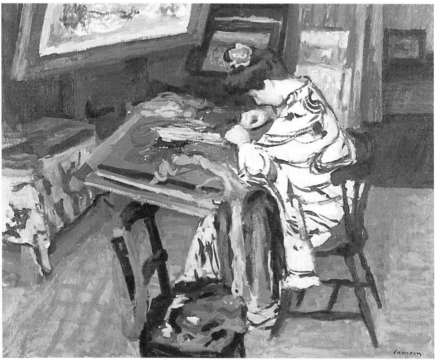

Japanese kimono and posed in it for members of the group.[29] But Charmy's adoption of the theme is significantly different. Matisse, Derain, Camoin and Marquet all show Mme Matisse seated with her hair arranged in oriental style, and Marquet and Camoin depict her doing needlework at a table. In Camoin and Marquet's paintings of Mme Matisse the decorative design of the kimono echoes the patterns of the furniture and fabrics around her; engaged intently in the (feminine) pursuit of needlework she seems to merge with her domestic surroundings. Mme Matisse is represented as a conventional image of decorative femininity, replete with oriental references. In contrast, Charmy's model, despite her oriental dressing gown, is represented as a 'modern' woman without ornamental or coiffured hair. She assumes an almost hieratic standing pose, in the centre of the canvas, and stares out somewhat disconcertingly, directly at the viewer. She seems to stand out rigidly against her domestic interior, a rigidity which is emphasised by the use of bright colours outlined in dark brushwork. And on the right of the canvas the artist has included a strange-looking object which seems out of place in an intimate domestic space – a lobster appears to be suspended just above the mantlepiece. Although there is no surviving documentation which explains the artist's decision to include the lobster in her composition, its effect is to render the image more puzzling, to undermine any sense of cosy domesticity.

As this painting indicates, many of Charmy's works had stronger claims for label 'Fauve' than those of the now better-known 'fringe' Fauves such as Kees Van Dongen, Louis Valtat and Jean Puy (PLS 21, 60), who exhibited in the same room as Matisse around 1905–6.[30] Although Charmy never exhibited with the group, we know that, apart from her close relationship with Camoin, she became a personal friend of Matisse and Marquet, with whom she must have discussed shared interests. It has been suggested by her family that she actively avoided association with any group, although this may be a retrospective rationalisation. As I have suggested, the roles and professional possibilities for women artists with 'avant-garde' interests were subject to complex forms of negotiation. While Charmy chose to work alone in a studio which she rented in the Place Clichy, she was also subject to some conventional social constraints for a woman of her class. During her earliest years in Paris she was continually chaperoned by her brother Jean, who apparently exercised a protective, paternal role over his younger sister (then already in her mid twenties).[31] In this respect, two of the 1906 Saint Cloud photographs showing the artist posed amidst her work are telling (PLS 22, 23). In both her brother is present; in one he is seated beside her, while in the other a reflection in the mirror on her left betrays the presence of her chaperon.

Charmy's early association with the *Indépendants* and the *Salon d'Automne* helped her to establish some personal and professional independence from her brother, albeit an 'independence' partly encouraged by an alternative relationship with Camoin, then a relatively successful Fauve artist. But even this relationship, which itself symbolised a break with conventional morality, did not provide access to the group's exhibiting space. As a woman artist she was in a difficult position. To be characterised as a 'wild beast' was to become, in a sense, a man.[32] In seeking her identity as a woman, Charmy saw herself as an 'independent', a category which, as I shall argue, all too easily became a devalued repository for 'women's art'.

'In the shadow of the Bateau Lavoir': women artists and the Cubists

In a retrospective article written in 1957 and titled 'In the Shadow of the Bateau Lavoir [the floating laundry]', Alice Halicka recalls her early years living and working in Montmartre and her visits to the dilapidated wooden building, which was Picasso's home between 1904 and 1909, and his studio until 1912. She provides a lighthearted description of this seedy environment.[33]

The Bateau Lavoir, cradle of Cubism; this strange decrepit and ramshackle house . . . hanging on the wretched slopes of the rue Ravignan . . . is still haunted by the memory of its tenants of yesteryear, Van Dongen, Picasso, Juan Gris among others . . . There was neither water nor electricity and a single tap provided water for the whole house. Picasso worked there in a studio filled to a respectable height with food tins.[34]

Halicka visited the studio with her (future) husband, the Cubist painter Marcoussis around 1912, soon after she moved to Paris. Like many retrospective observations and accounts of the surroundings which nurtured the early Cubists, Halicka's reminiscences have contributed to the somewhat romanticised mythology of that fertile bohemia which 'gave birth' to an artistic radicalism. Weill also added support to this powerful mythology when she recorded with characteristic enthusiasm the environment of the rue Ravignan from 1904 onwards:

The studio on the rue Ravignan, the *Bateau Lavoir* as they call it, is the meeting place for this noisy youth, for this army of artistic turmoil which is as much literary as pictorial. It's the whole revolutionary generation, the undesirables of official painting and of bourgeois literature. These disturbingly lively meetings have their loyal followers: Apollinaire, André Salmon, Fernand Fleuret, Picasso, Manolo, van Dongen, Max Jacob, Lesieutre, Albert Birot, Cazegema, Mac-Orlan, and so many others that I've forgotten.[35]

As one of the first dealers to show Picasso's work, Weill would have visited the studio and thus had access to this 'radical' space, inhabited by many who were to become the male figureheads of the artistic avant-garde. But for Halicka, a woman artist at the beginning of her career, this 'cradle of Cubism' seemed both awesome and inaccessible. She records that Marcoussis 'astonished her' by first taking her to visit Braque and Picasso,[36] implying that as a then relatively unknown woman artist, she felt it inappropriate to visit such a bastion of artistic radicalism. Like many women artists whose professional ambitions were mediated by the interests of their artist partners, she positioned herself outside – as 'other' to – the male avant-garde.

When Halicka first became interested in Cubism in 1912, the movement was well established as an important force in modern art, with Picasso and Braque widely recognised as the originators. The so-called 'Cubist' room in the *Salon des Indépendants* of 1911 had generated wide critical interest and the Cubist group's public profile was helped by the support and attention of influential critics such as Guillaume Apollinaire and André Salmon, and the writings of the artists Gleizes and Metzinger.[37] In October of 1912 a Cubist exhibition was organised at the Galerie Boétie under the title *La Section d'Or*, which sought to broaden perceptions of the range of the movement, and included artists such as Léger, Lhôte, Gris, Picabia, Kupka, Marcoussis, Archipenko and Dunoyer de Segonzac. Despite the notable absence of Picasso and Braque from the list of exhibitors, the accompanying publicity helped to establish the status of the Cubists. As Apollinaire wrote, the idea behind the exhibition was to 'present the Cubists, no matter of what tendency . . . as the most serious and most interesting artists of this epoch'.[38]

Apollinaire's implicit desire to gain recognition for an extended range of so-called Cubist interests should, in theory, have enabled several women artists who worked on the fringes of the movement, among them Halicka, Marie Vassiliev, Maria Blanchard, Suzanne Roger, Alice Bailly, Marie Laurencin, Marevna, Sonia Delaunay, Suzanne Duchamp and later Tamara de Lempicka[39] (PLS 31, 32, 33, 34) to gain recognition. Of this group it is Laurencin's work which is now the best documented and known, although it appears to be the least engaged with Cubist techniques. As I discuss in detail in Chapter 3, there are many possible economic, cultural, artistic and personal reasons for this historical status, to do with the patronage of dealers, the peculiar critical status of her work, and the support of her partner Guillaume Apollinaire, with whom she lived between 1908 and 1912. In 1907 Braque (who had been a fellow pupil at the *Académie Humbert*), first introduced Laurencin to Picasso and the circle of artists around the *Bateau Lavoir*, whom she commemorated in her two versions of the

31 Marie Vassiliev, *Woman with
Black Stockings*, 1913–14, oil on
canvas, Collection Yvette Moch,
Paris

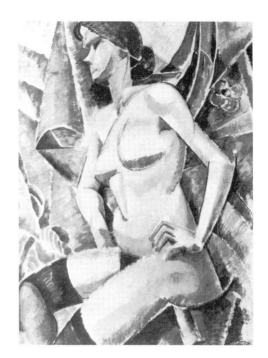

32 Marie Vassiliev, *At the Café
Select*, 1929, whereabouts
unknown

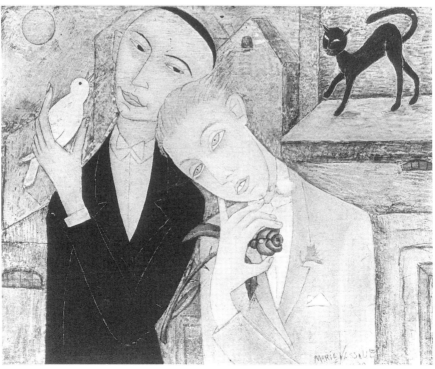

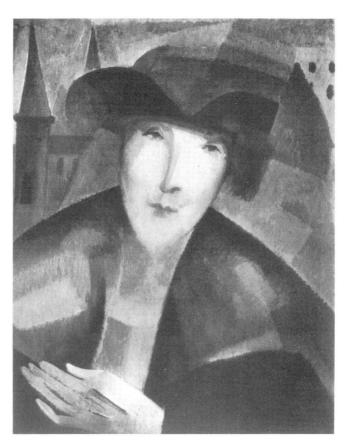

33 Alice Bailly, *Woman with a White Glove*, 1922, oil on canvas, 55.5 × 46 cm, Kunstmuseum, Lucerne

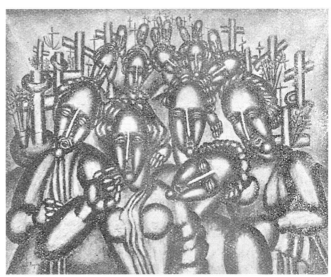

34 Suzanne Roger, *The Friends and the Dead*, before 1927, reproduced in Maurice Raynal, *Anthologie de la peinture en France: de 1906 à nos jours*, 1927 (whereabouts unknown)

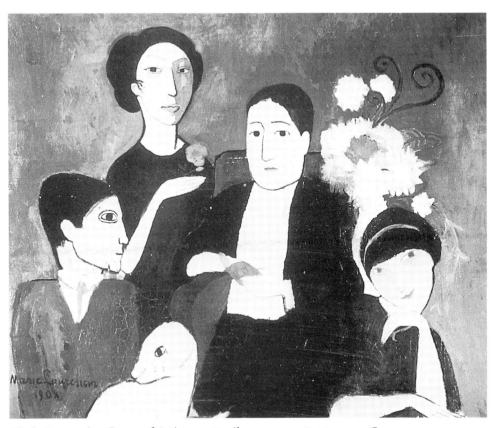

35 Marie Laurencin, *Group of Artists*, 1908, oil on canvas, 63 × 79 cm, Cone
Collection, Baltimore Museum of Art

painting *Apollinaire and his friends* of 1908 (COL. PL. 16; PL. 35). Just as
Halicka first gained access to the group through her husband Marcoussis, a
member of the broader Cubist circle, Laurencin's (albeit marginal) rela-
tionship with the *Bateau Lavoir* group was encouraged and promoted by
Apollinaire. In 1910 he described her exhibits in the *Salon des Indépendants*
as 'Cubist', and in the following year two of her works were hung in the
famous Cubist exhibition in Gallery 41 in the *Salon des Indépendants*. In her
first version of the circle of friends around Apollinaire, titled *Group of Artists*
of 1908 (PL. 35) Laurencin paints herself with Apollinaire, Fernande Olivier,
Picasso and their dog Frika. She is placed on the left, between the key fig-
ures of Picasso and Apollinaire. This painting was bought by the American
collectors Gertrude and Leo Stein and was promptly followed by a more
ambitious version, *Apollinaire and his friends* or *Country Reunion* (COL.
PL. 16), which also included the poet Crémitz, Gertrude Stein, Paul Fort and

his girlfriend Marguerite Gillot. Laurencin, dressed in blue, is seated on the
right and conspicuously separated off from the central group around
Apollinaire and Picasso, Gertrude Stein (whose status within the Cubist
circle is discussed in the following chapter) and Fernande Olivier. Apart
from the somewhat angular stylised faces (particularly in the portrait of
Picasso), reminiscent of Picasso's portraits from around 1907, and the greeny
brown tones of parts of this canvas, the work has little in common with the
early Cubist techniques of Picasso and Braque, of which Picasso's *Les
Demoiselles d'Avignon* of 1907 has come to be seen as a canonical illustra-
tion. In fact some of the angular forms of Laurencin's decorative works from
around 1912, including her decorations in 1914 for the Maison Cubiste
designed by Raymond Duchamp-Villon and André Mare have, perhaps, a
better claim for the label 'Cubist', albeit in the context of *les arts decoratifs*.
Several accounts of *Apollinaire and his friends* suggest that this work may be
more deeply rooted in Symbolist conventions. Julia Fagan-King has argued
that the painting is steeped in quasi-religious beliefs in a new and mystical
era in which the main protagonists play out exalted symbolic roles. She
suggests that while Apollinaire stands for Christ and Picasso for John the
Baptist, Laurencin is no less ambitiously cast as the Madonna in blue.[40]

However, it seems unlikely that such symbolic (and Symbolist) ambitions
were shared by other women painters practising on the fringes of the Cubist
movement. For example, Halicka's work from the period 1913–20 reveals a
more direct engagement with some of the technical and iconographical con-
cerns of Cubism. In her series of still-lifes from this period (COL. PLS 17, 18;
PL. 36), most of which are now hidden away in private collections, she dis-
plays a skilful manipulation of space and volume, close in some respects to
the Cubist still-lifes of Picasso and Braque from 1912–13. In many of her ear-
lier still-lifes from *c.* 1913–17 she adopts a dark-toned palette, often charac-
terised by a wide range of shades of grey and brown, and suggests a broken
space dominated by horizontal and vertical planes (COL. PL. 17). In these
works both line and (seemingly) looser forms of shading are used to define
objects and to establish spatial relationships. Familiar Cubist objects such as
guitar, pipe, bottle, glass, playing cards, newspaper and music are often rep-
resented from different angles. In her later Cubist works from around
1916–20 she introduces shades of warm colour into her still-lifes (COL. PL.
18), although she does not seem to have adopted the collage techniques
which accompanied the re-emergence of colour in the so-called 'synthetic'
Cubism of Picasso and Braque around 1914.

Not surprisingly, perhaps, Halicka's interest in exploring the role of colour
in her painted still-lifes has encouraged representations of her work as a
'feminine' version of Cubism, despite the evidence which they provide of

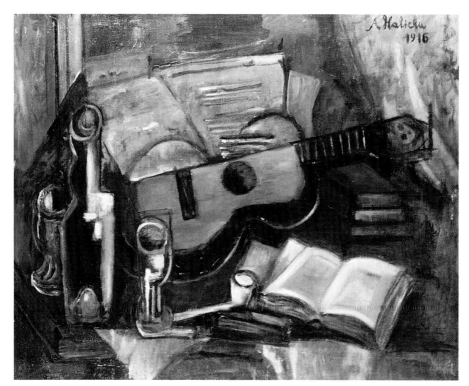

17, 18 Alice Halicka: *Cubist Still-Life with Guitar*, 1916, oil on canvas, 59.5 × 73 cm,
Musée Petit Palais, Geneva; *Cubist Composition with Violin and Musical Score*,
1919, oil on canvas, 65 × 81 cm, private collection, Paris

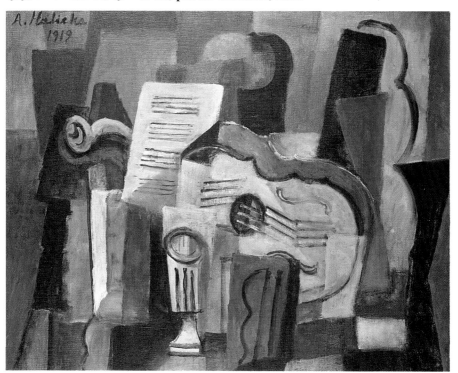

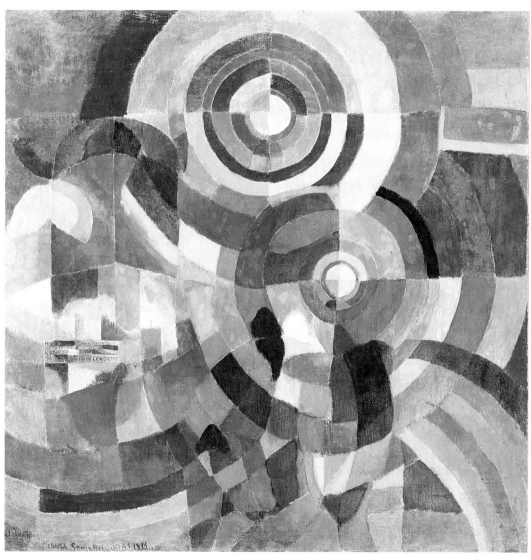

19 Sonia Delaunay, *Electrical Prisms*, 1914, oil on canvas, 250 × 250 cm,
Musée d'Art Moderne de la Ville de Paris

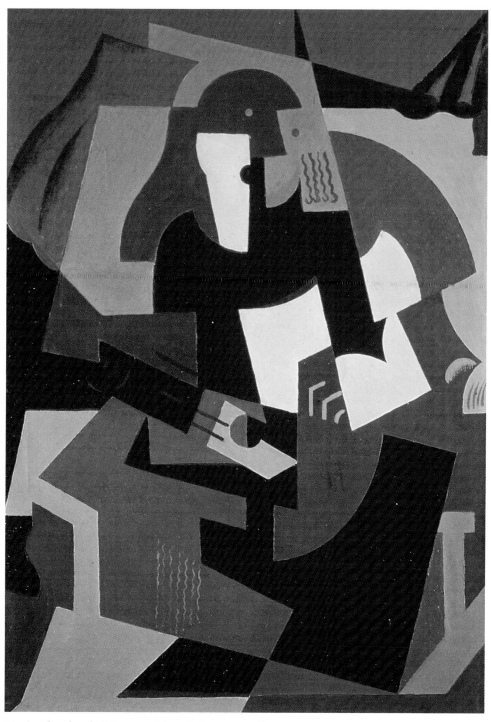

20 Maria Blanchard, *Woman with a Guitar*, 1917, oil on canvas, 115 × 80 cm,
Museé Petit Palais, Geneva

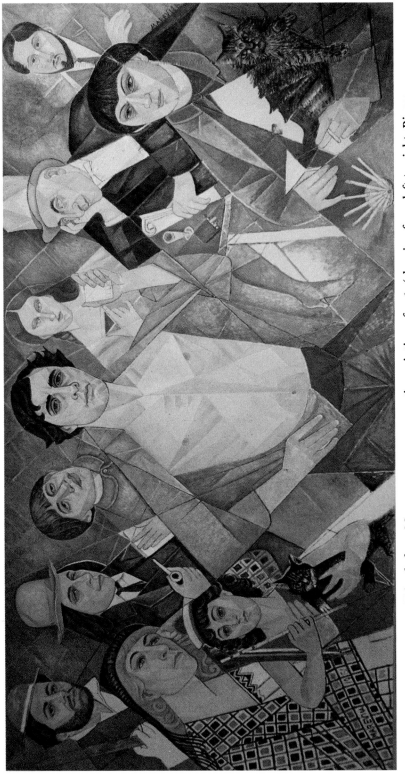

21 Marevna, *Homage to Friends from Montparnasse*, retrospective painting of 1961 (showing from left to right: Rivera, Marevna and her daughter Marika, Ehrenberurg, Soutine, Modigliani, Hébuterne, Max Jacob, Kisling, Zborowski), oil on canvas, 160 × 305 cm, private collection

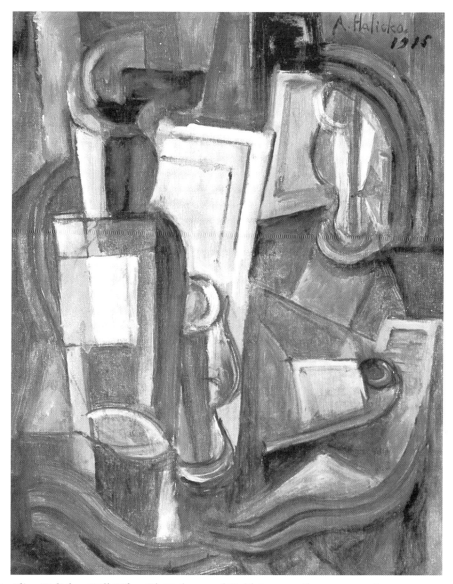

36 Alice Halicka, *Still-Life with Siphon and Goblet*, 1915, oil on canvas, 61 × 50 cm, private collection, Paris

her close involvement with the early aesthetic and technical interests of the movement. In 1927 Maurice Raynal was not prepared to give her work the full status of 'Cubist', perhaps influenced by her return to more figurative styles after 1920. He wrote: 'From Cubism she took not the aesthetics, but the discipline and the practical methods. In effect, her female sensibility

prevented her from taking on the conception of an art of pure creation, an art detached in its basic principles from all conscious intention'.[41] Just as Basler and Kunstler had sought to give Fauve achievements a quasi-spiritual status, Raynal identifies Cubism with a purer form of creation. This is by implication a *masculine* form of expression, from which Halicka is excluded by her 'female sensibility'. Even some relatively recent attempts to reclaim her work from the lost pages (and the hidden private collections) of early twentieth-century art history, have perpetuated a sense of the gendered characteristics of her work. For example, when the town of Vichy organised a show of her works in 1988, the exhibition was subtitled in the catalogue: 'Le Cubisme au Feminin'. While the catalogue essays sought to reinstate her as an intelligent and talented artist, the title qualified the identification of her work as 'Cubist'.

Like many of the women artists whose work is discussed in this book, Halicka's short period of engagement with avant-garde interests and techniques has been overshadowed by her later developments towards more figurative and 'independent' forms of painting, by her later tendency to dissociate herself from fashionable or radical movements. Furthermore, her role as 'the wife of Marcoussis', a better-known Cubist painter, has undoubtedly affected her claim for artistic status. Much of her Cubist work had been produced during the First World War, the period when Marcoussis was away on active service. When he returned home he discouraged her from following these interests, and from signing a contract with the dealer Zborowski. Without access to the details of their relationship and the psychological and professional struggles involved, we can only speculate about the reasons for Marcoussis's actions. However, it is reasonable to presume that after temporarily abandoning his career for war service, he might have felt his professional status threatened by the artistic achievements of his wife. As Jeanine Warnod has written, 'just one Cubist in the family was enough'.[42] As a result, Halicka became dissatisfied with her work from that period, destroying many of her canvases and returning to more figurative styles (PL. 37); in the late twenties she concentrated on a form of needlework and collage work which she called her *Romances capitonnées* (Quilted Romances).[43] Her later work is, therefore, clearly separated from the more 'avant-garde' pursuits of her husband, a separation which may have contributed to her disappearance from the history books.

The competing interests of a husband and wife partnership, and an increasing interest in the 'decorative arts', also affected public perceptions of the Cubist work of Sonia Delaunay. It has been suggested that her husband Robert Delaunay's reputation as the originator of the theory and practice of 'simultaneous contrasts' (*contrastes simultanés*) in painting overshadowed

37 Alice Halicka, *Bathers*, 1926,
oil, reproduced in Maurice
Raynal, *Anthologie de la
peinture en France: de 1906 à
nos jours*, 1927 (whereabouts
unknown)

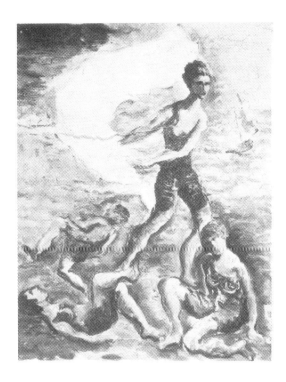

some of her own achievements on the fringes of the Cubist movement,
including her remarkable series of studies of light, represented in the 1914
Salon des Indépendants by her *Electrical Prisms* (COL. PL. 19).[44] However,
some accounts of Sonia Delaunay's use of Cubist techniques in her applied
designs from the post First World War period acknowledge her work as a
variation of avant-garde practice. Ironically, perhaps, she qualified for this
status both through her partnership with Robert, and through her applica-
tion of an avant-garde style to a form of artistic practice (*les arts décoratifs*)
traditionally seen as 'feminine'. Her work could thus be represented as
'avant-garde' without competing with that of the better-known (male)
painters associated with Cubism.[45]

 Cubist techniques and practices were also adopted by two other women
painters working in Paris in the 1910s and 1920s, Maria Blanchard
and Marevna, who became friends. Both used the *Salon d'Automne* and
the *Indépendants* to show their work, and became quite well-known on the
fringes of the Cubist groups, attracting the interest of dealers who patron-
ised those groups. Blanchard was first in Paris between 1909 and 1913, when
she studied at the *Académie Vitti*, where Van Dongen encouraged a brief
interest in Fauve techniques. She soon became interested in Cubism, encour-
aged by a close friendship with Juan Gris, another Spanish artist working

in Paris. After taking a teaching post in Spain between 1915 and 1916 she returned to Paris, and became associated with various Cubist circles, including the *Section d'Or* group.

Some of her earliest Cubist works, such as *Woman with Guitar* of 1917 (COL. PL. 20; see also PLS 38, 39) have a collage-like appearance, in which she paints parts of the canvas surface to simulate the appearance of paper or wood grain, visual 'tricks' which were also used by Picasso, Braque and Gris in their collages from the mid to late 1910s. Visual clues rather than recognisable

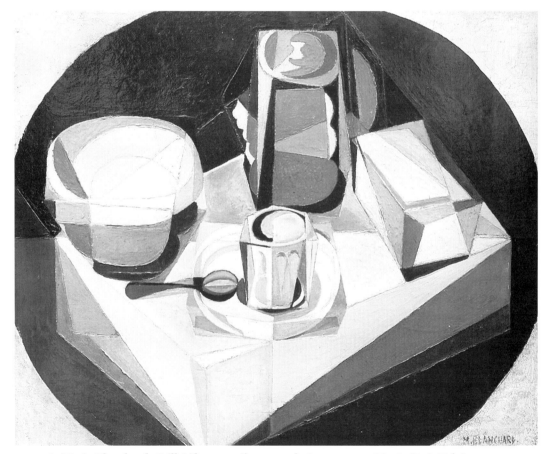

38 Maria Blanchard, *Still-Life*, 1915, oil on panel, 60 × 70 cm, Musée Petit Palais, Geneva

39 *facing page*
Maria Blanchard, *Be Good*, oil on canvas, 1917, Musée Nationale d'Art Moderne, Centre Georges Pompidou, Paris

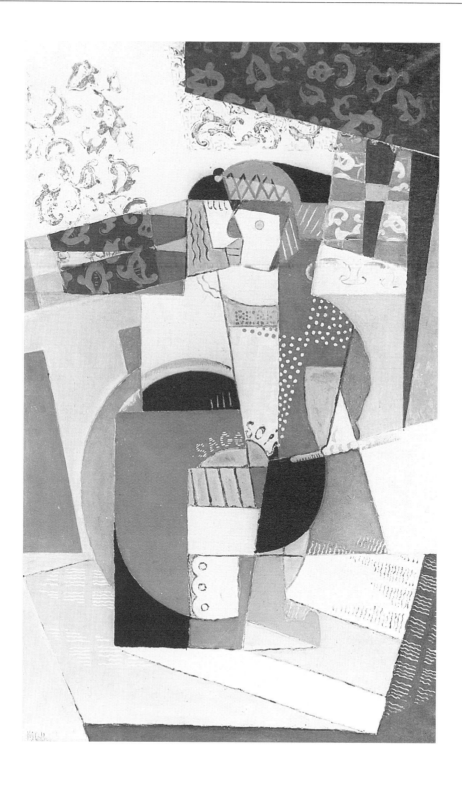

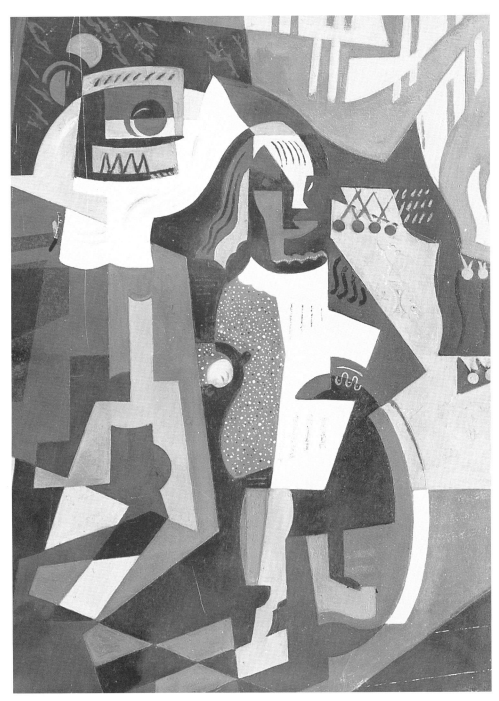

40 Maria Blanchard, *Child with a Hoop*, *c.* 1915, oil on canvas, 128 × 95 cm, Musée Petit
Palais, Geneva

images evoke the objects which make up the 'still-life', often the familiar Cubist repertoire of guitar, woman, newspaper, bottle, glass, and so on. But Blanchard also produced paintings in this style in which the subject matter seems to suggest a narrative content. Her *Child with a Hoop* of 1915 (PL. 40), for example, uses techniques associated with Cubist collage still-lifes to represent the activities and objects of a child's playtime. This interest in the possibilities of a readable subject matter was also a feature of her later, more figurative style of Cubism. In the 1920s she produced many canvases in which angular Cubist planes and spatial distortions are combined with figurative images which suggest a narrative content beyond that of the visible image. Such works often include groups of women and/or children involved in some (domestic) activity for which the 'story line' seems incomplete. In *La Toilette*, for example, a woman mysteriously leaves the room in the background (PL. 41).[46]

Blanchard's adoption of such ambiguous domestic subjects, and her rep etition of the mother and child theme, then well-established as part of the repertoire of women artists, may have contributed to the marginalisation of her work in histories of Cubism. Many male contemporaries such as La Fresnaye, Metzinger and André Lhôte (who was a friend and supporter of her work) (PLS 2, 3) also practised a figurative form of Cubism, and are now well represented in the histories of the movement. Critical representations of Blanchard's work, like those of Halicka, often represent a qualitatively different and gendered practice of Cubism. Although he was relatively supportive of Blanchard's Cubist paintings, Raynal emphasises her personal and physical vulnerabilities in his account of her work, stressing her 'refined sensibility' rather than her conceptual and analytical powers. Moreover, Blanchard's abandonment of Cubism in the late twenties in favour of more figurative and quasi-spiritual interests has encouraged a perception of her Cubist works as somehow going against her nature, of Cubism as 'too austere and architectural for her femininity'.[47]

Living in 'two worlds': professional and personal conflicts

During the late 1910s Blanchard became friendly with the Russian artist Marevna (born Maria Vorobëv) (PL. 42), another single woman exhibiting on the fringes of the Cubist movement and struggling to make a career in art. Marevna's autobiography *Life in Two Worlds*, extracts from which are included in Appendix 3, provides a moving and dramatic account of the experiences of a woman artist involved (both professionally and personally) with the group of Cubist artists and critics which had now transferred their social and artistic focus from Montmartre to the studios and bars of Montparnasse, especially the Rotonde and the Dome. This group is represented in Marevna's

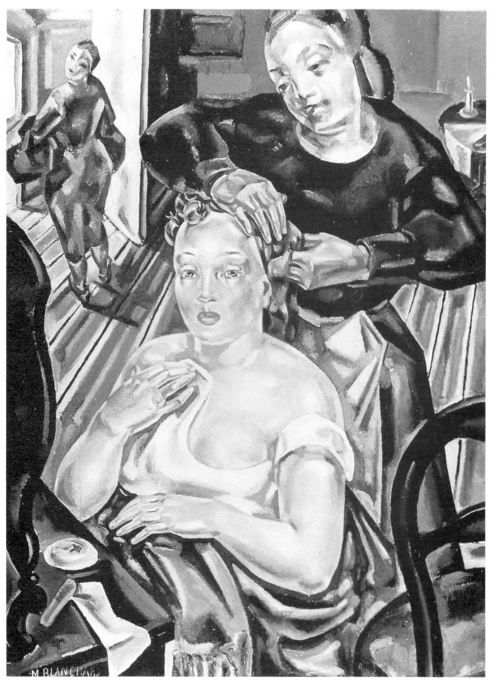

41 Maria Blanchard, *La Toilette*, 1928, oil on canvas, 100 × 73 cm, Musée Petit Palais, Geneva

retrospective painting *Homage to Friends from Montparnasse* (COL. PL. 21),
which includes portraits of two women artists on the fringes of the group,
Marevna herself and Jeanne Hébuterne (PL. 43), who was better known at the
time for her partnership with the artist Modigliani (shown in the centre of
this painting) than for her art.[48]

Marevna's book is revealing in many respects, not least because of the
self-image which it projects of a woman who is both emotionally vulner-
able and stubbornly independent, struggling in a world which, despite its
self-proclaimed bohemianism, is professionally hostile and sexually exploi-
tative. Marevna's participation in this social life, as represented in the book,
is fraught with emotional, sexual and social contradictions. She both
despairs of the promiscuity, which had itself become a trope for the radi-
calism of the male avant-garde, and appears to court it. In a 'bohemian'
world in which sexual intimacy is represented (by the author) as the main
currency of exchange between artistic friends of the opposite sex, Marevna
focuses more on the negotiation of her personal life than on the details of
her artistic production and achievements as a Cubist painter. On one level
this emphasis could be seen to reinforce a somewhat stereotypical image
of a woman painter, who saw her artistic production as of less significance
(or interest) than her relationship with a better-known male painter,
Diego Rivera. Yet her account is telling in its conscious and subconscious
revelations of the conditions which could affect or determine a woman's
achievement of professional status or avant-garde success.

When economic support stopped after her father's death in 1914, Marevna
was forced to earn a living through her art on the same terms as those of
her male colleagues, among them Picasso, Rivera, Modigliani and Soutine
(COL. PL. 21; PL. 44) who were then successfully building up artistic repu-
tations. However, as Marevna's autobiography reveals, the terms were not
the same for women, for whom the patronage of a (male) dealer could
frequently involve some form of sexual exploitation.[49] As a single parent
from 1919, when she gave birth to her daughter Marika, fathered by the
Mexican artist Rivera, Marevna was forced to exploit every means available,
including the financial aid provided by friends, to support her family. She
writes of this enduring problem for women artists who have no indepen-
dent means, and the double standards they must confront when they seek
comparable professional status to that of male colleagues:

If I am asked why I held aloof from the circle of contemporary artists who have all
achieved universal recognition, my answer is that my exhibitions were always fol-
lowed by long blanks, because I had to fight fearfully hard to bring up my child,
devote much time to commercial art and to decorative art, and give up exhibiting

for lack of money. By force of circumstances, then, I exhibited very seldom All
my life, unfortunately, money has come between me and my work. In order to paint,
a woman must enjoy a certain security, even if she has only quite a small family to
support. For a man the problem is easier to solve: he nearly always has a woman,
wife or mistress, who earns money: she works for 'her man'. She is devoted, and
sacrifices herself until the man becomes celebrated. She is capable of every sort of
self-denial: she tries to sell his pictures by seducing a client; she will even go to any
length, with the sole object of making 'her man' a celebrity. Then, when the pic-
tures begin to sell, she begins to dress a bit better; but it's hard on those who are
worn out, have aged and lost their bloom: like old brushes that are thrown into
the dustbin they see themselves replaced one day by an elegant young woman
who will make a fine model for nudes.[50]

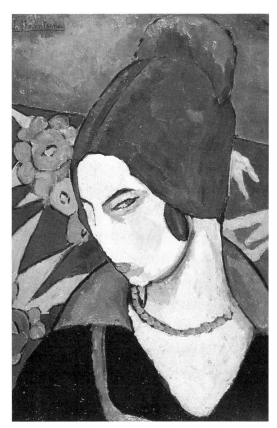

42 Marevna in the Dome, *c.* 1920

43 *right*
 Jeanne Hébuterne, *Self-Portrait*, 1916, oil on board, 110 × 61 cm, Musée Petit
 Palais, Geneva

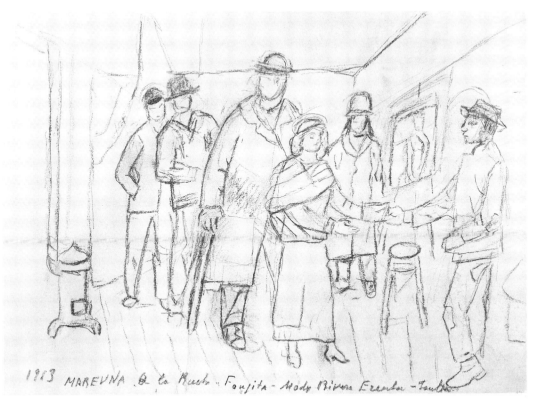

1913 MAREVNA à la Ruche - Foujita - Mody Rivera Erenba - Soutine

44 Marevna, *Sketch of Visit to La Ruche, Soutine's Studio* (showing Foujita,
Modigliani, Rivera, Marevna, Ehrenburg and Soutine), 1913, charcoal and pencil,
private collection

Despite significant improvements in the educational and exhibiting oppor-
tunities for women artists at the beginning of the twentieth century in
France, social and professional disadvantages were still much in evidence.
As Marevna indicates, these obstacles made it difficult for her both to prac-
tise and to promote her Cubist works immediately after 1919.

Although they are now little known, several works from the 1910s suggest
a serious early engagement with Cubist techniques and practices. In *The
Guitar* of 1914–15 and *Still Life* 1915 (PL. 45; COL. PL. 22) she distorts and flat-
tens out three-dimensional space, tilting objects from different angles, sug-
gesting overlapping and broken planes. Some of her paintings from this
period have a collage-like appearance (COL. PL. 23) which parallels those of
Blanchard from the period. Painted surfaces are sometimes textured to look
like woodgrain or fabric, and while some echo the conventions of the Cubist
still-life, others use those conventions to represent allegorical themes, such

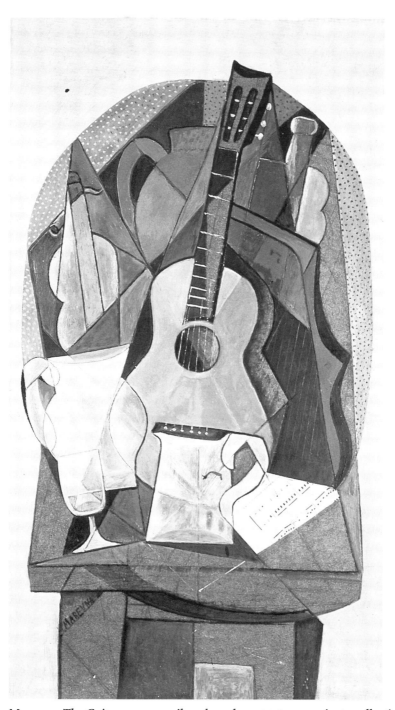

45 Marevna, *The Guitar*, 1914–15, oil on board, 110 × 61 cm, private collection

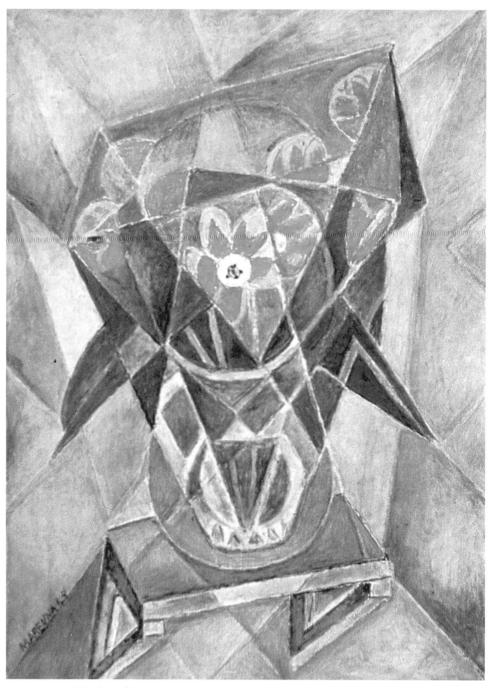

46 Marevna, *Still-Life: Tulips*, 1944, oil on canvas, 69 × 46 cm, private collection

as *Woman and Death* 1917 (COL. PL. 23) in which a skeletal soldier and a gas mask are used to symbolise the horror of war, a particularly topical theme at the time.[51] This work (which exists in several versions) is painted in bright shades of blue and pink, combining a 'decorative' effect with an allegorical theme, both conventions which could be seen to undermine earlier Cubist practices.

By 1920 Marevna had become disillusioned with Cubism, and became increasingly involved in Neo-Impressionist techniques which she developed and pursued, although she returned to Cubist influenced styles later in her career (PL. 46). Although she claims purely artistic reasons for her shift of interest, the move may have been partly an attempt to separate her professional interests from those of Rivera with whom she was emotionally involved at the time, and who had discouraged her from pursuing Cubist concerns.[52] Whatever the reasons, her change of style made the support of dealers even more difficult to find, for according to Marevna she had chosen 'an extremely difficult genre which not everyone liked'.[53] She had also chosen a genre which was no longer associated with the avant-garde, and could not be marketed on the basis of its 'newness'. The various markets for art which grew up around the fringes of the avant-garde, and which involved the patronage and support of so-called 'independent' artists, will be considered in the following chapter.

Notes

1 Berthe Weill, *Pan! dans l'œil! Ou trente ans dans les coulisses de la peinture contemporaine 1900–1930*, Lipschutz, Paris, 1933, p. 72.
2 *Ibid.*, p. 73.
3 See pp. 44–6 and n. 15.
4 Appendix 2 contains a list of exhibitions and artists shown at the Galerie Berthe Weill between 1901 and 1926. The list is reconstructed from information in *Pan! dans l'œil* and unpublished material, and may contain some omissions.
5 In her record of 1925 Weill described some of the financial and legal problems which she had to sort out in managing to run her business, writing with irony: 'Doux pays, pour les femmes seules!' (*Pan! dans l'œil*, p. 301).
6 *Ibid.*, p. 184.
7 *Ibid.*, p. 185.
8 Marval first showed with the *Indépendants* in 1902 and Charmy in 1904 (see p. 41). Laurencin showed there from 1907 onwards, and Mela Muter from 1905. Alice Bailly showed there in the 1910s.
9 *Bulletin de la vie artistique*, 15 Feb. 1921, pp. 108–10.
10 The *Salon des Indépendants* of 1911 included submissions by the Cubist group, and with the *Salon d'Automne* of 1910 is often seen as marking the 'launch' of the movement.
11 At the 1905 *Salon des Indépendants*, much of the critical limelight was stolen by the work of Matisse, with that of the Douanier Rousseau competing for controversial attention. According

to Weill, Matisse achieved the greatest 'succès d'hilarité' with his large canvas *Le Bonheur de Vivre*, sharing this prominence with Rousseau's *La Liberté invitant les artistes à la 22e Exposition des Indépendants*. She writes: 'Quel brouhaha dans ces deux salles! Les visiteurs, sans se connaître, échangent leurs reflexions; il se trouve toujours, en ces circonstances, un *bel esprit* qui bonimente au milieu de la foule et avec son approbation; j'ai maintes fois constaté ces faits devant mes vitrines; j'entendis même, un jour, cette réflexion admirable: "*C'est certainement un c... qui a fait ça! mais encore plus c... celui qui l'a acheté!*" Pan! dans l'œil de l'enfant!' (*Pans! dans l'œil!*, p. 125). Thus Weill found the title for her book in reactions to the 1905 *Indépendants*.

12 *Ibid.*, p. 115.

13 The list of founder members (*fondateurs*) numbers seventy-two, of which only four are women (these are indicated by 'Mlle' or 'Mme' before their names).

14 Quoted (without a date) in the catalogue of the *Salon d'Automne 1983, De Cézanne à Matisse*, Grand Palais, Paris, 1983.

15 Louis Vauxcelles, *Gil Blas*, 23 Mar. 1905.

16 I have addressed this problem of the reception of 'Fauve' exhibitions in G. Perry, *Two Exhibitions: The Fauves 1905 and die Brücke 1906* (Block IV of *Modern Art and Modernism*, The Open University, 1983) and in G. Perry, F. Frascina, C. Harrison, *Primitivism, Cubism, Abstraction*, Yale University Press, New Haven and London, 1993, p. 46ff.

17 See n. 11. For an account of the Fauve exhibition in the 1906 *Salon des Indépendants*, see also Alfred H. Barr, *Matisse, His Art and His Public*, Secker and Warburg, London, p. 83.

18 See Adolf Basler and Charles Kunstler, *La Peinture indépendante en France*, G. Crès & Cie, Paris, 1929, vol. i, p. 69.

19 Although, as we have seen, Weill noticed her work in the *Indépendants* of 1905.

20 According to the catalogue of the 1905 *Salon d'Automne*, there were fifty members of the salon committee of which eight were women. Four of these are listed with their husbands as, for example, 'MM' Aman-Jean.

21 Matisse, Marquet, Camoin, Puy and Manguin often worked together in Manguin's studio, usually sharing the same model.

22 This approach is illustrated in, for example, M. J. Grant, *Flower Painting through Four Centuries*, London, 1952.

23 Basler and Kunstler, *La Peinture indépendante*, vol. i, p. 20ff.

24 *Ibid.*, vol. ii, p. 81.

25 See the discussion of gender and colour theory in Anthea Callen, 'Coloured Views: Gender and Morality in Degas' *Bathers* Pastels', in *The Body-Journal of Philosophy and the Visual Arts*, Academy Editions, London, 1993, pp. 23–9. Gendered associations of colour in nineteenth-century art criticism are discussed in Tamar Garb's essay, 'Berthe Morisot and the Feminizing of Impressionism' in T. J. Edelstein (ed.), *Perspectives on Morisot*, Hudson Hills, New York, 1990, pp. 57–66.

26 Basler and Kunstler, *La Peinture indépendante*, vol. ii, p. 19.

27 I am grateful to Bernard Bouche for this information. See also Daniele Giraudy, *Camoin, sa vie, son œuvre*, Lausanne, 1972, p. 58ff. According to Giraudy, Charmy and Camoin were close friends until 1913.

28 Giraudy, *ibid.*, illustrates several portraits of Charmy by Camoin, see pp. 58 and 59.

29 Versions of the same theme painted by Matisse, Derain, Camoin and Marquet in 1905 are reproduced in John Elderfield, *The 'Wild Beasts': Fauvism and its Affinities*, The Museum of Modern Art, New York, 1976, pp. 41, 42.

30 In seeking to represent the relationship of Charmy's work to that of the group it should also

be noted that the exact dates of some of Charmy's canvases are unknown. Some were left undated by the artist, and have been dated by the family, drawing on available historical information and documentation. Where there is uncertainty, this is usually indicated in the caption.

31 According to stories recounted by the surviving family, Jean regularly opened her mail, and although he supported her desire to continue painting, his protective attitudes suggest that he preferred to see her as a sheltered amateur, painting as a 'hobby' rather than setting out on an independent career. Information about Charmy's 'independence' and her relationship with her brother was supplied to me in a series of interviews with Edmond Bouche in 1987.

32 Many critics found it inappropriate to apply the term 'Fauve' to a woman painter. Thus Apollinaire wrote of Laurencin's relationship with Fauvism that among 'les fauves' she was the 'fauvette' (Apollinaire, *Le Petit Bleu*, 5 April, 1912). And in 1987 the art critic Henry Nesmé still found it necessary to qualify Marval's relationship with the movement by describing her work in terms of a separate '*fauvisme marvalian*' (François Roussier, *Jacqueline Marval 1866–1932*, p. 9).

33 Alice Halicka, *Hier*, Du Pavois, Paris, 1946, and cited in *Alice Halicka 1895–1975: Periode Cubiste (1913–1920)*, Ville de Vichy, 1988. For a full account of the early days of the *Bateau Lavoir*, so-called because it resembled a wooden laundry boat moored on the Seine, see John Richardson, *A Life of Picasso*, vol. i, 1881–1906, Pimlico, London, 1992, p. 295ff.

34 Halicka, *Hier* (no page numbers).

35 Weill, *Pan! dans l'œil*, p. 88.

36 Halicka, *Hier*.

37 André Salmon's *La Jeune Peinture française*, published in 1912, included a chapter on Cubism. Gleizes and Metzinger published a more theoretical piece, *Du Cubisme* at the end of 1912, and Apollinaire wrote several articles on Cubism around 1912, including a short account *The Beginnings of Cubism* published in 1912.

38 Guillaume Apollinaire, *Chroniques d'art*, quoted in Douglas Cooper, *The Cubist Epoch*, Phaidon, London, 1971, p. 105.

39 I have chosen not to discuss the work of Tamara de Lempicka in this context as most of her 'Cubist' work covers a later period (late 1920s and 1930s). Although Suzanne Duchamp was associated with the Section d'Or exhibition, she went on to work with the Dada group, hence her exclusion from the group of 'femmes peintres' featured in this book.

40 Julia Fagan-King discusses this interpretation in the context of Rosicrucian doctrines which had preoccupied many Symbolist painters. See J. Fagan-King, 'United on the threshold of the twentieth-century mystical ideal: Marie Laurencin's integral involvement with Guillaume Apollinaire and the inmates of the Bateau Lavoir', *Art History*, 2:1, March 1988.

41 Maurice Raynal, *Anthologie de la peinture en France – De 1906 à nos jours*, Editions Montaigne, Paris, 1927, p. 187.

42 Jeanine Warnod, 'Alice Halicka et ses souvenirs', in *Terre Europe*, 48, May, Brussels, 1974.

43 Two of these are reproduced in Lea Vergine, *L'Autre Moitié de l'avant-garde 1910–1940*, des Femmes, Paris, 1982, p. 77.

44 The implications of this creative and social partnership for the status of Sonia Delaunay are considered in Whitney Chadwick, 'Living Simultaneously: Sonia and Robert Delaunay', in W. Chadwick and I. de Courtivon, *Significant Others: Creativity and Intimate Partnership*, Thames and Hudson, London, 1993, pp. 31–49.

45 Sonia Delaunay's status as a 'woman painter' and as a 'decorative' artist is discussed in Tag Gronberg, *Cité d'Illusion: Staging Modernity at the 1925 Paris Exposition Internationale des*

Arts Décoratifs et Industriels Modernes, submitted to the Open University, August 1994. See especially chapter 4.

46 Several works from this period are now displayed in the Musée d'Art Moderne de la Ville de Paris. See Introduction, n. 4.

47 See pamphlet *Maria Blanchard 1881–1932*, issued by the Petit Palais, Geneva, 1988.

48 See Chapter 3, n. 11 and biographical entry on Hébuterne in Appendix 1.

49 In *Life in Two Worlds*, Abelard-Schuman, London, 1962, she describes an incident in which a collector offered to buy works, but wanted sexual favours as part of the deal (p. 183ff). Her attitude to dealers is discussed in the following chapter, and extracts from *Life in Two Worlds* which reveal her experiences are included in Appendix 3.

50 *Ibid.*, pp. 183, 185.

51 More subtle references to war (the Balkan wars) have been identified in Picasso's collages from 1914. See Patricia Leighton, 'Picasso's villages and the threat of war 1912–13', *Art Bulletin*, 67:4, Dec. 1985, pp. 653–72.

52 *Life in Two Worlds*, p. 183.

53 *Ibid.*, p. 183.

The art market and the School of Paris: marketing a 'feminine style'

Amateurs and working mothers

Apart from exhibiting facilities and the support of a dealer, studio space was a crucial requirement in the pursuit of a career as an artist during the pre-war period (as now). As Marevna suggests in her autobiography, none were obtained easily by an independent woman artist. Adequate studio space was essential not only to enable the production of art, but also to establish the professional status of the artist in public perception. As the site of creative production, a meeting place for social and artistic exchange, and the space in which works were displayed for dealers to purchase, the artist's studio became a focus for avant-garde culture in the early twentieth century. Thus the mythology of the *Bateau Lavoir* and the *ateliers* of Montparnasse are inextricably bound up with the history of Cubism. For many women artists, domestic constraints could limit access to (and use of) this focus of avant-gardism.

There are many written and painted representations of *les femmes peintres* from the 1910s and 20s which suggest that both the forms and the contexts of artistic production by women were vulnerable to caricature and stereotyping. Kees Van Dongen,[1] an artist briefly associated with the Fauves, represented one such stereotype in his painting *An Honest Pastime* from the 1920s (PL. 47), in which the title and the image describe a form of 'women's art' as a somewhat frivolous hobby. The artist depicts a fashionably dressed woman dabbling in painting and chatting to her equally stylish companion (the object of her painting?). Painted in the style of Van Dongen's highly marketable society portraits from the period, the woman artist is depicted as a 'decorative' amateur, working in a domestic context, possibly her home, far removed from the grease and grime of a professional artist's studio. For this woman at least, painting is a pastime, not a serious career.

The experiences of actual women seeking to make a living through painting were somewhat different. As we have seen, Marevna makes many references to the economic and personal problems involved in trying to find independent space in which to work, and in trying to pursue that work despite domestic

constraints.[2] Emilie Charmy, who also became an (unmarried) mother, was able to address the problem rather differently. Around 1908, when she was slowly becoming known on the fringes of the Fauve group, she reorganised her domestic and professional life and moved into central Paris with her brother Jean. She took on a large fifth-floor apartment, which included well-lit studio-space, on the rue de Bourgogne near the Hotel des Invalides, where she continued to live and work for most of her life. Shortly after the move her brother, whose paternalistic attitude towards her had become increasingly unwelcome, moved to Avignon. The independence which this afforded her was helped by some (limited) private resources from her family, although she was dependent on her art for the main source of her income. In 1912 she became involved with the painter Georges Bouche (PL. 48), and gave birth to his son, Edmond, in 1915, by which time the relationship had already cooled.

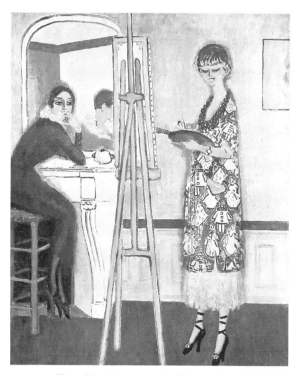 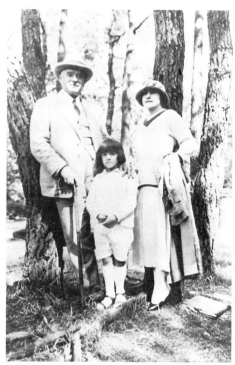

47 Kees Van Dongen, *An Honest Pastime*, *c.* 1920, oil on canvas, 100 × 81 cm, Cliché Ville de Nantes, Musée des Beaux Arts, P. Jean

48 *right*
 Charmy, Bouche and their son Edmond in 1923

Unlike Marevna, who participated energetically (her reported ambiva-
lence not withstanding) in the bohemian art world of Montparnasse, with
its apparently progressive moral codes,[3] Charmy pursued a more socially
reserved and separate artistic career, enforced early on by her brother's
protection and by the legacy of her provincial middle-class upbringing.
Throughout her career we find her embracing conflicting social attitudes
and personal ambitions. When pregnant, she dressed to disguise her rapidly
expanding stomach, and was clearly unable to reconcile her pregnancy with
her desire to work and seek professional status as an artist. In a biographi-
cal essay Edmond has recorded:

Nobody could believe that this elegant slender woman, born of a race of pumas,
was expecting a child . . . When he was born, however, he weighed nine pounds; he
was already hungry and thirsty. While some mothers glory in their offspring,
Charmy hid hers jealously. This newly born knew neither the disorder of the stu-
dio nor the smell of paint.[4]

Bouche provided some financial support and the baby was sent out to live
with a wet nurse in Étampes, about forty kilometres south of Paris. Thus
with her own child Charmy continued a domestic tradition which she her-
self had experienced and which may have left some psychological scars. But
she also rejected her child at a time when motherhood was popular, and
when single parenthood, due to the high male death rate at the front, was
common. Whatever the psychological implications of this disavowal, it was
also a response to the social constraints which an illegitimate birth imposed
on her as a member of a respectable bourgeois class. Charmy's attitudes echo
some of the contradictions inherent in middle-class culture and social mores
at the time. Despite the technological, industrial[5] and artistic developments
of the pre-war period, more traditional social pressures were still dominant.
In her book *Women of the Left Bank: Paris 1900–1940*, Shari Benstock has
described some of the conflicting cultural influences on French society in
general, and on women in particular, at this time:

At this period two contradictory elements were influencing French society and mov-
ing it in opposite directions simultaneously: there was an increasing move towards
individualism (in behaviour, dress, taste, politics and cultural preferences) coun-
tered by strong pressures on the part of the general public in favour of conformism.
While these concurrent pressures were evident in all aspects of society, especially
in literature and the arts, they caught in their wake the more marginal and fragile
elements of French society; they had, for instance, great effect upon women. French
women in the early years of the century lagged far behind their American and
English peers in their efforts to gain political and legal equality. They did not receive

the vote or equal pay until 1944. Except, perhaps, for poets and salon hostesses, most middle-class French women were highly influenced by the church and preferred traditional values of home and family.[6]

Charmy could be seen both to conform to respectable middle-class convention and to disdain the traditional values of 'home and family' which had little impact on Edmond's early life. Apart from occasional days out and visits from one or both parents, he was placed with paid nurses and carers until he was fourteen (PL. 49).[7] Charmy's disavowal of a 'feminine' role, her refusal throughout Edmond's childhood to embrace contemporary values of motherhood, was also derived from her overriding preoccupation with her work. Despite the tendency of retrospective accounts to romanticise or exaggerate dogged commitment, she is consistently represented as an artist for whom painting was an obsession which dominated many other aspects of her life.[8] As Marevna's life-story clearly demonstrates, a young dependent child would have limited Charmy's freedom to work and seriously affected the progress of her artistic career. Moreover, this rejection of convention is reinforced in her art, in which, apart from a few images of pregnant women (COL. PL. 24), she conspicuously avoided the mother-and-child theme so often associated with a 'feminine' iconography,[9] at a time when the subject of *maternité* was enjoying a popular revival in the work of many established and avant-garde male artists, among them Picasso, Derain and Fernand Léger. Some of the contemporary myths of creativity which, as we have seen, flourished among the predominantly male avant-garde, were incompatible with the discourses on mothering. While the male artist could represent motherhood, an active engagement with the nurturing and parenting involved might undermine these myths.

Not surprisingly, Charmy's unmaternal behaviour attracted some criticism from her friends, including even Berthe Weill who regularly visited Edmond at his wet nurse's home in Étampes, while his parents were away during the war.[10] Although Weill criticised both parents for neglect, it was Charmy's behaviour which attracted the most concern. Illegitimacy involved less of a social stigma for the male partner, and the fathering of illegitimate children had even become a signifying characteristic of male avant-garde artists, among whom Rivera, Picasso and Modigliani all acquired romantic notoriety for the various children born to different partners.[11] The father was not expected to shoulder the domestic responsibilities of child-rearing. Moreover, for the male artist such public demonstrations of fertility could signify sexual potency, fashionable promiscuity and even creativity. As Marevna observed, the conditions of parenthood for women artists were significantly different:

No: a woman artist is far from having the luck of a man; and especially a decent, unattached woman who prides herself on having a child of her own and on wishing to bring it up to be good and honest. A male artist can more easily live for his art alone: he is not bothered by questions of *duty*, as a conventional man is – or a woman. The man who is building a career will take duty and prejudice in his stride:

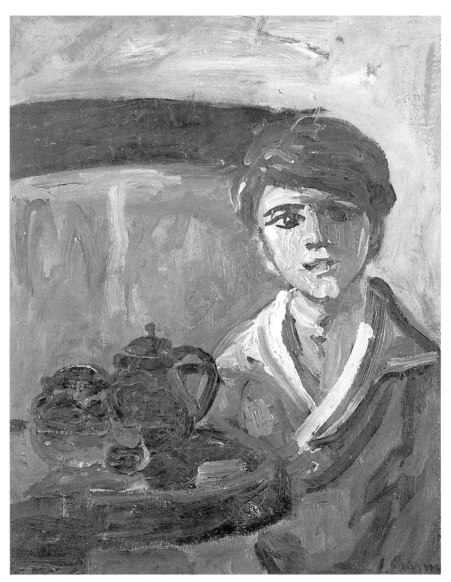

49 Emilie Charmy, *Portrait of Edmond, c.* 1929, oil on canvas, 73 × 60 cm, private collection

he will always be forgiven, especially if later on he becomes a lion. The man who has achieved fame must seek in his heart and conscience for excuses for his past meanness and dishonesty; and sometimes, perhaps, he will find the strength to correct his faults.[12]

Given the constraints which motherhood imposed on the pursuit of a career in art and the dominance of traditional attitudes to women as mothers, it is not surprising that many of those women artists who managed to secure some professional status as independent painters on the fringes of the avant-garde did not have to struggle to bring up children. For example, Blanchard and Laurencin were childless, and Marval lost her only child, a baby son, in 1891. And of those women artists featured in this book who had children, many had only one child, including Valadon, Marevna, Charmy and Sonia Delaunay.[13] I have already documented the various ways in which Marevna and Charmy negotiated their maternal roles. Charmy's almost obsessive commitment to her work seems to be paralleled (in some respects) in Sonia Delaunay's approach to motherhood. Her son Charles, born in 1911, recalls in his autobiography that both his parents were too preoccupied by work to devote much time to their son, and that the demands of Robert Delaunay on his wife left her little time for mothering.[14] Valadon's complex relationship with her only child Maurice Utrillo, who himself became a successful painter, and the positive and negative effects of this relationship on her life and early career, has inspired many hagiographies.[15]

Dealers, patrons and women as consumers of art

During the pre-war period artists were increasingly looking to the support of collectors and dealers, as well as the *Salon des Indépendants* and the *Salon d'Automne* as a means to exhibit, publicise and sell their work. At this time dealers such as Bernheim-Jeune, Ambroise Vollard, Clovis Sagot, Daniel Kahnweiler and (as we have seen) Berthe Weill became renowned for their patronage of young avant-garde artists.[16] A dealer's contract, which could ensure a regular income, became an important source of professional security for many Fauve and Cubist painters.[17] Although many women artists were supported by dealers, and some received contracts, the recorded memories and accounts of several women suggest that the relationship between a female artist and a male dealer was often subject to exploitation by the latter. According to her family, Charmy harboured an enduring suspicion of male dealers, and rarely entered into agreements with them. And Marevna has vividly recounted some of the experiences which contributed to her own wariness. Writing of the period around 1920 she reports:

I was repelled by the way in which picture-dealers and collectors tried to treat me. I wished to work and to have no contact with traders whose first enquiry was how many pictures a month one painted: and when one told them they said it was not enough; or they said that one must manufacture very pretty women and children, or something of the sort. To say nothing of their attempts to paw you into the bargain, if you were a woman, and their suggestion that you should go to bed with them. I could not stand such cynical coarseness: I never would see again a swine who, after buying a picture, thought he had paid enough for it to have the woman who had painted it thrown in . . . Being a woman and painter does not mean that one is a whore![18]

Marevna's personal experiences fuelled the anger expressed in her autobiography, in which she omits to mention (significantly) that during the mid 1920s she was involved with the art dealer Pierre Loeb, who also sold some of her works. Loeb was also the dealer for the Surrealist painter Jean Miro and supported many Cubist artists. Marevna's omission of the relationship from her book may reveal her own anxieties that the liaison would have been seen by some as a form of sexual exchange in return for sales. The break-up of Marevna's relationship with Loeb coincided with her move away from Cubism towards Neo-Impressionist techniques, which he was not interested in supporting.[19]

The insecurities and ambiguities involved in the relationships which women artists negotiated with some of their male dealers may have encouraged many of them, including Valadon, Charmy, Marval, and Halicka, to continue loyally to show with Berthe Weill, despite the financial problems encountered by her gallery. But economic necessities meant that, like their male colleagues, many were in search of dealer's contracts, which Weill could not usually afford to give. Apart from Weill, many better-capitalised dealers bought and promoted work by women artists, including the brothers Paul and Léonce Rosenberg and the Polish dealer Zborowski. Paul Rosenberg and Jos Hessel gave Laurencin a substantial contract after the success of her Cubist work,[20] and Rosenberg also bought work by Maria Blanchard. Even Marevna had hoped for a contract from him, after he bought two of her works in the late 1910s, but her hopes were soon dashed when Rivera cancelled his contract with the dealer, thus souring the relationship between herself and Rosenberg.[21] Léonce Rosenberg, who set up the famous *Galerie de l'Effort Moderne*, bought up some of Blanchard's Cubist works from the years 1916–19, although he does not appear to have helped to publicise them. Zborowski, who won his reputation largely through his support of School of Paris painters such as Modigliani and Soutine, bought and exhibited Marevna's work in the twenties and thirties, and offered Halicka a contract which Marcoussis discouraged her from taking on. However, Marcoussis

does not appear to have discouraged her relationship with Weill, although he seems to have constantly sustained an involvement in his wife's professional decisions which can only be described as a form of control. Even Weill, who described Halicka as 'painting with intelligence', groups the husband and wife together, including them in the same show in 1920.[22] Kahnweiler, one of the dealers who supported and promoted the Cubists, showed an interest in the work of several women on the fringes of the movement. He patronised the work of Suzanne Roger (PL. 34) described by one critic as 'a feminine Fernand Léger'.[23] According to Marevna's daughter, Kahnweiler wanted to buy work from her mother, but the ambiguous terms of the deal were rejected by Marevna.[24] Vollard, who is mischievously criticised under a pseudonym in Weill's *Pan! dans l'œil*,[25] and was known for his shrewd speculative deals, also bought work by several women artists, including Marval, Valadon and Muter. Valadon's career was also helped when Bernheim-Jeune gave her a contract in 1924. It is significant that of the women artists discussed in this book, the two whose work is now best known, namely Valadon and Laurencin, were both supported and promoted at crucial points in their careers through contracts with established and well-financed dealers.

Charmy consciously avoided such contracts, with the exception of an unfortunate business deal with the dealer Pétridès in the 1930s. Apart from the support of Weill, she was patronised by Katia Granoff, another woman dealer who began to establish a reputation in the 1920s, and who also bought work by Laurencin.[26]

Although their numbers were still relatively small, increasing numbers of women had entered the traditionally male-dominated profession of dealer by the late 1920s and several were becoming known for their patronage of modern art. Apart from Weill and Granoff, these included Jeanne Bucher, who held the first Paris exhibition of Mondrian's work in 1928, Blanche Guillot and Colette Weil.[27] The best-known and most successful dealers in modern art were often those male dealers with the most substantial capital assets, including Bernheim-Jeune and the Rosenberg brothers. It was not enough for a woman dealer to have adequate financial backing. As Weill suggests, public perceptions of their roles were still subject to social prejudice. She wrote in 1917, 'a woman's struggle is hard and requires an exceptionally strong will',[28] and reviewing her achievements in *Pan! dans l'œil*, she despairs of her financial problems and the fact that 'I was not taken seriously': 'A single woman has only one goal all her life: to defend herself'.[29]

Of course, the reasons for Weill's financial problems were complex, and were also caused by her well-known generosity to impoverished artists, her lack of capital resources, and some anti-Semitism which was still very much

in evidence in France in the wake of the Dreyfus affair and which encour-
aged suspicion towards the activities of other Jewish art dealers.[30] But the
role of dealer, ambiguously poised between the predominantly 'masculine'
worlds of culture and business, was not easily appropriated by a woman. As
Pauline Ridley has argued, the most conventionally acceptable ways in which
women could relate to the world of culture around the turn of the century
was as hostesses of literary and artistic 'salons',[31] a form of patronage which
deliberately echoed the *salonnières* of the eighteenth century, and which was
dominated by wealthy women from the *haute bourgeoisie* or aristocratic
backgrounds. The traditional class-based status and publicly perceived roles
of these 'hostesses' began to shift during the early twentieth century, partly
with the influx to Paris of many wealthy American women, of whom
Gertrude Stein is among the best-known.

For Stein, the economic power to purchase works of art (as a collector
rather than dealer), although this was often done in consultation with her
brother Leo Stein, first gave her access to the somewhat hermetic circle of
avant-garde artists gathered around the figure of Picasso. As Shari Benstock
has written, 'to understand Stein's place in Paris, then, one must understand
her position among male Modernists'.[32] Although Stein rarely participated
in the public bohemian culture flourishing (according to popular myth-
ology) in the cafés of Montparnasse, her own home became the focus of
various artistic and literary occasions in which she positioned herself as
a teacher and a leading force within avant-garde culture, rather than as a
woman patron on the margins of artistic practice. At a certain point in her
career she saw her own writing as a literary equivalent to Picasso's methods
of painting. She wrote in *Charmed Circle*: 'Well, Pablo is doing abstract por-
traits in painting. I am trying to do abstract portraits in my medium,
words'.[33] Picasso's respect for, and close relationship with Stein may have
blossomed partly because her medium was not in direct competition with
his own. Cynically, one might also suggest that Stein's economic power to
buy works encouraged this respect. But there are other possible reasons for
her peculiar social position.

To gain significant status within these close-knit artistic groups on the
same terms as the male participants, it seems that women not only had to
display a high level of artistic achievement (as Stein claimed for her writ-
ing), but also had to be seen to appropriate certain masculine codes of artis-
tic and sexual behaviour. Stein's patronising treatment of her partner Alice
B. Toklas and her lack of interest in the work of other women writers and
artists have generated considerable debate among feminist writers about
the extent to which she was able to change popular conceptions of women's
creative and social roles. Stein's form of lesbianism, her assumption of

dominant 'masculine' social roles, and her powerful sense of her own artis-tic achievements, have been seen by some feminists to duplicate some of the power relations and inequalities of much of heterosexual culture.[34] I would suggest, however, that this indictment involves an easy over-simplification of the complex artistic and social culture within which women artists, writ-ers and patrons found themselves participating during the early part of this century. Stein saw herself as a *woman* modernist, albeit in a role tradition-ally assigned to men. But for a woman to assume such roles was itself unset-tling in a culture in which (as I have suggested) critics were constantly seeking to define the boundaries between 'masculine' and 'feminine' modes of expression. As Benstock has argued:

An examination of Stein's use of the adopted masculine identity sheds light not only on the ways she lived her lesbianism but on the ways in which she wrote about that experience. A careful analysis of this living/writing experience unsettles expectations about Stein's relation to women writers of the community and her place among the male Modernists. It also upsets conventional notions of the heterosexual woman writer's experience as distinct from that of the homosexual woman, revealing the extent to which Stein's presence threatened attitudes about lesbian behaviour among both homosexual and heterosexual women.[35]

Although this quotation is primarily addressed to the roles of women within the literary community, the perceptions of women's sexuality which Stein is seen to disturb are as relevant to her relationship with the world of modern art, and to her patronage of that art. The processes of masculini-sation which that patronage sometimes involved could entail some con-tradictory interests.

For example, as a woman art dealer, Berthe Weill was subject to a range of representations of her 'masculine' activities. We have seen how Cravan disparagingly accused her of being a 'feminist', a term which was then often used, as Cravan suggests, in a critical or derogatory sense to suggest deviant 'unfeminine' behaviour. In his introduction to *Pan! dans l'œil*, Paul Reboux confesses his surprise on meeting Weill to find that rather than the 'robust giant', a tall well-built conquering figure he had expected, she was a little old woman with rounded shoulders, a modest bespectacled figure (COL. PL. 9).[36] Her famous struggles in the face of financial and critical opposi-tion were symbolised for him by a strong masculine body. And he described her loyalty, generosity and warmth as *bon garçonnisme*, as part of her boy-ish chumminess. Weill's chosen role as an independent woman dealer was incompatible then with contemporary perceptions of quintessential 'femi-nine' behaviour, a shifting concept which I will consider in the following

chapter. And it was that very same sense of independence which encour-
aged her to patronise the work of several women artists.

As to her sexuality, the limited historical information which survives sug-
gests that she may have been bisexual, although I have found no indisputable
evidence of any specific sexual inclination. An unpublished manuscript from
1917 suggests that she may have had some kind of flirtation with Georges
Bouche, who married Charmy in 1935,[37] and we know from her published
diary that after much consideration she turned down the offer of marriage
from a neighbour. In the same book she often describes certain incidents
or preferences which might indicate homosexual tendencies, only to dis-
claim them. In her somewhat critical account of Laurencin on their first
meeting in 1906, she describes the artist as greeting her in the gallery with
the exclamation: 'I should like to know a Lesbian!' Weill's disclaimer to her
readers is that she dared not say to Laurencin that she did not know what
that statement was supposed to mean.[38] In her account of 1912 she defends
her taste for 'pretty women' who are above all 'intelligent, lively, a little bit
funny, and . . . elegant'. In an aside she then seeks to reassure the reader that
any suspicions which this statement has aroused are unfounded.[39] At times
it seems as if Weill is using her book to provide information for those
who are already 'in the know', while officially denying any rumours for the
public at large. Unlike Stein who publicly pursued her lesbianism, even
aping patriarchal behaviour in her relationship with Toklas, Weill presents
her reader with a deliberately ambiguous, or at least undeclared sexuality,
perhaps a safer position from which to pursue what she called 'a woman's
struggle' in a masculine world of business and commerce. In such an
environment homosexuality was less likely to be tolerated than in the more
sexually permissive world of artistic 'bohemia'.

Whatever Weill's sexual inclinations, there is little doubt that her loyal
support of several women artists was derived from both a 'feminist' sense
of the injustice of social prejudices against women, and a genuine belief in
the value of their work. In her writings she discusses and defends their works
in the same terms as those of her male artists, rarely adopting a gendered
critical language which (as we have seen) characterised some contemporary
forms of writing about the work of *les femmes peintres*. For example, in *Pan!
dans l'œil* she praises Valadon's determination in the face of some opposi-
tion, describing her in many instances as a 'great artist',[40] and Halicka is rep-
resented as painting with 'intelligence'. In her unpublished diary from 1917
she frequently discusses Charmy's work and records a visit to her gallery
by Vauxcelles when he was unable to separate his perception of Charmy
as a painter from his somewhat patronising view of her as a woman. Weill
refuses to conflate the two issues, affirming that 'as an artist she interests

me enormously'.[41] And in *Pan! dans l'œil* Charmy is praised for her dogged refusal to belong to any 'chapel', and her fierce pride in resisting the appeal of contemporary 'fashion' (*la mode*) in painting.[42] In her positive accounts of the work of these women Weill frequently emphasises their proud 'independence' from other contemporary movements. Ironically, it is this very sense of their self-proclaimed difference which has encouraged critical representations of their work as unrelated to that of their male colleagues, as belonging to a separate group of *les femmes peintres*.

Effects of the war and the School of Paris

The outbreak of war in 1914 significantly affected the economic conditions for the production and sale of art. Many artists and dealers were mobilised or evacuated Paris, and for those who were left the market was sluggish. Weill describes a deserted Paris, from which government ministers and their deputies had fled to Bordeaux, while those who remained lived in fear of approaching German armies. Meanwhile she supplemented her income by selling postcards.

Although the larger salons (including the *Salon d'Automne* and the *Salon des Indépendants*) closed for the duration of the war, many of the private dealers continued to buy and sell. Business picked up somewhat after the initial slump of the first year of war, and the absence of many male artists on military service meant that women artists were more visible on some exhibition lists. One of the largest and most publicised exhibitions of modern art held during this period was the *Salon d'Antin* of July 1916. Titled 'L'Art Moderne en France', it was organised by André Salmon and included Picasso's *Les Demoiselles d'Avignon* of 1907 and exhibits by Matisse, Derain, Marquet, Van Dongen, Friesz, Modigliani, Lhote, Max Jacob, Léger, Severini and De Chirico. Around one fifth of the artists exhibiting were women, including Marevna, Vassilier, Marval and Blanchard, an unusually high proportion for a show which claimed to represent the contemporary avant-garde.[43] Vauxcelles, whose increasing lack of interest in Cubist developments led him to condemn what he saw as the radical and unbalanced picture of contemporary art which this show afforded, made a peculiar comment on Picasso's *Les Demoiselles d'Avignon*. He claimed that it did little more than reveal Picasso's influence on Laurencin, a criticism intended to belittle the work of the former.[44]

Between 1914 and 1918 Weill's exhibition lists also show a concentration of women's names, including regular shows by Valadon and Charmy.[45] During this period both Valadon and Marval showed at the Bernheim-Jeune Gallery, and Marval's name also appears regularly on the exhibition lists at

the Galerie Druet. We have already seen that Halicka produced some of her best work when her husband Marcoussis was away at the front, and both Blanchard and Marevna were involved with Cubist techniques during the war, although both left Paris for part of that time.[46] Although exhibiting opportunities could be better for women, working conditions were often difficult in Paris, and many artists (male and female) left the capital, which helped to reduce artistic activity. Charmy went to Marnat in the Auvergne, where Georges Bouche had a country house, the subject of many of her canvases from these war years. Laurencin fled to Spain with her German husband, and Sonia Delaunay moved to Madrid with her husband Robert and their son Charles. Most returned after the armistice, but the immediate effects of the war in France were those of continuing economic crisis. On 1 January 1920, the art dealer Gimpel described a grim social and economic scenario:

1919 has seen the peace signed and the soldiers passing under the Arc de Triomphe. But the war isn't over. Our mines are flooded, 500,000 buildings have been destroyed, from the North Sea to the peaks of Alsace, 1,500,000 combatants sleep under warring soil. Our railways have been used beyond their limits. We owe 40 billion francs. We can send nothing abroad. The value of the franc falls every day. The pound will soon be worth fifty francs. Under these frightful conditions, the cost of living is going up, salaries are doubled, trebled and so they have to be.[47]

Despite this post-war depression, during 1919 and 1920 the trade in art works soon began to revive and expand. Demobilised artists and dealers were working again, and with the prospect of rapid post-war inflation, investment and speculation in art works became an attractive, if sometimes risky prospect for those with capital. Around the same time that he had described an economic depression, Gimpel noted in his diary the veritable explosion of small galleries or 'little salons' opening in Paris: 'They multiply and it's now impossible to keep up with them. Every post brings me one or two invitations'.[48]

 The growth of small private galleries was crucial in the expansion of the market for works loosely associated with the label the School of Paris (*l'École de Paris*). This label was used with different emphases at the time and has confused many critics since. In the twenties, some writers, including Adolphe Basler, used the label to describe a group of foreign emigrés, such as Modigliani, Soutine and Kisling, who were working in Paris after the war.[49] However, increasingly the term assumed a broader meaning, and was used to describe a wide range of figurative or 'fringe' modernist styles, many of which were seen during the twenties as marketable alternatives to

the more radical contemporary developments of Purism, Dada and Surrealism. The term was often used to embrace those artists who were seen to be working *independently* from recognised contemporary movements or groupings. Thus work by many women painters from this period, including Charmy, Marval, Laurencin and Valadon, is often grouped with the School of Paris, as are paintings from the twenties by Matisse and other erstwhile Fauves, such as Rouault (PL. 49) and Bonnard, and several other male artists who acquired a status as individuals working outside the avant-garde such as Picasso (during the twenties), Utrillo, Soutine, Modigliani, Van Dongen, Chagall and Dunoyer de Segonzac.[50]

While it is difficult to identify any single set of interests which is common to all the painters now associated with the broad label of the School of Paris, a factor which clearly distinguished this group from the more radical avant-garde was their commercial success. Yet both contemporary and more recent critical accounts have increasingly identified the meaning of the label in terms of shared painterly (rather than economic) interests. Vauxcelles and Basler and Kunstler, who produced accounts of French painting in the 1920s, supported artists associated with the label on the grounds that, apart from their continuing interests in nature, they were preoccupied above all with the processes and effects of *painting itself*. This emphasis was reinforced and developed in a good deal of criticism after the Second World War. Thus the influential American critic, Clement Greenberg, reviewed a 1946 exhibition of the School of Paris painters as follows:

The School of Paris [after 1920] no longer sought to *discover* pleasure but to *provide* it. But whereas the surrealists and the neo-romantics conceived of pleasure in terms of sentimental subject matter, Matisse, Picasso, and those who followed them saw it principally in luscious color, rich surfaces, decoratively inflected design.[51]

By the 1940s then the associations of the label School of Paris had been rendered more homogeneous; for some critics it was seen to describe above all a preoccupation with the sensual surface effects of painting, an emphasis rooted in earlier modernist writing. However, I hope to show that similar preoccupations with the 'decorative' potential and sensual effects of painting were also often associated by critics in the twenties with *les femmes peintres* and a so-called 'feminine style'.

The categories of art criticism during this period were not fixed; Greenberg's homogeneous post-war view belies some of the competing definitions which characterised writing about art between the wars, and which also seem to have confused writers who sought (consciously or unconsciously) to construct a notion of 'feminine' art. Thus the critic André

Salmon helped to formulate a less contentious category than the School
of Paris when he produced his survey of contemporary French art in 1920
entitled *L'Art Vivant* ('living art'). For Salmon *l'art vivant* was fundamen-
tally anti-academic; it was opposed to the official salons and the standards
of the *École des Beaux Arts*, and covered a wide range of work from Cubism
to the 'naturalism' of artists such as Segonzac and Utrillo. It was not tied
then to notions of sensual or decorative painting, and as a result lent itself
less easily to the construction of a gendered sub-category of 'women's art'.
Salmon developed his views on contemporary French art and *l'art vivant* in
the periodical *La Revue de France* in a series of articles during 1921 and the
term was used as the title of a journal (*L'Art Vivant*) started in 1925.
Significantly, this journal included regular sections on *les arts de la femme*.
In July 1921 Salmon vigorously defended Charmy's work in *La Revue de
France*, describing her as an 'original and spontaneous' artist. In Salmon's
terms, Charmy was unquestionably a *l'art vivant* artist.[52] The label was often
interchangeable with the concept of an 'independent' art, a term adopted
by many contemporary artists and critics who saw themselves battling
against the establishment.[53] The fact that *l'art vivant* was also an area of
extraordinary commercial expansion in the early 1920s, with rich pickings
for the astute dealer, does not seem to have been perceived as in conflict
with the idea of an anti-establishment art.

To 'see like a woman'

A large one-woman show of Charmy's work held in 1921 at the Galeries
d'Oeuvres d'Art became the focus of a good deal of critical debate around
the possible meanings of a 'feminine' art, and attracted the attention of
many influential reviewers, among them Vauxcelles and Salmon. During the
1910s she had continued to work in a post-Fauve style, in which rich colours
and thickly applied paint predominate (PLS 50, 51), interests which have
encouraged critics clearly to separate her work from that of (then) more
radical movements of Cubism or Purism. However, there are also several
little-known still-lifes from this period which suggests that she combined
Fauve techniques with an ongoing interest in the spatial ambiguities asso-
ciated with the still-lifes of Cézanne (PL. 52).

 According to the 1921 catalogue illustrations and contemporary reviews,
the 1921 exhibition included a large number of portraits of women, female
nudes, and flower studies (PL. 53). The show was organised by the Count
de Jouvencel who had noticed her work at Berthe Weill's gallery in 1919,[54]
and who was to become one of Charmy's loyal supporters. The exhibition's
impact and success were helped by the production of a lavish catalogue. This

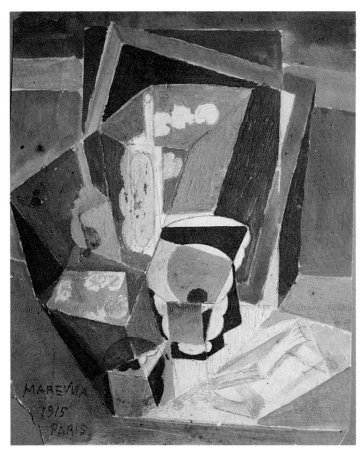

22, 23 Marevna: *Still-Life*, 1915 (*L'Atelier-rue Asseline*), gouache on paper, family collection; *Woman and Death* or *Prostitute and Dead Soldier*, 1917, oil on wood, 107 × 134 cm, private collection

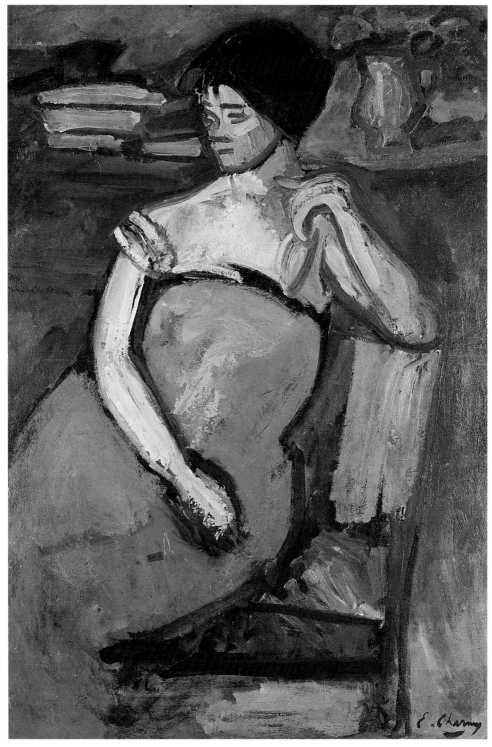

24 Emilie Charmy, *Young Pregnant Woman*, 1906–7, oil on board, 106 × 74.5 cm,
private collection

50 Emilie Charmy, *Portrait of
 Georges Rouault*, 1919, oil on
 canvas, 93 × 73 cm, private
 collection

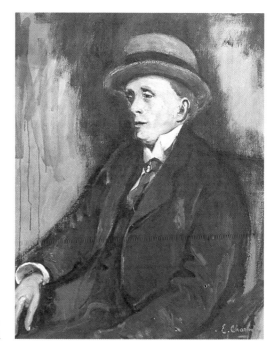

51 Emilie Charmy, *Still-Life with
 Jug and Fruit*, 1914, 65 × 81 cm,
 oil on canvas, private collection

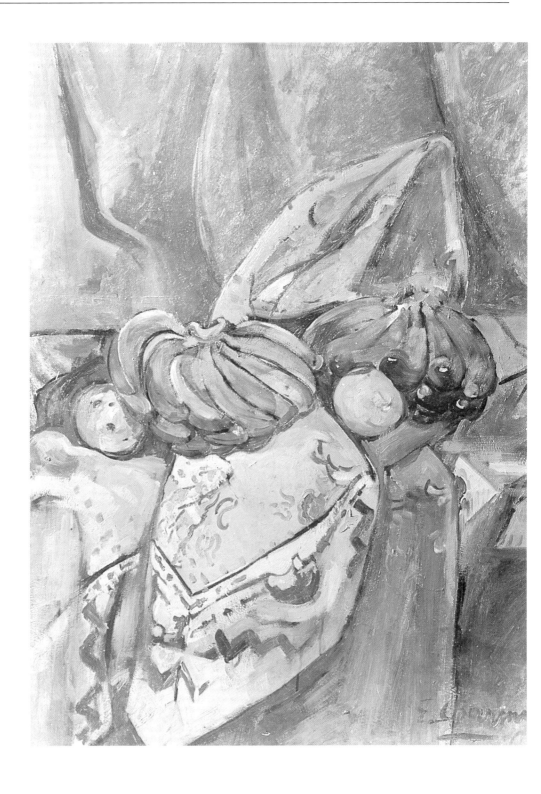

52 *facing*
 Emilie Charmy, *Still-Life with Bananas, c.* 1912, oil on canvas, 100 × 74 cm,
 Musée des Beaux Arts de Lyon

53 Emilie Charmy, *Young Woman with Hat, c.* 1920, oil on canvas, 61 × 50 cm,
 private collection

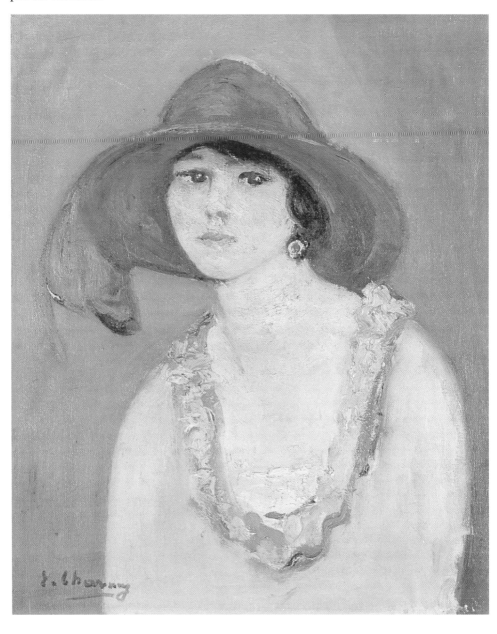

lengthy tome included four essays on Charmy's work by well-known French writers Louis Léon Martin, Roland Dorgelès, Pierre Mac Orlan and Henri Béraud. Béraud, an old friend from Lyon, was largely responsible for introducing Charmy to this circle of writers who played a significant part in the promotion of her work.

The styles of their catalogue essays are remarkably similar; each is a eulogy to her work, a poetic description of her canvases and the 'sensibility' which they are seen to represent. Roland Dorgelès (1886–1973),[55] who sometimes published under the pseudonym of Roland Lecavelé, describes her work as follows:

Charmy is a great free painter; beyond influences and without method, she creates her own separate kingdom where the flights of her sensibility rule alone. Look at these lively young breasts, painted with such delicacy, or at these freshly cut flowers, still cool from the garden; or these made-up faces betraying an inner anxiety by just a glance or a pursing of the lips. Look at these harmonies of tone; is not all this perceived by feminine eyes? And yet women have not accustomed us to so solid a craft. Emilie Charmy, it would appear, sees like a woman and paints like a man; from the one she takes grace and from the other strength, and this is what makes her such a strange and powerful painter who holds our attention.[56]

Dorgelès is concerned to portray Charmy as a 'free spirit', an independent artist, uninfluenced by contemporary art movements. In this respect he echoes the idea behind the concept of *l'art vivant*, that a refusal to conform to the contemporary schools of art was itself a virtue and a mark of the *individual* artist. However his belief that her work could be totally 'beyond influences' betrays a disingenousness, and hints at a notion of artistic autonomy which was common currency in the critical writing which also gave shape to the idea of the School of Paris.

According to Dorgelès, this artistic independence is derived from Charmy's extraordinary ability to suggest atmospheric and tactile qualities through her use of colour, tone and brushwork. Like Vauxcelles, Basler and Kunstler, then, Dorgelès places enormous value on Charmy's painterly skills. But then he seems to get confused. In common with many contemporary critics he is preoccupied with the idea of a gendered style, and argues that these painterly qualities, and the subjects they describe, can only be observed by 'feminine eyes'. But he finds it hard to reconcile these supposedly 'feminine' characteristics with what he sees as a bold, more 'masculine' application of paint, associating her thick impasto and 'solid craftsmanship' with male artists. The catalogue essay by Louis Léon Martin reveals a similar confusion. Martin writes of Charmy's work: 'this firm, bold and passionate

painting, which is sometimes even brutal, is not, however, the painting of a man'. Thus Charmy's 'bold craftsmanship' was not merely unusual for a woman, but (it is implied) was borrowed from a more vigorous male vocabulary.

The ambiguous distinctions which are made in discussions of Charmy's work by Dorgelès and Martin merely serve to reveal the contradictions behind some of their assumptions. While the subject matter of flowers, portraits of women and the female nude, and the subtle harmonies of tone fit contemporary stereotypes of a 'feminine' style, some of the bolder techniques which she employs do not. Both writers therefore seek to resolve contradictions and identify these mysterious 'feminine' qualities in the sensitive emotion which supposedly lies *behind* the brushwork. Thus Martin talks of Charmy's 'totally feminine gravity', a quality which (he believes) underlies her art, and in which 'the resonances are purely sensitive'.

It is significant that the 1921 exhibition should have attracted so much interest from writers. The authors of the catalogue seem to have identified in Charmy's work a preoccupation with independent 'expressive' elements which they sought in their own writing. Charmy's work was seen to be devoid of intellectual or theoretical pretensions (unlike the contemporary Purist movement), and, therefore, a vehicle for the more immediate expression of emotions. The richness of her paint and the free, suggestive manner in which it was applied were seen to be the expression of a deep artistic 'sensibility'. Thus Henri Béraud, who championed her work in many essays from this period, wrote in his catalogue essay:

For the painter, as for the writer, art is only a means of forcing those independent elements which everyone possesses in varying degrees inside oneself. It is only rarely that a painter – from outside her profession, which is to a painter as a literary culture is to a writer – is able to understand the exact place in which these elements belong in her work. It rests with a sensitive public to discover them.

Béraud believed that Charmy revealed such 'independent elements' through the relationship of volumes, colours and lines, and through the application of paint itself, in other words through the actual means which are peculiar to painting. By the 1920s a concern with the autonomous 'expressive' potential of the formal elements was well established in contemporary art criticism of both the avant-garde and of more traditional forms of painting. As Malcolm Gee has described it: 'The whole focus of contemporary criticism was on the individual artist, on the sensibility and originality which he exercised in his work'.[57] Much of the criticism that had surrounded the early Fauve exhibitions, including that of Vauxcelles, and Maurice Denis, had

focused on notions of autonomy and 'pure' painting, and on the idea that 'expressive' elements were evoked through the *means* of painting, the relationship between colours, forms, volumes and lines.[58]

But the central paradox of this early form of modernist writing is that this tendency to seek the meaning or value of a painting in the 'expressive' potential of the processes of painting was also the means whereby the category 'feminine' was consolidated and separated off from the 'masculine', and devalued accordingly. Gee's use of the pronoun 'he' in the quotation above is telling in this respect. The concept of the original individual artist was mostly reserved for male artists. When women artists were seen to convey a parallel sensibility through their work this was often redefined, as in Charmy's case, as evidence of a borrowed expressive capacity which is restrained by a 'feminine' gravity or 'feminine eyes'. Her paintings could then partly be defined in terms of some essentially 'feminine' sensitivity. So their meanings are implicitly separated off from the more profoundly 'expressive' meanings of works by independent or avant-garde male artists. And the work of some contemporary women artists was more easily represented in these terms than others. As I shall argue in the following chapter, Laurencin's delicate soft-toned style (COL. PL. 25) allowed (or, one might argue, encouraged) contemporary critics to construct a notion of a soft, sensitive, 'feminine' style, while Charmy's bold brushwork and rich use of paint confused contemporary assumptions about what constituted the 'feminine'. Both Dorgelès and Martin, however, sustained these assumptions, but formulated critical compromises to deal with the problem.

Perhaps the most relevant review of Charmy's 1921 show was written by André Salmon in *La Revue de France*. In comparison with those critics of the 1921 show who merely wrote adulatory accounts of Charmy's work and her 'sensibility', Salmon attempts to explain the appeal of her work and to place it in a contemporary artistic context. He tries to place her work in relation to other various 'schools':

There is a well-meaning move afoot to promote to the front rank an original and spontaneous artist who has not yet won wide public recognition – namely Mademoiselle Charmy. I shall soon come to the often powerful gifts which we must concede to her. However, if one wants to see one's way clearly through the confusion of opposing schools, it may be sensible to recall that Mademoiselle Charmy's defenders, her passionate champions, are those talented writers who, without exception, were indifferent or thoroughly hostile to the whole contemporary endeavour of construction, discipline and classical rigour (even when it might appear to be intemperately revolutionary) in reaction to the shapeless if attractive efforts of post-Impressionism. These new aestheticians have already made their mark by praising to the skies all that contradicts reflection and well-founded theory in the work of

the poor and charming Utrillo (who is out of his senses); we saw them salute the agreeable beginnings of Heuzé and Macle. They have now made Mademoiselle Charmy the flag-bearer of a brand-new standard. Mademoiselle Charmy has better things to do than to 'boot out' the wicked constructivists. These should delight in being challenged by, and no doubt soon engaged in combat with, adversaries of real merit. Such a counterweight was necessary to the rather flabby and wholly fashionable acceptance of doctrines which only yesterday were considered insurrectional. It must be said that living art flourishes in the heat of battle, particularly at a time when it is so quickly threatened by the dangers of an all too official approval.[59]

According to Salmon, then, she is an 'original and spontaneous artist' of great talent. However, one had to be aware that Charmy was being put forward by a group of writers and 'new aestheticians' to do battle against the avant-garde. But Salmon added with gentle irony, Charmy had better things to do than be used as a battering ram against the 'wicked constructivists'. And they in turn should rejoice in having an adversary of real merit. Unlike the authors of the 1921 catalogue essays, Salmon does not introduce the idea of a separate 'feminine' art. Within the atmosphere of controversy which he describes, her work is accorded (surprisingly) the same status as that of contemporary male artists.

Irrespective of the different forms of explanation they provided, those contemporary critics who applauded Charmy's work all seem to have focused on her technical skills. A common theme is the 'originality' of her technique, her ability to suggest a range of textures and tactile qualities through her use of rich colour and bold brushwork. My argument is that critical misrepresentations take place when that notion of 'originality' is qualified in gendered terms, or is seen as evidence of women borrowing from 'masculine' modes of expression.

Notes

1 Van Dongen's relationship with several women painters is mentioned in Chapter 4, p. 115.
2 The extracts from Marevna's autobiography *Life in Two Worlds*, Abelard-Schuman, London, 1962, included in Appendix 3 include frequent references to these problems.
3 The art world of Montparnasse is described in the extracts in Appendix 3.
4 Edmond Bouche, 'Ma Mère' in *Le Peintre*, 1 Dec. 1952.
5 By the outbreak of the First World War Paris could boast an underground system; there were 54,000 cars in the country, with France leading the world in the production of motor cars, and the telephone system was already well-established.
6 Shari Benstock, *Women of the Left Bank: Paris 1900–1940*, Virago, London, 1987, p. 73.
7 When he was fourteen Edmond eventually went to live with his mother at the rue de Bourgogne, Paris.

8 During the process of my research, I interviewed many people who had known Charmy well, including her son Edmond, her grandson Bernard Bouche, the Comtesse de Jouvencel and Patrick Seale. All have emphasised her life-long obsession with her work.

9 As far as I am aware, there are no mother and child subjects among Charmy's work, although there are several portraits of Edmond and several paintings of pregnant women (PL. 49; COL. PL. 24). However, the theme appears frequently within the work of Blanchard, Valadon, Muter, Marevna and Marval (PL. 16).

10 In her unpublished diary pages, from July to October 1917, now in the collection of the Bouche family, Berthe Weill makes many references to Charmy's relationship with her child. These entries suggest that during the war, when Charmy left Paris for the safety of George Bouche's country house in the Auvergne, Weill became a kind of guardian for Edmond, then nearly two years old. In 1917 she regularly visited him at his wet nurse's home in Étampes and regularly sent him presents. During this period Edmond was infrequently visited by his parents, but Weill had grown exceptionally fond of him, always referring to him as 'petit mignon'. On 15 August she wrote: 'Saw entrancing "petit mignon"; his eyes have gone a dark blackish grey, his eyebrows and hair are as if they have been hennaed – red and silky; first thing on seeing me he cried; you're not allowed to touch him. Took him cakes and chocolate, he deigned to offer me his cheek; his appetite for embracing has passed. His hair is long, poorly combed and we dare not cut it without permission.' Weill found it difficult to understand the attitudes of Edmond's parents, and wrote in October: 'This little stranger put into the world by the one to learn how to collect an inheritance [from Bouche], and seen by the other as an instrument capable of bringing some benefits into the home [for Charmy]; the attitude towards this little child will be a mixture of the one and the other: fine present to give a child!'

11 Marevna's *Life in Two Worlds* included many references to the notorious romantic adventures of these three artists, and some of the children they fathered. Shortly before Marevna became pregnant with Rivera's child he had fathered a son with another partner Angelina, with whom he lived while he was also involved with Marevna. See Appendix 3. Modigliani's partner, the artist Jeanne Hébuterne lived with the artist from 1917 until his premature death in 1920. The following day Hébuterne, who was nine months pregnant with their second child, committed suicide at the age of twenty-one. See Patrice Chaplin, *Into the Darkness Laughing: The Story of Modigliani's Last Mistress Jeanne Hébuterne*, Virago, London, 1990.

12 Marevna, *Life in Two Worlds*, p. 187.

13 This information is put together from available historical evidence on these women. For bibliographical information and references, please see Appendix 1.

14 Charles Delaunay, *Delaunay's Dilemma – De la peinture au jazz*, Editions W., Mâcon, 1985, p. 25. He wrote: 'Mes parents n'avaient guère la fibre familiale. Leur commune préoccupation pour la peinture était trop dévorante'.

15 See for example, John Storm, *The Valadon Drama: The Life of Suzanne Valadon*, E.P. Dutton and Co., New York, 1957, and Sarah Bayliss, *Utrillo's Mother*, Pandora, London, 1987.

16 One of the most useful sources of information about dealers and collectors between 1910 and 1930 is Malcolm Gee, *Dealers, Critics, and Collectors of Modern Painting: Aspects of the Parisian Art Market Between 1910 and 1930*, Garland, New York and London, 1981.

17 Gee provides details of the different sorts of contracts issued by dealers Bernheim-Jeune, Zborowski, Léonce Rosenberg and Kahnweiler during the 1910s and 1920s. See Gee, *Dealers, Critics and Collectors*, Appendix E.

18 Marevna, *Life in Two Worlds*, pp. 183–4.

19 I am very grateful to Marika Rivera Phillips for information on her mother Marevna's relationship with the dealer Pierre Loeb, provided in a series of interviews with myself in London,

May 1994. For further information on Loeb's interests as a dealer see Gee, *Dealers, Critics and Collectors*, p. 77.

20 According to the art dealer René Gimpel, in 1925 Rosenberg had been paying Laurencin 50,000 francs a year for several years. R. Gimpel, *Diary of an Art Dealer*, Hamish Hamilton, London, 1986, p. 261.

21 This is described in the extract from her autobiography reproduced in Appendix 3 (Part 2, Chapter 20).

22 *Pan! dans l'œil*, p. 248.

23 George Limbour, quoted without a date in E. Bénézit, *Dictionnaire des peintres, sculpteurs, dessinateurs et graveurs*, Grunde, Paris, 1976, vol. ix, p. 46.

24 In an interview with Marevna's daughter, Marika Rivera Philips in May 1994, she described to me a meeting with Kahnweiler in the 1950s. She recalled that Kahnweiler discussed with her the 'problems' of working with women artists, admitting that he found it difficult to work with women because they felt threatened by him. Marika Rivera Philips quotes Kahnweiler as having said: 'I like to be the master when I work with women – and put my hands where I want – that was one thing your mother wouldn't let me do'.

25 Weill gives Vollard the pseudonym Dolikhos in the early section of *Pan! dans l'œil*, which is humorously critical of his speculative activities. For Vollard's own account of his dealing activities see Ambroise Vollard, *Recollections of a Picture Dealer*, Doner, New York, 1978 (first published in English in 1936). Unlike Weill, Vollard did not own a gallery, but worked from his private house.

26 Katia Granoff first set up a gallery with René Marie Lefebure in 1926. This went into liquidation in 1928, after which she set up her own gallery at 19 Quai de Conti (the present home of the gallery).

27 Bucher's gallery was at 5 rue du Cherche-Midi, Guillot at 32 rue de Seine and Colette Weil at 71 rue La Boëtie. For information on dealers active in Paris in the 1910s and 1920s see A. Fage, *Le Collectionneur des peintures modernes, comment acheter, comment vendre*, Paris, 1930, and Gee, *Dealers, Critics and Collectors*.

28 This quotation is taken from Weill's unpublished diary from July to October 1917. The entry is dated 13 August.

29 *Pan! dans l'œil*, p. 312.

30 Weill briefly addresses the problem of being Jewish in *Pan! dans l'œil*, p. 165.

31 I am grateful to Pauline Ridley for discussing her research with me, and for allowing me to see a copy of a paper which she gave to the Association of Art Historians in 1989, entitled 'Matrons, Patrons and Consumers', in which she discusses perceptions of women as consumers and patrons of art in France around the turn of the century.

32 Benstock, *Women of the Left Bank*, p. 115.

33 *Ibid.*, p. 117.

34 Some of these views are discussed in Benstock, *Women of the Left Bank*, pp. 18–19.

35 *Ibid.*, p. 19.

36 *Pan! dans l'œil*, p. 15.

37 Although they had been living separately, Charmy and Bouche eventually married in 1935 to legitimise Edmond's status.

38 Weill, *Pan! dans l'œil*, p. 130.

39 *Ibid.*, p. 181.

40 Weill's account in *Pan! dans l'œil* is full of praise for Valadon's work, including references on pp. 248 and 264. Interestingly, her unpublished diary entries for 1917 show that at times she also had reservations about Valadon's work. I think that the discrepancy arises because the

unpublished diary from 1917 which I have been citing was part of her more intimate and personal record of daily events, which she used as her source material for the later publication *Pan! dans l'œil*. In the later public document she wishes (I believe) to provide a more coherent overview of her attitudes to various artists.

41 Unpublished diary 1917. Entry for 11 August.

42 *Pan! dans l'œil*, p. 117.

43 Malcolm Gee includes the contents list of the 1916 *Salon d'Antin* in appendix J. See Gee, *Dealers, Critics and Collectors*, pp. 253–4. Maria Blanchard is listed in the catalogue as Maria Gutherez, a version of her Spanish name Gutierriez.

44 Cited in *ibid.*, p. 223.

45 See the list of Weill's shows and artists exhibited in Appendix 2.

46 See biographical details provided in Appendix 1.

47 Gimpel. *Diary of an Art Dealer*, p. 119.

48 *Ibid.*, entry for 4 December 1919, p. 119.

49 A. Basler and C. Kunstler, *La Peinture indépendante en France*, vol. ii *De Matisse à Segonzac*, G. Crès et Cie, Paris, 1929, includes a chapter titled 'La Peinture multinationale ou l'École de Paris' (pp. 96–105).

50 Gee has discussed some of the shifting meanings of the term *École de Paris* in *Dealers, Critics and Collectors*, p. 255ff. The term did not always have the same meaning during the period *c.*1910–*c.*1930, but 'it was coined as a term of reference which could cover work in different styles produced by "independent" artists unrelated by either training or nationality' (p. 255).

51 Clement Greenberg, in *The Nation*, 13 July 1946.

52 See his review of her work, reproduced later in this chapter, p. 102.

53 The label *l'art vivant* and its closeness to the notion of *l'art indépendant* is discussed at length in chapters 7 and 8 of Christopher Green, *Cubism and its Enemies: Modern Movements and Reaction in French Art 1916–28*, Yale University Press, New Haven and London, 1987.

54 I obtained this information from the Comtesse de Jouvencel in an interview in Paris on 24 March 1984.

55 Roland Dorgelès was a writer and graduate of the *École des Beaux Arts* who later became president of the Académie Goncourt. In 1919 he published *Les Croix de bois* a successful novel of the 1914–18 war, and a series of short stories *Le Cabaret de la belle femme*. He was known for art criticism which was sceptical of the avant-garde, and had (surprisingly perhaps in view of his support of Charmy) been critical of much of Matisse's Fauve work. In an article in *Fantasio* in 1910 titled 'Le Prince des Fauves' he wrote disparagingly of Matisse's methods: 'he has method, and his most laughable paintings are the fruit of painstaking efforts and long meditation' ... 'M. Matisse perpetrated *Le Bonheur de Vivre* and exhibited it at the Indépendants instead of giving it to a circus as a present, as sound logic demanded, and from being merely known of, the young painter became famous'. Quoted (and translated) in Jack Flam, *Matisse: A Retrospective*, Park Lane, New York, 1990.

56 Galeries d'Oeuvres d'Art, *Charmy: Toiles*, June 1921 (unpaginated catalogue).

57 Gee, *Dealers, Critics and Collectors*, p. 152.

58 For a discussion of critical reactions to the early Fauve exhibitions see Ellen C. Oppler, *Fauvism Reexamined*, Garland Publishing, New York and London, 1976.

59 A. Salmon, *La Revue de France*, 18 July 1921.

4 Women painting women

'Une forme féminine'

In much art criticism from the 1910s and 1920s, the idea of a 'feminine' style of painting was often conflated with the representation of a 'feminine' image. That is to say, a gendered mode of painting was thought to be required to produce a particular image of 'woman'. In the work of many artists associated with the School of Paris a marketable style of portraiture emerged in which women's bodies were stylised, elongated and depicted in fashionable dress and make-up. Although the representation of such physical types was most often associated with the work of women painters such as Laurencin and Marval (COL. PLS 16, 25; PL. 65), they were in fact well established in the society portraits of Van Dongen, and epitomised in the elongated and stylised 'women artists' who appear in *An Honest Pastime* (PL. 47).

For some critics, Laurencin's portraits provided a model of femininity against which other representations of women might be measured. Her delicately painted, fashionably dressed women provided contemporary critics with an ideal *forme féminine*, or what Louis Vauxcelles called *un Marie Laurencin*.[1]

A young slender person . . . sinuous, even angular; with an elongated oval face, almond shaped eyes, slightly slanted mouth, slim hands. This adolescent, repeated in scores of images yet never boringly the same, looks at herself in the glass, combs her hair, plays the mandolin, embroiders, dreams, strolls about, goes to the circus, strokes a horse that looks more like a unicorn, or a tame doe that has strayed out of an Indo-Persian miniature rather than a thicket; she dances, flirts, flourishes her tennis-racket.[2]

The refashioned adolescent woman who appeared in Laurencin's canvases was a romanticised version of the thin, elongated 'modern' woman often with short cropped hair who haunted contemporary fashion plates (PL. 57). This *forme féminine* seems to have had an appeal and a cultural power beyond the discourses of art history and criticism. In 1924 René Gimpel,

himself a patron of Laurencin, described the public reaction (as he saw it) to Laurencin's painted sets for the ballet *Les Biches*. He wrote: 'the whole ballet comes to look like the figures she paints. In the corridor I heard a woman say to a man: "Look around the house, all the women look as though they were by Marie Laurencin; she has fashioned a type just as Boldini created the eel look fifteen years ago".[3]

In his account Vauxcelles goes on to conflate the representation of this *forme féminine* with a 'feminine' style, with a use of soft, delicate colour harmonies. In common with several other contemporary supporters of her work, he also attributes this Laurencin type with a national identity. Her sensibility is, apparently, true to her race (*une sensibilité racée*); she is indisputably French.[4]

Surprisingly, Vauxcelles's attempt to give this *forme féminine* a national identity was not incompatible with his continuing status in the early 1920s as a 'radical' critic. Although he professed himself to be anti-intellectual and sceptical of the Cubist avant-garde, he continued to represent himself as against the official *Salon des Artistes Français* and the State, and a champion of 'individualism' in art.[5] His status as a 'radical' critic was bolstered by the fact that his writings were often targeted by writers associated with the extreme right-wing nationalist group *L'Action Français*. In his perception of Laurencin's ideal French woman he was drawing on notions of femininity which had been in currency in nineteenth- and early twentieth-century artistic and cultural discourse and which underwent a revival in the post-war period. In her discussion of late nineteenth-century perceptions of French women and the roles they could assume on gaining entry to the *École des Beaux Arts*, Tamar Garb writes that the idea of a 'national character', which stemmed from hereditary ethnic traits was widely accepted:

Although anthropologists and sociologists would speculate about the origins of 'national characteristics' and dispute the relative claims of essentialists and evolutionists, few people, if any, disputed the 'fact' that they existed and that they were important marks of difference. The French had long regarded English and American women as more 'masculine' than their French sisters, who were thought to represent the quintessentially 'feminine'.[6]

In the context of debates about women's entry into the *École*, this French femininity was seen (by some) to signify sexual vulnerability - or availability. It was suggested that by participating in the mixed life-drawing classes, French women artists in particular might become vulnerable to corruption by, or contribute to the corruption of, their male colleagues.[7] With the refashioning of this quintessentially 'feminine' woman in the 1910s and 1920s, the construction of her sexuality was crucial. In his representation of

Laurencin's *forme féminine*, Vauxcelles combines an image of vulnerable youth, of a slender adolescent, with that of a playful, flirtatious woman who admires herself in the mirror. Her sexuality is perceived as that of a child and a woman; in its playful childlike form it is unthreatening and 'feminine'. Unlike the masculinised sexuality of, for example, Gertrude Stein, it is safely contained within the boundaries of acceptable (French) femininity. As such it was highly marketable and generated a body of critical writing around the idea of the *femme-enfant* (child-woman). In their chapter '*Les Femmes Peintres*', Basler and Kunstler describe Laurencin as constructing a fantasy world of *femmes-enfants*: 'In imaginary lands, she gave herself pleasure by bringing to life legendary characters, types of *femmes-enfants* who watch you with their mouse-like eyes, smiling at you with their "tender mouths"'.[8]

The popularity of Laurencin's child-like women for many male and female observers was not confined to critical representations of her work. It was inextricably linked with public perceptions of her own role as a *femme peintre*. Many contemporary accounts emphasise her naive 'feminine' qualities, her enigmatic sensitivity, perceptions which have been reinforced in subsequent biographies (PL. 54). According to her biographer Flora Groult,

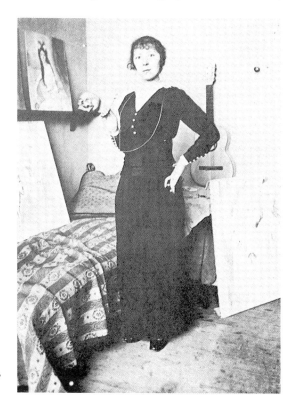

54 Marie Laurencin, in Madrid, 1914

Laurencin retained throughout her life 'the miracle of childhood'.[9] Some contemporary accounts suggest, however, that Laurencin was complicit in the construction of her own femininity, that she promoted herself as an innocent, child-like, 'feminine' artist, recognising that it helped to sell her work. Her work could thus be seen both as a narcissistic preoccupation with her own image, and as an astute form of self-promotion. Fernande Olivier was well known for her scepticism about Laurencin's public persona, and in *Picasso and his Friends* she suggested that Laurencin worked hard to appear 'naive'.[10] Even friends and supporters of the artist have recorded a somewhat disingenous participation in the construction of her own public image. In 1922 the dealer Gimpel wrote:

I told the artist [Laurencin] that Aubry loves the feminine sensibility in her work, and I added: 'Perhaps you won't consider that a compliment.'
 'Oh yes, I want to remain a woman and I'll admit it to you' – Marie Laurencin suddenly blushed – 'that each day I make myself do some sewing, as it's the most feminine exercise there is; it reminds me that I am woman. And I don't go in for embroidery, but darning; honest darning, done in all seriousness, is a duty passed from woman to woman.'[11]

Through her work and projected self-image Laurencin helped to consolidate an image of a marketable 'feminine' art, inhabited by *femmes-enfants*, and produced by the quintessentially 'feminine' artist. In seeking to make a living as a woman artist, she sought to capitalise on the success of this form of femininity. She thus chose to pursue a public role, and to develop a form of painting, which ensured (rather than simply encouraged) a separate classification from that of her male colleagues. As a consequence of this, Laurencin has acquired a position, though marginal, within modernist art history, while some other women artists who (as we have seen) were more directly involved with avant-garde practices are now absent from that history. One of the reasons for Laurencin's sustained public success lies in the relative ease with which her works from the 1910s and 1920s could be appropriated into a critical vocabulary of difference, a vocabulary which remained dominant in art-historical discourses in the 1930s. The discourses around the idea of Laurencin's *femme-enfant* also provided a possible source for later Surrealist conceptions of women's capacity for 'child-like' roles. In the late twenties and thirties some Surrealist painters and theorists applied the idea of the *femme-enfant* to women artists, directly conflating a concept of women's creativity with child-like qualities.[12]
 Laurencin's construction of an untroubling image of the 'feminine' in art and life helped her win both critical attention and financial rewards.

According to the sales lists of the Hôtel Drouot, one of the most important auction houses of contemporary art, Laurencin's prices rose steadily during the 1920s.[13] This was partly due to the contractual patronage of the dealers Paul Rosenberg and Jos Hessel, who also bought up large numbers of her works during the period 1920–30. This patronage sustained demand for her work between the wars and helped to guarantee Laurencin a place within accounts of modern French art history written after the Second World War.

Despite the fantasies of some male commentators, the Laurencin type did not appear on the canvas through some kind of intuitive 'feminine' sensibility on the part of the artist. Laurencin's *femme-enfant* was derived from a complex range of images of women in circulation in the worlds of the 'high', popular and decorative arts. As I suggested earlier, similar conventions for representing women, for producing a standardised female body, were well established in the society portraits of many School of Paris artists, especially Kees Van Dongen. According to Louis Chaumeil, Van Dongen issued his own guidelines for painting flattering portraits of women, advocating elongation, slimming down, and exaggerated jewellery,[14] recommendations which the artist exemplified in his depiction of women artists in *Pastime*. The erstwhile Fauve painter Maurice Vlaminck even saw Van Dongen's portraits of women (PLS 47, 55) as symbolic of a degenerate post-First World War society. In 1943 he wrote that Van Dongen had painted all *la putasserie féminine* (the terrible feminine mess – associated with 'whoring') of the post-war period. According to Vlaminck, this group included 'hysterical society women', French and foreign 'girls', exotic and eccentric women: 'Portraits of women? Portrait of "the" woman of inflation. Marvellous and sinister portrait of the woman with make-up [*la femme maquillée*]'.[15] Vlaminck, then, had seized upon Van Dongen's stylised, fashionable and heavily made-up society women and prostitutes as metaphors for a modern materialistic society, dogged by galloping inflation.

Vlaminck's misogyny notwithstanding, Van Dongen's imagery was easily appropriated to fit this representation of a debased femininity. Although the latter's work from this period is now seen to represent the degeneration of earlier Fauve practices, his exotic, elongated and sometimes sinister portraits (PL. 55) were highly marketable among the wealthy bourgeoisie and the demi-monde. The highly stylised 'naturalism' of such works allowed the client to claim them as 'modern' forms of portraiture, while also indulging a sense of the fashionable and exotic associations of the stylised conventions employed. What Vlaminck could claim as *la putasserie féminine*, others could cite as evidence of fashionable style and modernity. And within some contemporary writings on fashion, fashionable style itself became a sign for woman; through their dress women were seen to express a form of creative

55 Kees Van Dongen, *Portrait of Commodore Drouilly*, 1926, oil on canvas, 225 × 130 cm, Musée Petit Palais, Geneva

femininity. Fashion could thus be seen as a means of expressing a deeper female identity, an alternative form of creativity to that of the male artist.[16]

The modernity signified by Van Dongen's *forme féminine* was informed by a range of modern sources beyond the boundaries of so-called 'high art'. The post-war conventions of fashion design and illustration pervaded many areas of popular and applied design, encouraged by the growth of women's magazines which promoted the latest designs from the Paris fashion houses, then the main forces which determined notions of bourgeois taste and fashion. In the 1910s the activities of designers had been bolstered by the successes of Paul Poiret, whose innovative 'oriental' designs had transformed French fashion and the *haute couture* industry. In the 1920s a group of French illustrators became well known for their style of fashion drawings published in French and American magazines.[17] They included artists such as Georges Barbier, René Bouché, Christian Berard and Jean Pagès, for

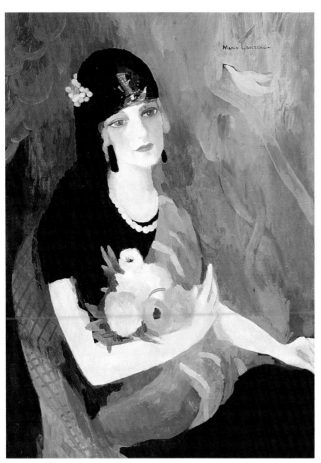

25 Marie Laurencin, *Portrait of the Baroness Gourgaud with a Black Mantilla*, 1923, oil on canvas, 51 × 36 cm, Musée Nationale d'Art Moderne, Centre Georges Pompidou, Paris

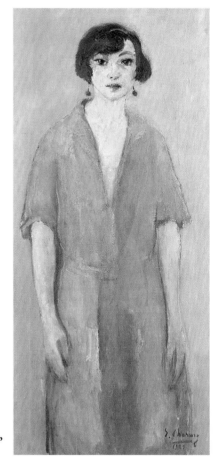

26 Emilie Charmy, *Self-Portrait: Woman in Pink*, 1921, oil on canvas, 147 × 67 cm, private collection

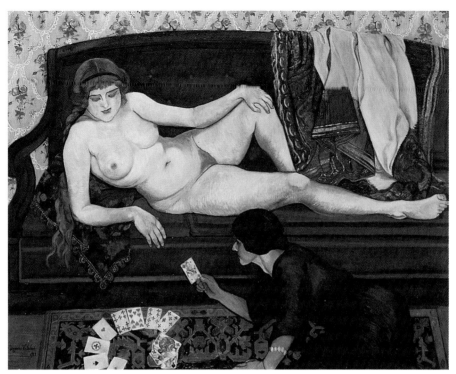

27, 28 Suzanne Valadon: *The Future Unveiled* or *The Fortune Teller*, 1912, oil on canvas, 63 × 130 cm, Musée Petit Palais, Geneva; *The Blue Room*, 1923, oil on canvas, 190 × 116 cm, Musée Nationale d'Art Moderne, Centre Georges Pompidou, Paris

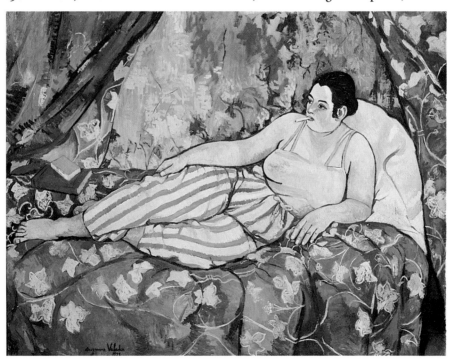

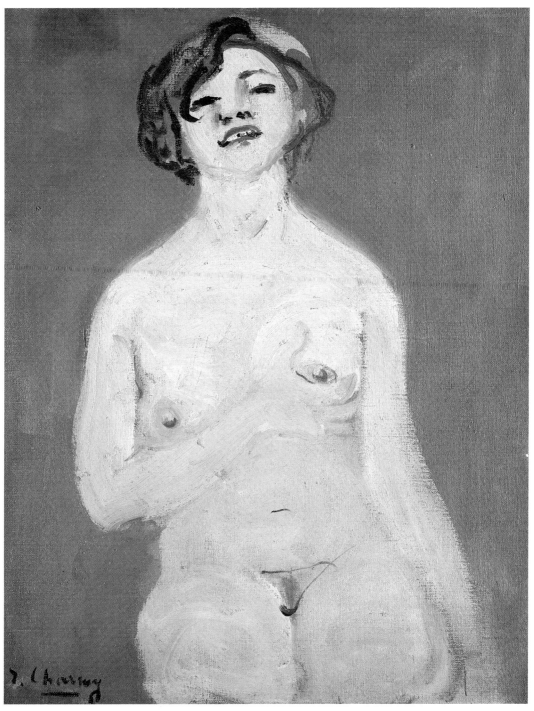

29 Emilie Charmy, *Nude Holding Her Breast*, mid 1920s, oil on canvas, 93 × 73 cm, private collection

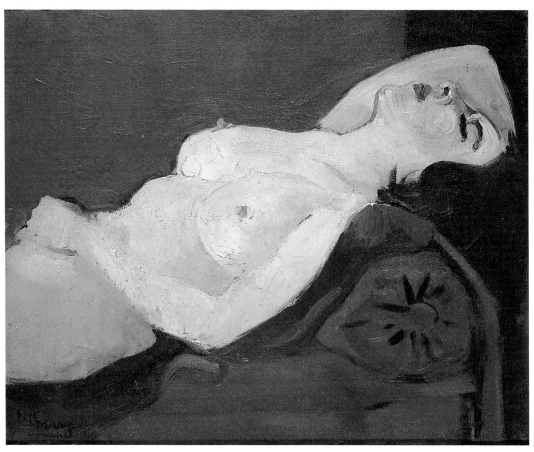

30 Emilie Charmy, *Sleeping Nude, c.* 1925, oil on canvas, 65 × 80 cm,
private collection

whom a slim elongated female shape with cropped hair emerged as an ideal type and a symbol of one aspect of the supposedly emancipated 'modern' woman, now liberated from corsets and elaborate coiffure (PL. 56). Van Dongen participated in the popular dissemination of such images of woman in his work for poster design and book illustration (PL. 57). By the 1920s *haute couture* had itself acquired the status of a (Parisian) art form, identified by some as an indication of French commercial and artistic progress. As Tag Gronberg has shown in her work on the role of *l'art décoratif* in the 1925 Paris Exhibition of Decorative Arts, 'an identification with the production of *haute couture* was one means of defining Paris as the centre of the "modern" and consequently France as "in advance of other nations" '.[18]

The 'modern' associations of Van Dongen's *forme féminine* were further reinforced when he illustrated the 1925 edition of Victor Margueritte's controversial story of a 'modern woman', *La Garçonne*, first published in 1922.

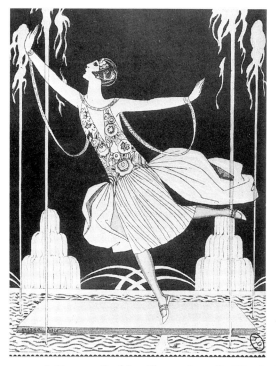 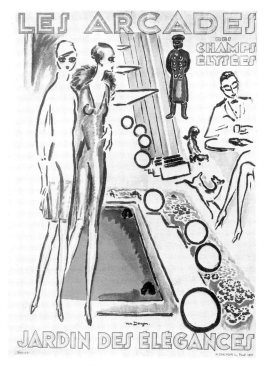

56 Georges Barbier, illustration of a Worth dress being modelled in front of Lalique's illuminated fountains

57 *right*
Kees Van Dongen, *Poster for Les Arcades on the Champs Elysées*, 1922

The novel told the story of a young bourgeois girl, Monique Lerbier, who set up her own interior decoration shop in an attempt to free herself from the constraints of middle-class family-life. She chose to liberate herself from her unfaithful fiancé by experimenting with other lovers and lesbian relationships, finally finding love and giving birth to an illegitimate child. The heroine's refusal of hypocritical middle-class values and her pursuit of sexual pleasure contributed to an unconventional narrative which scandalised the Church and caused the book to be banned from bookstalls. Although the book could be seen as a social and moral warning, the author, the son of a general and President of the Société des Gens de Lettres, was stripped of his Légion d'Honneur for producing a novel which was seen by some contemporaries to champion a dangerous political feminism.[19]

The central character of La Garçonne, albeit represented by a male author, suggested a considerably more complex (written) construction of 'modern' femininity than that evoked through Van Dongen's painted or graphic images, and the combination of Margueritte's text with Van Dongen's illustrations in the 1925 edition may now seem somewhat inappropriate. The masculinisation implicit in the book's title and in the appropriation of 'masculine' sexual behaviour which Lerbier seems at times to advocate, provided a far more threatening and unstable image of female sexuality than that suggested in even the most sinister of Van Dongen's female portraits. But in the 1910s the available visual languages for representing 'modern' femininity were either highly marketable versions of the Laurencin or Van Dongen formes féminines associated with the School of Paris, or less easily readable and distorted images of women associated with the Fauve and Cubist avant-garde. In both cases the sexual gaze was controlled largely by the male observer, with whom, as I have suggested, some women artists could be seen (consciously or unconsciously) to collude.

Given the nature of the relations of power and control which operated within the markets for artistic and popular illustrations of 'modern' women, it is not surprising that many women artists participated in the construction of marketable versions of femininity, whether in the form of femmes-enfants or femmes maquillées. Both Marval and Charmy, who earned a proportion of their income through commissioned portraits, adopted conventions in their images of women which echo those of Van Dongen. Both were also his close friends and had known him since all three artists were associated with the early Fauve group. Like many of his male contemporaries, Van Dongen's early reputation as an avant-garde Fauve painter was inseparable from that of a flamboyant bohemian womaniser. In her record of 1905, Weill mentions his participation in a group exhibition of that year, describing him as 'this great devil' who is to be found in all quarters of Paris,

'tormenting damsels, whatever their background'.[20] Van Dongen seems to have deliberately cultivated this bohemian image, courting the attention of, and encouraging friendships with many women artists who adopted similar styles of portrait painting. Charmy worked closely with him around 1920 when both artists were in Deauville, a smart resort on the channel coast where commissions for 'society' portraits were relatively easy to come by. And Marval became Van Dongen's neighbour in 1914 when she moved into the rue Denfert Rochereau, commenting in a letter to a friend that her studio was a good deal smaller than that of her successful neighbour.[21]

During the 1910s, when Marval was showing regularly at the *Salon d'Automne*, the *Indépendants*, and at the Galerie Druet, she became known for her own elongated *forme féminine*, similar in many respects to the almond-eyed *femmes maquillées* of Van Dongen's canvases. But for many critics Marval's use of soft colours, and her repetition of the themes of children and 'tender adolescents'[22] constituted a 'vision' which was closer to that of Laurencin. After a successful show of her work at the Galerie Druet in 1912, Apollinaire wrote an article entitled '*Les Peintresses*', in which he reviewed some of the shows of 1911–12 and was quick to identify the emergence of a distinctive style of art by women:

What they bring to art is not technical innovation, but rather taste, instinct, and a vision which is new and full of the joys of the universe . . . Mme Marval has offered the amateurs of painting an altogether different treat. This artist has imagination and an individual talent. Abstraction is not her strong point but she has a marvellous way of showing the poetical reality of the subjects she paints . . . Men usually come unstuck in compositions in which good taste is allied with delicacy [*délicatesse*] . . . Charm is the really French artistic quality that women like Mme Marval and Mlle Laurencin have been able to preserve in art . . .[23]

Amateurism, Frenchness, delicacy and charm are thus established as the qualities of a 'feminine' art, qualities which were seen to be represented symbolically by the *formes féminines* of their canvases.

Decoration, modernity and femininity

I have suggested that the variations on this *forme-féminine* which were available in popular illustrations and the canvases of Van Dongen, Laurencin and other *femmes peintres*, themselves became signifiers of a cultural modernity, of a fashionable, 'modern' outlook and an unconventional or ambiguous sexuality. While the sexuality of Laurencin's *femme-enfant* could be appropriated to represent an unthreatening child-like availability, some of Van

Dongen's images could be seen to evoke the seedier world of prostitution and sexual deviancy, or even (as Vlaminck argued) to symbolise the degeneration of modern society. For a contemporary art-consuming public, modernity could thus be signified by various representations of women as a decorative spectacle, as a highly stylised, stylish and heavily made-up female form.

Drawing on the imagery of modern fashion design, these female types belonged in the worlds both of the 'decorative arts' and of the 'decorative'. While the former was a label used (with some different emphases) to represent the applied arts, the label 'decorative' was a shifting signifier, often used to designate a field in which 'high' and applied art met.[24] Although the well-established historical and cultural associations made between the 'decorative' and the 'feminine'[25] allowed for easy appropriation of, for example, Laurencin's images of women as quintessentially 'feminine', the concept of 'decorative' painting was the subject of some contemporary theoretical debates. In the writings of Symbolist critics and painters, among them Georges Albert Aurier and Maurice Denis, the 'decorative' had been given other levels of aesthetic and metaphysical meaning deemed necessary for the production of a (Symbolist) modern art, thereby salvaging the term from the derogatory connotations of being 'merely decorative' or ornamental.[26] Matisse reworked some of these Symbolist ideas in his much quoted *Notes of a Painter*, written in 1908, in which he argues for the 'decorative' as a pivotal notion in his theory of expression, as a value-laden concept which is central to the development of aesthetic organisation.[27]

There were then many theoretical attempts to salvage the concept of the 'decorative' in its application to the work of the early twentieth-century avant-garde, and the concept was significantly reworked in the critical writings of Clement Greenberg.[28] However, given the power of traditional historical associations of the 'merely decorative' with supposedly 'feminine' forms and modes of artistic production, such thereotical uses of the term rarely emerge in the critical languages which define and evaluate the work of women artists. Thus Raynal wrote in 1927 that despite her choice of subject matter, Laurencin's work was somehow saved from falling unreservedly into *la décoration* by the subtlety of her tones and the 'softness' and 'freshness' of its overall effect. It is ironic that those effects which are seen to save her work from *la décoration* are also the qualities which Raynal associates elsewhere with a 'feminine' style.[29]

In practice few women artists from this period could be 'saved' from *la décoration*, for many, including Delaunay, Laurencin, Marval and later Halicka, earned their living partly from their work in the decorative arts.[30] After 1914 Sonia Delaunay increasingly concentrated on fabric, clothes and

set designs (although she also continued to paint), and Laurencin became well known for her applied designs, including her stage sets, for the Russian ballet *Les Biches*. Despite contemporary attempts to give *haute couture* and the 'decorative arts' a higher artistic status, they tended to occupy lower positions in contemporary hierarchies of artistic production. And the association of women painters with the category 'decorative art' tended to confirm their separate (and often devalued) status within the art world as a whole. In 1916 Weill questions these associations when discussing the work of a female decorative artist called Charlotte Gardelle. She asks why talented *décorateurs* do not like being classed as such, concluding that it is 'because the artist-painters value themselves as having a superior essence to the artist-decorators, despite the fact they are usually both'.[31] More often than not this 'superior essence' was attributed to the heroes of avant-garde painting.

The stylised conventions of portraiture adopted by Laurencin, Charmy, and Marval (among others) were not confined to commissioned portraits; they also appeared in some of the forms of self-portraiture adopted by each (COL. PLS 16, 26; PLS 35, 58). Such conventions could signify the artist's fashionable modernity both as part of her self-identity, and as a form of public masquerade. In their departure from naturalism towards a visibly exaggerated and painted (i.e. made-up) female form, these self-portraits signalled the artist's desire publicly to identify herself with an artificial or 'decorative' femininity, to construct a disguise which complied with marketable stereotypes. But as I shall argue, for some women artists, and for Charmy in particular, this complicity did not extend to the production of self-images for largely private consumption, raising some important and problematic issues about the different strategies of artistic production adopted by women artists working in the context of, and in competition with, the artists of the School of Paris.

Laurencin's self-portrait on the fringes of the avant-garde as represented in both versions of *Apollinaire and his friends*, could be seen both to reinforce the ambivalent role which she occupied in relation to that group, and a self-conscious construction of herself as delicately 'feminine'. Although the second version includes several women associated with the *Bateau Lavoir* group, the femininity of each is clearly suggested through more 'delicate' poses, which contrast with Apollinaire's relatively stiff central pose, or the less exaggerated forms of facial stylisation of Laurencin and her female companions, which contrast with the clearly primitivised face of Picasso, itself reminiscent of the female faces of *Les Demoiselles d'Avignon*.

The self-portrait recurs throughout the work of Charmy, although it is sometimes unidentified as an image of the artist. As a less successful artist than Laurencin, and one who was not tied to the production quotas required

by a dealer's contract, more of her work remained unsold, or was actually painted (as I will suggest) for private consumption. Given these functions, it is tempting to see the recurrence of self-portraits in her work as evidence of an introspective self-examination of the sort which has been identified in the work of some other women artists working in the early twentieth century.[32] Although some of Charmy's self-portraits suggest a somewhat critical and unflattering self-image many were more likely to function as a projection (of a fantasy) of her own ageless femininity. Many are largish exhibition pieces in which Charmy was not concerned to suggest any psychological insights, or realistic observations. These public works suggest a rather self-confident, fashion-conscious Charmy of indefinable age (COL. PL. 26; PLS 58, 59). Such self-images reveal some of her own obsessions (as reported by friends and family) with ageing and the loss of conventional 'good-looks' which it involved. Such concerns echo a dominant sexual morality which placed enormous emphasis on women's physical appearance, on youthful good looks as a measure of the ideal 'feminine', and which helped to account for the success of Laurencin's *femme-enfant*. Later in life Charmy was renowned for her obsession with *haute couture* and her use of heavy make-up, without which she would not appear in public. Through painting she could construct an ageless image, and continued throughout her career to produce self-portraits which disguised her real age and physical appearance. In these later works she also increasingly showed herself dressed in a hat, itself a form of symbolic disguise which could represent the close association of woman and fashionable style (PLS 58, 59).

The female nude: (de)constructing a feminine body

Some more ambiguous and less flattering forms of self-portraiture can be found among Charmy's many studies of the female nude (COL. PL. 29). The theme was of special importance in the work of many women artists active during the first quarter of the twentieth century, especially Charmy, Valadon and Marval. I have argued that by the early twentieth century conditions of artistic practice for women were changing in complex ways. Better access to education and exhibiting facilities meant that women were less restricted, and less reserved in the genres and iconographies which they adopted. Images of the female nude were common within both more traditional and 'progressive' forms of art at the time. The increasing numbers of women working in the genre was itself an indication of their increased participation in professional artistic spaces (PL. 60). As a theme with a significant history within Western art and aesthetics in general, and within Academic art in particular, the representation of the female body could be seen as a

metaphor for the value and role of high art, for the symbolic transformation of ordinary nature into more elevated forms of culture.[33] But these symbolic roles were increasingly problematised in the late nineteenth century with the emergence of concepts of modernity and reworkings of the 'modern' subject. The female nude has come to be seen as one of the most significant motifs in the work of the early twentieth-century avant-garde, and its status much trumpeted – and debated – in the work of Picasso, Matisse and the pre-war German Expressionist painters.[34] Many of the best-known artists associated with the School of Paris also acquired both fame and notoriety for their representations of this theme, among them Modigliani, Segonzac, Foujita and Van Dongen (PLS 61, 62). During the 1910s and 1920s the theme became the focus of a whole range of debates about sexuality, pornography, desirable femininity, aesthetic codes, bourgeois morality, the exotic and the 'oriental'.

Within bohemian artistic circles an interest in painting the theme of the female nude liberated from the trappings of mythological or historical themes combined with non-naturalistic styles, could itself signify a rejection of bourgeois morality and a declaration of sexual freedom. During the 1900s and the 1910s art world 'scandals' were regularly provoked by exhibitions of paintings of the nude by well-known modern artists. Negative reactions frequently accompanied the exhibition of controversial studies of the nude shown at the 'independent' salons, including Matisse's *Blue Nude: Souvenir de Biskra* in the *Salon des Indépendants* of 1907[35] and Van Dongen's *Tableau* (or *The Spanish Shawl*) in the *Salon d'Automne* of 1913 (PL. 62). The inclusion of the figure of a love-struck crippled beggar with an unconventional image of the female nude in *The Spanish Shawl* broke with Academic traditions for representing the theme, and generated a furious critical debate. After the press view of this Salon, the French Secretary of State for the Arts ordered the police commissioner for the Champs Elysées area to remove the painting.[36] Van Dongen's status as a hero of bohemian sexual freedom was assured. Similar publicity was generated by a show of Modigliani's paintings and drawings at Berthe Weill's gallery in 1917, when Weill reports that during the opening she was asked by the local police commissioner to remove a Modigliani nude from her gallery window, and subsequently to remove all nude paintings from the show.[37] The capacity to instigate such outrage was not reserved for the work of male artists. In her account of 1906, Weill describes an exhibition in which several *grands nus* by Marval provoked a furious reaction by one of her clients.[38]

As a focus of such debates, the representation of the female body raises problems of spectatorship; it begs questions about who is doing the looking, what social and sexual position this person is looking from, and what

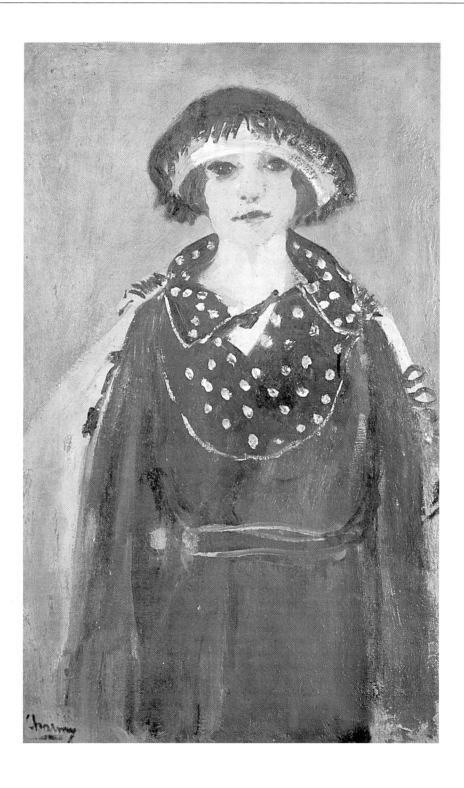

58 *facing*
 Emilie Charmy, *Self-Portrait
 with Hat, c.* 1916, oil on
 canvas, 100 × 66 cm, private
 collection

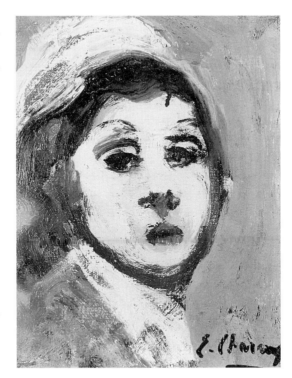

59 Emilie Charmy, *Self-Portrait
 with Hat,* 1940s, oil on
 board, 27 × 22 cm, private
 collection

expectations (aesthetic, sexual, social, psychological) are involved in the process of looking. It also raises the question of what viewer or group of viewers the representation is intended for: is the artist/viewer producing an image of the female body intended for a particular public? Much work has now been done on this problem of spectatorship and various theories of the 'gaze' have been adopted as tools for understanding the processes involved in looking at representations of women's bodies. The theory of the 'gaze' (which originated in film theory) has been that 'the determining male gaze projects its fantasy onto the female figure which is styled accordingly'.[39] This theory has been widely applied to the historical conventions of the painting and reception of the nude, conventions which have been seen (broadly speaking) to have constructed images of women's bodies according to male desires, to have objectified the genre of the female nude as signifying the object of male desires and fantasies.[40]

 While various reworkings of the theory of the gaze have helped to reframe debates about the status and meanings of the female nude in art history, and have provided an invaluable tool for feminist (and psychoanalytic) analysis, I would caution against a too rigid or unreflective application of this model. The meanings of paintings are heavily mediated by both historical context

and the techniques and concerns of the medium itself, which may interfere with or contribute to the literal or symbolic readings suggested by the iconography or the pose.[41] And, of course, the work of women artists in this genre raises difficult questions about the possibilities for a 'female gaze' through which women might develop languages for representing the female body which relate to their own (psychological, cultural and sexual) experiences of their bodies, rather than as the objects of somebody else's desire. However, given the traditions and artistic vocabularies available to women working at the beginning of the century, and the notions of femininity dominant in French culture at the time, the production of alternative images of the female body to those of contemporary male painters (whether associated with the avant-garde or the School of Paris) was neither an easy nor an obvious artistic strategy to follow. Hence the contradictions and shifting forms of representation evident within the imagery of the female nude produced by women artists such as Valadon, Charmy and Marval.

Valadon's work on this theme has been the focus of some recent feminist study which has identified images of the female nude that radically rework the conventions of the genre. Rosemary Betterton has argued that many of

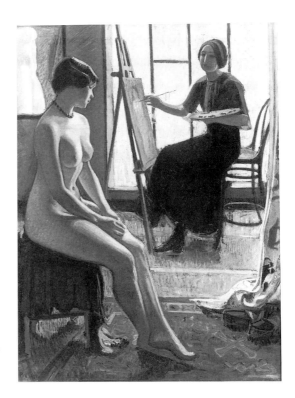

60 Jean Puy, *Artist and Model*,
 1911, oil on canvas, 143 × 112
 cm, Musée Petit Palais,
 Geneva

her images of women 'mark a point of resistance to dominant representations of female sexuality in early twentieth century art'.[42] Valadon's heavily proportioned, unidealised female nudes, some of which appear strangely asexual, could be seen to break the mould of the sexually available erotic nudes of some of her male contemporaries. And her strong outlines, visible brushstrokes, rich colour, and bodies placed boldly across the foreground picture plane, as in for example, *Nude with a Striped Coverlet* of 1922 (PL. 63) or *The Blue Room*, 1923 (COL. PL. 28), combine to give her figures a powerful presence which engages the viewer's attention, but which also seems to refuse an eroticised male 'gaze'. During the 1910s Valadon adopted many iconographical themes and poses familiar to the genre of the female nude, such as traditional allegories of Adam and Eve, fortune-telling and bathers in nature as in her *Joie de Vivre* of 1911.[43] In her adaption of an allegorical theme in *The Future Unveiled* of 1912 (COL. PL. 27), the artist reworks the familiar nineteenth-century theme of the female odalisque, combining it with an allegory of cards and fortune-telling. But it is difficult to attribute clear narrative readings to this image. Even the odalisque figure appears actively engaged with her female companion, rather than passively

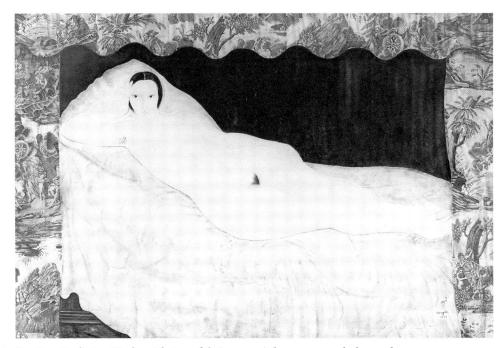

61 Foujita, *Reclining Nude with Jouy fabric*, 1922, ink, crayon and charcoal on canvas, 130 × 195 cm, Musée d'Art Moderne de la Ville de Paris

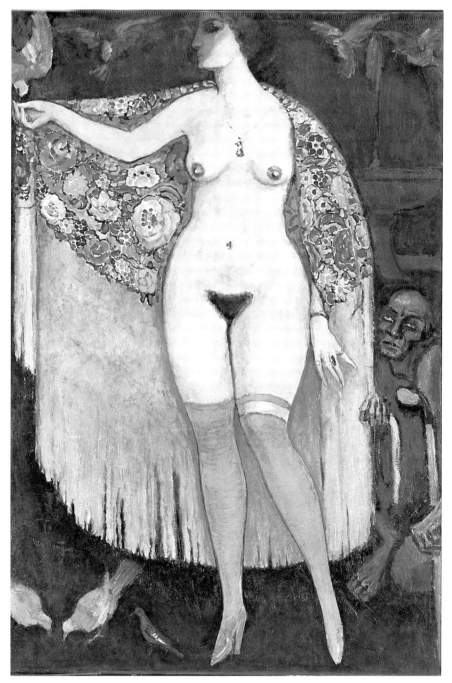

62 Kees Van Dongen, *The Spanish Shawl*, 1913, oil on canvas, 195.5 × 130.5 cm,
Musée d'Art Moderne de la Ville de Paris

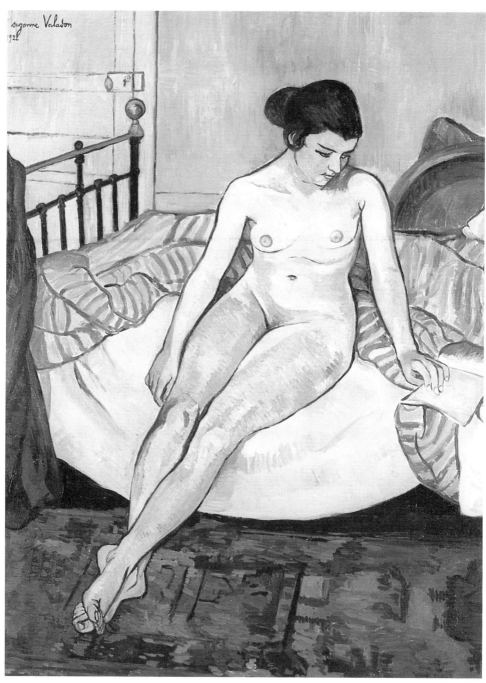

63 Suzanne Valadon, *Nude with Striped Coverlet*, 1922, oil on canvas, Musée d 'Art Moderne de la Ville de Paris

reclining as the object of the (male) viewer. Patricia Matthews has suggested some other possible disjunctions and intersections of meaning in this work:

> The symbolism of the queen of diamonds held in the hand of the fortune-teller directly relates the allegory to the reading of the odalisque as a sexualized body. The card connecting the two women's bodies is a sign of the feminine principle, of physicality and the senses, and of money matters. In conjunction with the four kings in the circular arrangement of cards, it evokes a prostitute or courtesan. The painting thus implicates the folly of indulgence in card games and fortune-telling, generally an activity performed by gypsies assumed to be thieves in the most common representations of them during the seventeenth century, and the eroticism of the odalisque or courtesan, leading to a moralizing reading of the nude. The symbolism of the queen of diamonds can also be read as a celebration of that body as physical, sensual and sexual, with overtones of an essential femininity, or its opposite, a working woman/prostitute.[44]

In formulating these arguments, Matthews cites the traditional symbolic associations of the queen of diamonds.[45] Of course, without evidence of artistic intention, we can only suggest possible narrative meanings intended by the imagery within this painting. But the complexity of the imagery, and the various possibilities of meaning which it suggests, does not allow for comfortable readings of the picture as a whole. As Matthews has argued, 'Valadon subverts the consistency of the illusion not by breaking its visual connection to "reality" as her avant-garde colleagues did, but rather by contradicting its seemingly coherent narrative through conflicting readings'.

Valadon's ability to produce some unconventional representations of the female nude and female sexuality has been explained with reference to her unusual class position. As one of the few successful women artists of her epoch who did not come from a middle-class background, the conditions of her early training and artistic experiences were significant in her later career, allowing her to break with (it is argued) the normative artistic categories of her time.[46] As the illegitimate daughter of a domestic worker, and a child who experienced poverty and an awareness of the Parisian art world on the streets of Montmartre, the social and artistic spaces she inhabited were clearly different to those of Berthe Morisot or Mary Cassatt. Valadon's early access to the conventions for painting the female nude was partly acquired through the back door, as she posed as a nude model for many famous male artists, among them Puvis de Chavannes and Toulouse Lautrec. While such experiences have helped to fuel the fashion for hagiographies of her life, they must also have encouraged her interest in the theme, and perhaps enabled her 'transgressions'.

It has been argued that Valadon's 'transgression' was also to do with her actual choice as a woman to paint the female nude, and that 'very few women artists through Valadon's era worked in the genre'.[47] As I have indicated, my own research suggests that this was not the case, and that by the early 1900s the female nude was as important a theme in the œuvre of women artists as it was for their male avant-garde colleagues. The problem for feminist art history is that access to this material has (thus far) been limited, and much research still remains to be done. From the evidence available so far it is also clear that the artistic conventions and strategies adopted in representations of the female nude by different women artists of the period were by no means consistent, revealing a wide range of aesthetic and social interests.

Charmy's different works on this theme reveal some interesting contradictions, and suggest that the artist may have consciously distinguished between the functions of marketable paintings of the nude produced for public exhibitions and those produced for more private or personal reasons. Surviving documentation on the prices of her work indicates that between the wars Charmy's nude studies fetched some of her highest prices.[48] This was partly because they were often larger canvases, but it also points to a growing market for her paintings of the female nude. Two of these were included in an exhibition of 1922 at the Galerie Styles called *Le Nu féminin*. The show presented Charmy's exhibits, which included her *Large Reclining Nude* 1921 and her *Reclining Nude* 1921 (PL. 64), as part of a great tradition of nude painting in Western art. Charmy was the only woman painter

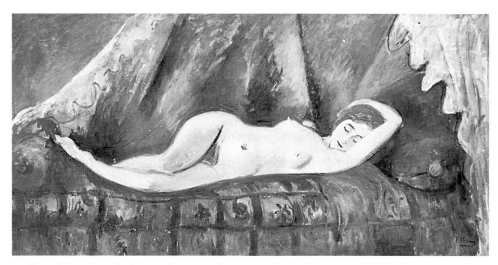

64 Emilie Charmy, *Reclining Nude*, 1912, oil on canvas, 97 × 195 cm, private collection

represented, and the artists selected to represent this tradition included
Delacroix, Manet, Corot, Cézanne, Renoir, Lautrec, Derain and Matisse.
Among the better known exhibits was Manet's watercolour study for
Olympia and a Cézanne *Bathers*. The inclusion of her work in the show was
partly due to the personal preferences and interests of the organiser, the
Count de Jouvencel. But her status as an important 'modern' representative
of a European tradition of nude painting is also emphasised by many con-
temporary reviewers; an important assumption behind the organisation of
the show was that this was a celebration of a 'modern' tradition which could
be traced back to Delacroix's oriental nudes, and to Manet's *Olympia*, an
image of a courtesan which had confused and enraged many critics in the
1860s.

For some critics, Charmy's work was seen as the apotheosis of this
tradition. For example, a long review of the exhibition, which gave special
prominence to Charmy's work, appeared in a monthly magazine *Les
Hommes du Jour*. As the title suggests, this magazine was aimed almost
exclusively at a male readership and included articles of contemporary
artistic and intellectual interest. The exhibition was featured on the cover
with a full-page illustration of Delacroix's *Women of Algiers*. The review was
written by André Gybal, an established art critic who also wrote in the more
radical art press, including the magazine *Clarté*, and who was known for his
support of the Constructivists.[49] The review opens with a comment on the
contemporary economic slump. 'Economic conditions are appalling', writes
Gybal, yet 'whatever our fears and the hardships of living, the shortage of
everything, it is impossible that art will not show itself'. He claims to have
identified an 'immortal' quality of art in this exhibition. He is anxious to
give the show historical credibility and writes that the organiser has demon-
strated an unbroken thread of art which 'unites Cimabue with Gleizes,
El Greco with Rouault and Goya with Charmy'. It is unclear exactly what
are the unifying factors in this unbroken 'thread', but Gybal's major pre-
occupation seems to be with various artists' abilities to convey 'sensuality'
(*la volupté*) in painting. And this 'sensuality', which he identifies in both
technique and interpretation of the subject, is epitomised, he argues, in
Charmy's exhibits. He describes his encounter with her *Large Reclining Nude*
in effusive terms:

But in the corner of the alcove, in the shadows, here burns the flame of another
nude: fire of delight! It is the large reclining nude by Charmy; a long undulating
form like an arc; a thread of flesh, a thread of silk suspended from two angles above
the canvas, which balances itself, provocatively, so supple that on seeing it one feels
enmeshed. And see the hips turning below the flattened-out bust, and that rounded

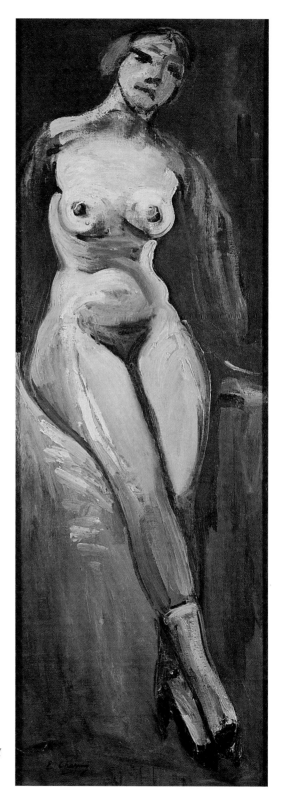

31 Emilie Charmy, *Large Standing
Nude, c.* 1925, oil on canvas,
140 × 48 cm, private collection

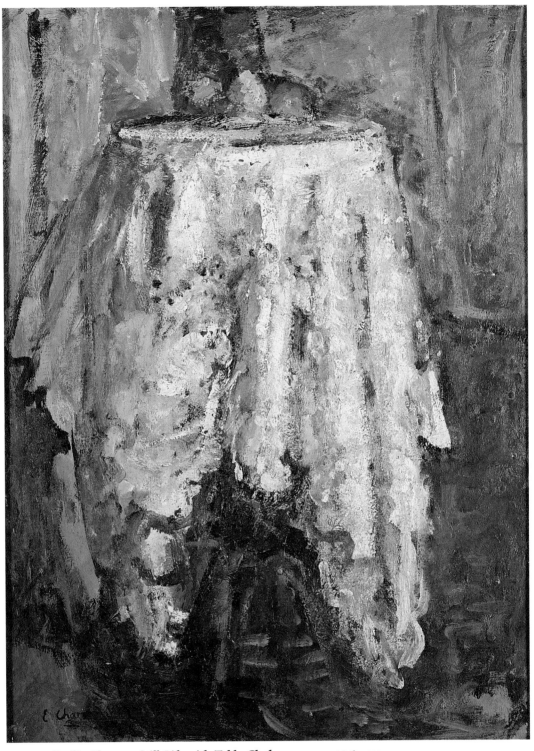

32 Emilie Charmy, *Still-Life with Table-Cloth, c.* 1945, 91 × 67 cm, private collection

stomach, luminous as if it has just left a heavenly star, but above all the innocent stomach of a wonderful creature.[50]

In view of Gybal's critical profile as a supporter of ideas of construction, the emphasis of this review is somewhat surprising. He is preoccupied with this painting as an expression of the 'sensuality' which he exalts. According to Gybal, Charmy's nude is mysterious and unreal, an endless source of delight for the male observer, and based in a concept of sensuality which appears to have originated in male fantasy. Even the language of art criticism is sexualised, evoking the impression that Gybal is literally 'enmeshed' with this (representation of) the female body. However, Gybal's characterisation of Charmy's nudes as unearthly, yet sensual creatures was not entirely a product of his own vivid imagination. *The Reclining Nude* and *Large Reclining Nude* are both heavily stylised images of the female nude. The rhythms of the sleeping body are accentuated to suggest flowing 'S' curves, which are echoed in the decorative lines of the drapes. Both nudes represent a clichéd objectification of the female body as a form of erotic, passive display.

In works such as these was Charmy, then, uncritically reinforcing a masculine language for looking at the female body? It could certainly be argued that several contemporary women artists, among them Marval, produced marketable images of the female nude which reinforced a stylised, erotic image of fashionable femininity as in Marval's *La Bohémienne* of 1921 (PL. 65) in which a prettified reclining nude signifies the sexual availability – or perhaps promiscuity – associated with bohemian artistic culture. And in Marval's *Desire* of 1908–9 (PL. 66) an adoring black page boy worships at the feet of a milky white female body, reclining in front of what appears to be an Egyptian frieze. 'Desire' is thus represented as a 'primitive' or non-Western longing for a Western ideal of female beauty.

Despite the contemporary fashion for variations on the nude in an oriental or exotic context, for reinforcing the representation of woman as sexual and cultural 'other',[51] Charmy rarely engaged with such themes in her works. Moreover, her canvases for the 1922 show were not typical of her work in this genre. During the 1920s she seems to have developed a range of conventions for representing the theme of the female nude (PLS 67, 68). A different imagery of the female body emerges in works which had a more private function, which were not directly – or initially – intended for public exhibition, and which remained in the artist's personal collection until her death, or which were privately commissioned. These works reveal some different images of female sexuality, and suggest contradictions of which the artist herself seems to have been aware. While the more public, marketable, nudes are often depicted in stylised and erotic poses, others from the same

period are depicted in unselfconscious and less passive poses. These nude subjects often stare directly out of the canvas, their heavy and fleshy dimensions are emphasised. At a time when a slim adolescent woman had become the ideal 'modern' shape, beloved of fashion designers, these broad fleshy women, like those by Valadon from the period, seem conspicuously opposed to Vauxcelles's *forme féminine*.

Many of Charmy's nudes from this period flaunt their sexuality in unconventional ways. In, for example, her *Nude Holding her Breast* from the mid 1920s (COL. PL. 29) her half-seated figure has dishevelled hair and defiantly holds one breast. She appears to have a blackened tooth and looks directly at the spectator as if to taunt him or her. Her sexuality is thus of a different order to that of Charmy's passive, frail-looking reclining nudes. The hairstyle and the facial features of *Nude Holding her Breast* indicate that this work may have been a self-portrait, and the defiant pose and heavy body suggest that this is a representation of a woman's body as seen by herself, rather than conforming to the conventions adopted in her 1922 exhibits. Although Charmy used models for her nude studies, she also often painted herself nude, but rarely labelled these representations as self-portraits. Not surprisingly, she reveals an ambivalence about identifying a naked image of herself. To identify herself as the artist's model was to place herself within a socio-cultural group usually separated (in terms of status) from that of the artist. It is significant that Valadon, who had actually worked as an artist's model, also painted several nude *self*-portraits, but seems to have had fewer qualms about publicly identifying herself as the object of representation. Given Valadon's experience, she appears to have moved more easily between her roles as subject (i.e. author) and object of painting.

By the mid to late twenties Charmy's nude studies, and some of the critical readings which they encouraged, reveal some rather different, or at least shifting, notions of female sexuality. During this period Charmy painted and exhibited nudes in reclining or seemingly passive poses, using rich background colour such as deep reds and blues and thick layers of impasto, with the brushwork deliberately exposed. The women's faces are often heavily made-up (COL. PLS 30, 31), and suggest forms of sensual pleasure which are rather different to the passive sensuality of the nudes exhibited in the 1922 exhibition. In her *Sleeping Nude* from the mid twenties Charmy's subject is set against a deep red background and red velvet sofa and reclines with a hand over her genital area as if masturbating, and with an expression of pleasure on her face (COL. PL. 30). This work remained in her private collection until her death, and may have been intended as an essentially personal work in which the eroticism, and the voyeurism which the subject evoked, was not for public consumption. The possibility that this sort of

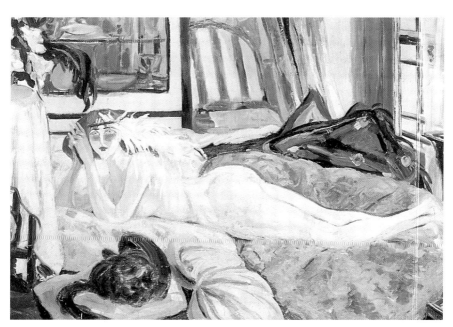

65, 66 Jacqueline Marval: *La Bohémienne*, 1921, oil on canvas, 130 × 200 cm;
 Desire, 1908–9, oil on canvas, 130 × 161 cm. Both private collection, London

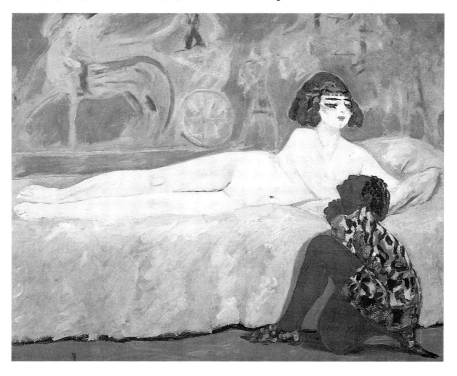

work was intended for a private, possibly female, audience is supported by
the knowledge that the artist may have been bisexual. Although she main-
tained a veil of secrecy around her private life, her son has claimed that his
mother maintained an ambivalant attitude towards her own sexuality.[52] She
was a close friend of Colette, whose literary work has been seen to have con-
structed an informed sexual gaze, an *écriture féminine* through which figures
such as Léa in the novel *Chéri* are represented as taking control of their own
sexuality.[53] Despite the voyeurism which Charmy's *Sleeping Nude* encour-
ages, this woman's pursuit of her own sexual pleasure could be seen as a
visual equivalent to the forms of female sexuality observed and championed
in Colette's writing. By 1926 Colette had published some of her best known
novels, including *La Retraite Sentimentale* (1907), *L'Ingénue Libertine* (1909),
La Vagabonde (1910). The openness with which she wrote about women's
sexual experiences made her a controversial figure within the literary estab-
lishment and something of a heroine within some feminist circles.

 Colette herself seems to have identified parallels in the techniques and
interests of her own writing and those of Charmy's painting, and wrote the
catalogue introduction for a one-woman show of Charmy's work held at the
Galerie d'Art Ancien et Moderne in 1926. According to information contained

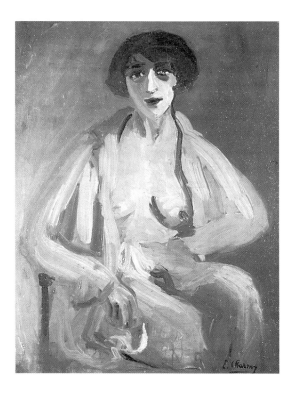

67 Emilie Charmy, *Nude in a
 Dressing Gown*, 1916, 93 ×
 73 cm, private collection

in the catalogue and reviews, the show included portraits (including Charmy's portrait of Colette, PLS 69a, 69b), flower paintings and a series of boldly painted sensual nudes which although publicly exhibited were similar in style and composition to Charmy's *Sleeping Nude*. In her catalogue introduction Colette praises the artist's 'passionate' technique, her 'lack of artifice' and her individualism. She exalts the sensuality of her nudes; identifying a 'wise and fresh beauty' in their reclining bodies.[54]

Parallels between the interests of both artists were noticed by contemporary critics, including Henri Béraud who called Charmy 'the Colette of painting',[55] a comparison which was made frequently in subsequent reviews of her work. The comparison was generally understood on two levels. Colette's position as the most important female writer in France was paralleled (as some claimed) by Charmy's status as a woman painter, and the spontaneity of technique and the sensuality of her forms (both bodies and objects) were seen to parallel Colette's rich use of language to describe elements of nature and women's experiences. Clearly, the constraints of the two media are different, but in their separate disciplines both displayed technical skills which were highly valued by their contemporaries. It is likely that the artists themselves identified similar aims in their works, as is

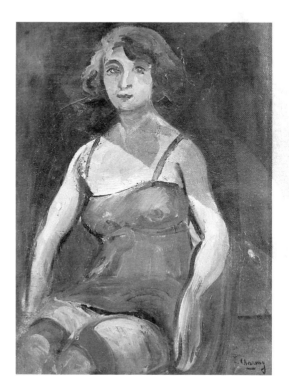

68 Emilie Charmy, *Nude in a Slip*, 1916, oil on canvas, 92 × 71 cm, private collection

suggested by Colette's catalogue introduction. Although there are no sur-
viving written statements by Charmy herself on this issue, she seems to have
consented to Colette's reading of her work. According to family and friends,
Charmy rarely theorised about her painting. Like many of her reviewers
from the 1920s, she adhered to the view that her work offered little or no
intellectual content, that it should be *experienced* rather than theorised over.

While it is tempting to see both Charmy and Colette reclaiming the female
nude for a 'feminine' audience, the active sensuality which Colette finds so
seductive is interpreted in rather different terms by several male critics. In a
review of the 1926 show in *L'Avenir* André Warnod, the editor of the liberal
arts magazine *Comoedia*, described Charmy's nudes as possessing 'a primi-
tive sensuality', which he associated with a bacchanalian sexuality, an 'ani-
mal' instinct. He wrote that these nudes 'have abandoned all coquettishness,
all civilisation. They are drunken priestesses of Bacchus, damned women; on

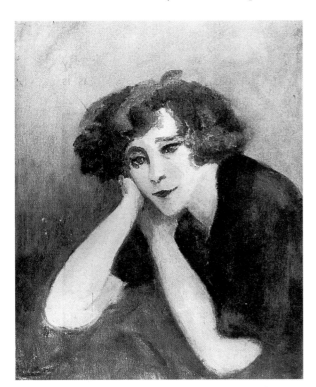

69a Emilie Charmy, *Portrait of Colette*, early 1920s, oil on canvas, private collection

69b *right*
Emilie Charmy, *Sketch for Portrait of Colette*, 1920s, pencil drawing, 18 × 12 cm,
private collection

70 Emilie Charmy, *Sleeping Nude, c.* 1935, pencil drawing, 20 × 29 cm, private
collection

their faces they wore masks'.[56] For Warnod, Charmy's images of the female
body expressed an instinctive, uninhibited sexuality associated with less
civilised societies, they are implicitly identified with the cultural 'other',
which is alien and 'damned' according to civilised Western codes. Warnod's
readings of Charmy's paintings of the nude thus echo a set of associations
well-established in late nineteenth-century painting and literature, associa-
tions which were embodied in various forms in the mythical figures of Eve,
Salome, or in the idea of women as essentially degenerate and as 'primitive'.
This reading of her nudes, which suggests an active, albeit alien, sexuality, is
further qualified in Warnod's review by the notion of a 'feminine' means of
expression. He compares her handling of paint with the coarse, 'brutal'
application of painting by a 'man of instincts' such as Vlaminck, or Van
Dongen. He writes: 'But the virility of her means of expression is in the ser-
vice of a truly feminine sensibility, and a clairvoyance pushed almost to the
point of tragedy when it involves painting a woman.'[57]

 Warnod, then, sustains a contemporary notion that a bold, brutal
application of paint is an essentially male and actively sexual – or 'virile' –

characteristic, but denies Charmy's right to possess such a creative force by placing it in the service of 'truly feminine sensibility'. While the language of Warnod's criticism is infused with sexual metaphors, the creative attributes involved are modified by his knowledge that these are women painted by a woman.

Notes

1 Vauxcelles used the terms '*une forme féminine*' and '*un Marie Laurencin*' in his section on Marie Laurencin in *L'Histoire générale de l'art français, de la Révolution à nos jours*, Librairie de France, Paris, 1922–25, vol. i, p. 321.
2 *Ibid.*, p. 321.
3 René Gimpel, *Diary of an Art Dealer*, Hamish Hamilton, London, 1986, entry for 17 May 1924, p. 260.
4 Vauxcelles, *L'Historie générale de l'art français*, vol. i, p. 322. In an article in *L'Art Vivant* André Salmon provided a similar account of Laurencin's quintessential 'Frenchness'. He wrote of her as: 'Française de sang intact, elle garantit son art de toutes les vertues pratiques de la race', 'Marie Laurencin', *L'Art Vivant*, 5 November 1926, p. 806.
5 For a discussion of the development of Vauxcelles's criticism see Malcolm Gee, *Dealers, Critics and Collectors of Modern Painting: Aspects of the Parisian Art Market between 1910 and 1930*, Garland, New York, London, 1981, p. 138ff.
6 Tamar Garb, *Sisters of the Brush: Women's Artistic Culture in Late Nineteenth Century Paris*, Yale University Press, London and New Haven, 1994, p. 94.
7 *Ibid.*, p. 94.
8 Adolf Basler and Charles Kunstler, *La Peinture indépendante en France*, G. Crès & Cie, Paris, 1929, vol. ii, p. 81.
9 Flora Groult, *Marie Laurencin*, Mercure de France, Paris, 1987, p. 12.
10 In *Picasso and his Friends* Fernande Olivier wrote of Laurencin 'She took a good deal of trouble to appear to be just as simply naive as she actually was'. Quoted in Donald Hall and Pat Corrington Wykes, *Anecdotes of Modern Art*, Oxford University Press, 1990, p. 168.
11 Gimpel, *Diary of an Art Dealer*, entry for 5 Jan. 1922, p. 210.
12 The nature of this Surrealist preoccupation is discussed in Whitney Chadwick, *Women Artists and the Surrealist Movement*, London and Boston, 1985.
13 The Hôtel Drouot sales lists are included in the magazine *L'Esprit Nouveau* from the early 1920s. These lists provide useful information on prices of avant-garde and School of Paris works in the Hôtel Drouot sales from this period.
14 Cited in Musée d'Art Moderne de la Ville de Paris, *Kees Van Dongen*, Paris, 1990, p. 24.
15 *Ibid.*, p. 32. The concept of *maquillage* as a sign for modernity was rooted in Baudelaire's nineteenth-century theories on the representation of woman in his essay *The Painter of Modern Life*. In sections XI 'In Praise of Cosmetics' and XII 'Women and Prostitutes' he constructs a notion of 'modern' beauty which is dependent on artifice: 'face painting should not be used with the vulgar, unavowable object of imitating fair Nature and of entering into competition with youth. It has moreover been remarked that artifice cannot lend charm to ugliness and can only serve beauty . . . Maquillage has no need to hide itself or to shrink from being suspected'. Charles Baudelaire, *The Painter of Modern Life and Other Essays*, Phaidon, London, 1964, pp. 31–8.
16 Briony Fer has examined some of the different psychic and cultural meanings of women's

dress in the Surrealist discourses of the 1920s in her article 'The hat, the hoax, the body', in Kathleen Adler and Marcia Pointon (eds.), *The Body Imaged*, Cambridge University Press, Cambridge, 1993. Fer cites the final words of René Bizet's 1925 book on fashion: 'Le chic est à la femme, ce que le génie est à l'artiste' (p. 163).

17 In the early twenties such magazines included *Modes et Manières d'Aujourd' hui, La Bonheur du Jour ou les Graces à la Mode,* and French and American editions of *Vogue.*

18 Tag Gronberg, 'Cité d'Illusion: Staging Modernity at the 1925 Paris Exposition Internationale des Arts Décoratifs et Industriels Modernes', Ph.D. thesis submitted to The Open University, August 1994, p. 47. Gronberg's thesis includes a fascinating discussion of the contemporary discourse on Paris as a feminised or 'woman's city'.

19 Victor Margueritte (1867–1942) had collaborated with his brother Paul in a series of socio-historical novels about the period of the Franco-Prussian war under the general title *Une Epoque 1898–1904* and in a series of popular children's books. Margueritte was an advocate of female emancipation, for which *La Garçonne* came to be seen as a rallying call. However, the book also reveals a male fear of a liberated female sexuality. As Adrian Rifkin has written: 'Margueritte confected his heroine, Monique Lerbier, out of a tradition of political feminism and out of male sexual tears and fantasies of uncontrolled female sexuality'. *Street Noises: Parisian Pleasure 1900–1940*, Manchester University Press, Manchester and New York, 1993, p. 118.

20 Berthe Weill, *Pan! dans l'œil! Ou trente ans dans les coulisses de la peinture contemporaire 1900–1930*, Lipschutz, Paris, 1933, p. 113.

21 Quoted in François Roussier, *Jacqueline Marval 1866–1932*, Didier Richard, Grenoble, 1987, p. 27.

22 André Warnod, Albin Michel, *Les Berceaux de la jeune peinture: l'École de Paris*, Paris, 1925, p. 228.

23 Guillaume Apollinaire, 'Les Peintresses, Chroniques d'Art', *Le Petit Bleu*, 5 April 1912.

24 Some of the different definitions of the terms 'decoration' and 'decorative' in the period 1895–1925 are discussed in Nancy Troy, *Modernism and the Decorative Arts in France: Art Nouveau to Le Corbusier*, Yale University Press, New Haven and London, 1991. See especially 'Introduction': Modernism and the Decorative Arts', p. 1ff.

25 The historical, cultural and aesthetic associations made between the concepts of the 'decorative' and the 'feminine' in both literary and artistic discourses in the eighteenth century are discussed in Gill Perry and Michael Rossington (eds.), *Femininity and Masculinity in Eighteenth-Century Art and Culture*, Manchester University Press, Manchester and New York, 1994.

26 I discuss some of the Symbolist reworkings of the concept of the 'decorative' in G. Perry, F. Frascina, C. Harrison, *Primitivism, Cubism, Abstraction*, Yale University Press, New Haven and London, 1993, especially pp. 20–21.

27 For a discussion of Matisse's interpretation of the concept of the decorative see Roger Benjamin, *Matisse's Notes of a Painter: Criticism, Theory, and Context 1891–1908*, U.M.I. Research Press, Ann Arbor, Michigan, 1987.

28 I discuss Greenberg's reworkings of the concept in G. Perry *et al.*, *Primitivism, Cubism, Abstraction*, pp. 61–2.

29 M. Raynal, *Anthologie de la peinture en France – De 1906 à nos jours*, Editions Montaigne, Paris, 1927, p. 204. In a footnote to his discussion of Laurencin's work Raynal points out that the influence of Laurencin's work was felt in different ways in the art of fashion design, for the designers Groult and Paul Poiret executed costumes and fabrics after her designs.

30 The various contemporary representations of women in the decorative arts are discussed in
 Gronberg, *Cité d'Illusion*. For a study of gendered perceptions of fin-de-siècle styles see also
 Deborah Silverman, *Art Nouveau and Fin-de-Siècle France: Politics, Psychology and Style*,
 University of California Press, Los Angeles, 1989.
31 Weill, *Pan! dans l'œil*, p. 211.
32 The repetition of the self-portrait in the work of, for example, Gwen John, Paula Modersohn-
 Becker and Käthe Kollwitz has encouraged debate about the different functions of self-
 portraiture in women's art. For a discussion of the role of self-portraiture in the work of
 some women Expressionist artists see Alessandra Comini, 'Gender or Genius? The Women
 Artists of German Expressionism', in Norma Broude and Mary D. Garrards (eds.), *Feminism
 and Art History: Questioning the Litany*, Harper and Row, New York, 1982, p. 217ff.
33 These symbolic associations are discussed in Lynda Nead, *The Female Nude: Art, Obscenity
 and Sexuality*, Routledge, London and New York, 1993, p. 2.
34 Some feminist debates around this issue were set in motion by Carol Duncan's essay 'Virility
 and Domination in Early Twentieth-Century Vanguard Painting', in Broude and Garrard
 (eds.), *Feminism and Art History*, p. 293ff.
35 The historical, cultural and political context of Matisse's *Blue Nude* and what the work might
 have signified in the context of French colonialism and gender relations are discussed in
 James Herbert's excellent book *Fauve Painting: The Making of Cultural Politics*, Yale University
 Press, New Haven and London, 1992.
36 Musée d'Art Moderne de la Ville de Paris, *Kees Van Dongen*, pp. 26, 29.
37 Weill, *Pan! dans l'œil*, pp. 227–9.
38 *Ibid.*, p. 121.
39 A seminal point in the theorisation of the 'gaze' was the publication of Laura Mulvey's essay
 'Visual Pleasure and the Narrative Cinema' in *Screen* in 1975. The essay is included in her
 collection of essays *Visual and Other Pleasures: Language, Discourse, Society*, Macmillan,
 London, 1989, p. 14ff. In this article Mulvey argues that the 'male gaze' is the structuring
 principle for the representation of women (on film), that 'the determining male gaze pro-
 jects its fantasy onto the female figure which is styled accordingly'.
40 Some of these arguments are discussed in Patrica Matthews's article on Valadon, 'Returning
 the Gaze: Diverse Representations of the Nude in the Art of Suzanne Valadon', *Art Bulletin*,
 73:3, 1991, pp. 415–30.
41 I discuss the possibilities of this form of 'mediation' in Matisse's *Blue Nude* in Perry *et al.*,
 Primitivism, Cubism and Abstraction, pp. 58–61.
42 Rosemary Betterton, 'How do women look? The female nude in the work of Suzanne
 Valadon', in R. Betterton (ed.), *Looking On: Images of Femininity in the Visual Arts and the
 Media*, Pandora, London, 1987, p. 217ff.
43 *Joie de Vivre* is in the Metropolitan Museum of Art, New York.
44 'Returning the Gaze', p. 420.
45 *Ibid.*, p. 420.
46 These arguments are developed in the articles cited above by Betterton and Matthews.
47 Matthews, 'Returning the Gaze', p. 418.
48 A selective list of prices obtained for her work during this period is included in the entry in
 E. Bénézit, *Dictionnaire des peintres, sculpteurs, dessinateurs et graveurs*, Gründ, Paris, 1976,
 vol. x.
49 Gybal wrote for a wide range of magazines in the early 1920s, including the avant-garde
 journal *Clarté*. As Briony Fer has shown, Gybal's concept of modernity aligned itself
 with the post-war Cubists and the idea of 'constructiveness'. See Briony Fer, 'Russian Art and

theory in France 1918–25: a comparative study of artistic avant-gardes', Ph.D. thesis submitted to University of Essex, 1987, p. 191.

50 André Gybal, 'Le Nu féminin d'Ingres à nos jours', in *Les Hommes du Jour*, 11 March 1922, p. 2ff.

51 Albeit (in this case) a representation of a black male figure gazing upon a white female body. Marval may have been drawing on some nineteenth-century conventions for the representation of this theme, such as Jules-Jean-Antoine Lecomte du Nouy's *L'Esclave blanche*, 1888, Musée des Beaux Arts, Nantes. (Reproduced in G. Perry *et al.*, *Primitivism, Cubism, Abstraction*, p. 7.).

52 Charmy's possible bisexuality was discussed in an interview (by the author) with her son Edmond Bouche in 1984.

53 In the psychoanalytic writings of Hélène Cixous and Luce Irigaray the concept of an *écriture féminine* is based on the idea of a 'female symbolic', rooted in female identity and libido. The character of Léa, the lover of Chéri, could be seen to suggest an empowered female sexuality in touch with a female libido.

54 Colette, *Quelques Toiles de Charmy – Quelques Pages de Colette*, Galerie d'Art Ancien et Moderne, Paris, 1926.

55 Henri Béraud, in *Comoedia*, 23 Jan. 1926.

56 André Warnod, in *L'Avenir*, 18 Jan. 1926.

57 *Ibid.*

5 Postscript and conclusion

By the late 1920s and early 1930s the works of many of the women artists featured in the preceding chapters were seen as 'modern' alternatives to the avant-garde, albeit alternatives often qualified in critical accounts by expectations of 'feminine' modes of painting. By 1930 Marval and Valadon were already in their sixties, Charmy was in her early fifties and Laurencin in her late forties. Even the younger group of women artists who had been involved on the fringes of Cubism, including Blanchard, Marevna and Halicka, had left behind their Cubist interests and turned towards (then) more marketable forms of 'naturalism' associated with the School of Paris. By the late 1920s Surrealism had emerged as the dominant avant-garde tendency, bringing with it a new concept of artistic radicalism rooted in left-wing politics (many of the early members of the Surrealist group joined the French Communist Party) and committed to undermining bourgeois values. Not surprisingly, many of those critics, including Vauxcelles, Salmon, Raynal and Apollinaire, who had promoted the work of some of these women artists, were critical of developments in Surrealist painting, identifying in it a dominance of literary and psychological interests over 'painterly' and artistic concerns.[1]

Femininity and feminism: Charmy and Valadon

Despite the critical tendency in the 1920s, encouraged (to varying degrees) by the work of these writers, to create a separate category of *les femmes peintres*, we have seen that their work was also often hailed as evidence of the artistic independence and individualism which challenged that of the most fashionable avant-gardism. Thus Vauxcelles saw Laurencin's painting as an acceptable alternative to the Cubism which he disliked, and Salmon saw Charmy as an 'adversary of real merit' for the constructivists. At the time, this sense of 'independence' was adopted as part of the self-image of many of the older group of women artists whose work I have considered in the preceding chapters, especially Charmy and Valadon, who were both

enjoying considerable professional success in the 1920s and 1930s. During this period Charmy was showing regularly in right-bank galleries, was patronised and supported by a wide range of writers and critics, and in 1926 she received the award of *chevalier* of the Légion d'Honneur. In the same honours list, the painter Paul Signac was made a *commandeur* of the Légion d'Honneur. These annual awards, and the associated ceremony, had become something of a self-congratulatory national pageant, and represented the seal of approval by the establishment. Furthermore the decoration usually increased the success and market value of the recipient's work. The award was bestowed on many other School of Paris painters during the twenties, despite the claims which might have been made on their behalf for 'anti-establishment' independence.[2] This approval was further consolidated for Charmy in the series of portraits of politicians belonging to the Radical and Socialist parties which she was commissioned to paint in the 1930s. These included a much publicised portrait of the ex-prime minister and foreign minister, Aristide Briand, on his deathbed in 1932,[3] portraits of Edmond Daladier, a member of the centre 'Radical' party and President of France in 1934–36 (and during the first years of the Second World War) (PL. 71), and Albert Sarrault, another Radical who was president in the mid 1930s.

For Valadon, the period of the mid 1920s was one of the most affluent of her career, particularly after she had signed a contract with Bernheim-Jeune in 1924. She bought a small dilapidated thirteenth-century *château* in Saint-Bernard in the Saone Valley in 1923, where she lived and worked with her partner the painter Utter and her son Maurice Utrillo. During this period Valadon's life was a conspicuous mixture of bourgeois luxury and bohemian non-conformism. Like Charmy she appears to have courted success and some of the bourgeois conventions which came with it, while also disdaining some of the social codes and constraints which it imposed on her life. Her partnership with Utter, who was twenty-one years her junior, and for whom she left her marriage, went against the contemporary codes of bourgeois morality, as did many aspects of her personal and sexual life. Although her work has been easily reclaimed by feminist art history, she did not perceive herself as a feminist, and was sceptical of organised feminism.[4] Valadon is reported to have disliked 'women's art', resisting the opportunity to show with the *Salon des Femmes Artistes Modernes* until 1933, when she was persuaded to contribute by the then President, Marie-Anne Camax Zoegger.

Similar views were held by Charmy, who (according to her family) was not interested in contemporary feminist movements and ideas. There are references in existing material on both Charmy and Valadon which suggest that the two women were good friends, having most likely met through Berthe Weill's gallery and their participation in the 'independent' salons.

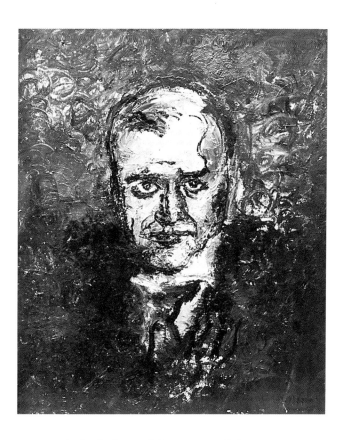

71 Emilie Charmy, *Portrait of
Daladier*, 1930s, oil on
canvas, private collection

Charmy was one of the guests at Valadon's funeral in 1938, and in 1926
Valadon dedicated a still-life with the words: 'To E. Charmy, for her fine
talent'.[5] Their friendship may have encouraged their shared resistance
towards various forms of feminism, despite the possibilities of meaning
which I have considered in the work of both artists. This resistance
was clearly fraught with contradictions, for as I suggested in the preceding
chapter, Charmy's ambivalent sexuality and her friendship with Colette may
have encouraged an interest in producing images of women for women,
focused around the ideas and writings of Colette. Despite the unconven-
tional nature of their personal lives, both Charmy and Valadon were prob-
ably influenced (consciously or unconsciously) by the broader cultural
climate in France between the wars which, even within more liberal social
circles, did not encourage the growth of feminism. Organised feminist
movements were viewed with suspicion by a wide range of social and polit-
ical groups during the first few decades of the twentieth century, although
'the woman question' as it came to be known was attracting wide public
interest. In the wake of the First World War the popularity of the cult of

maternity, which promoted women's roles as mothers and child-bearers, was actively encouraged in a society seeking to repair the social and economic devastation of the war, and coexisted with the cult of the emancipated 'modern' woman. The American writer Janet Flanner believed that the cause of French feminism was thwarted by the predominance of such traditional values. In 1932 she wrote on the failure of the vote for women's suffrage to be passed by the French Assembly:

It would seem a little late to bring up the question of votes for women if the French men weren't a little late in bringing it up themselves. Never has a struggle for civil liberties been so calm. Outside of the aviatrix's having dropped feminist pamphlets on the roof of the Senate to influence the senator's minds, no one would guess that the French sexes are in danger (well, not very much) of being equalised. There is none of the excitement that marked the London and Washington campaigns – nothing, except the hunch that the French women won't get it. Nor do they seem to care. France is still a country given to marriage and little to divorce, where in small shops *Maman* is traditionally the power cashier. And if, as feminists aver, she can't call her soul her own because, whether she loves and honours her husband or not, she must obey, at any rate she can call her wages her own.[6]

We have seen that even within the supposedly liberal bohemian artistic circles which nurtured the avant-garde, women's roles were often ambivalently placed in relation to those of the leading male painters, and there is little evidence that these circles provided a breeding ground for clearly defined feminist ideas. While mythical notions of sexual freedom, *déclassement* and an anti-bourgeois defiance of convention abounded within those bohemian spaces which sheltered the activities of some Fauve, Cubist and School of Paris painters, the testimonies and experiences of many women artists indicate that for them, access to that space was often subject to both professional and sexual negotiation. As I have suggested, the strategies which women artists adopted to enable them to gain status within or alongside these artistic circles were by no means consistent, and often conditioned by the demands of a market largely controlled by male dealers.

It was not until the belated extension of the franchise to French women in 1944 that the French feminist movement could claim a significant victory. It was during the immediate post-war period, in the wake of this major political change, that women's roles in society increasingly came under scrutiny, and there was a noticeable growth in public interest in their professional and artistic achievements. In the years 1945–46 there was a series of shows of work by women painters in public and private galleries in Paris, and in 1946 a huge exhibition at the Palais des Beaux Arts, the *Salon des Femmes Peintres et Sculpteurs* included a retrospective of fifteen canvases

by Berthe Morisot and seven hundred exhibits by contemporary women artists.[7] This profusion of shows by women artists also reflected the social and economic effects of the war. As with the First World War, the war years of 1939–45 had affected the production of many male artists, enabling their female colleagues to occupy some of the professional spaces left open by their absence. However, this post-war shift in attitude did not necessarily bring with it a significant shift in the critical languages available to represent the work of women artists.

The 1946 *Salon des Femmes Peintres et Sculpteurs* was the sixty-second Salon of the *Union des Femmes Peintres et Sculpteurs*, founded in the nineteenth century, which had managed to sustain its exhibiting role, albeit without a high artistic profile, during the first half of the twentieth century. In view of her contribution to Impressionism, the Morisot retrospective helped to give the notion of 'women's art' some historical status and credibility. The 'modern' exhibits by practising women artists included works by Laurencin, Charmy and a long list of artists little known then and now.[8] Despite the aim to allow large numbers of women artists a platform for their art, the sheer quantity and range of exhibits seems to have encouraged a view of women's art as peripheral to more important schools of painting by male artists. Despite the implications of the Morisot retrospective, there was little attempt to discriminate between, or provide information on the history of context of the different forms of artistic production by women artists. The content of the show was thus easily used to confirm the views of many critics, that women artists necessarily occupy a separate area of artistic production, concerned essentially with 'decoration', 'sensibility' and 'delicacy'. Hence the observations of the reviewer in the journal *Arts* who wrote that these women artists showed a markedly superior ability to produce works which were 'mid-way between nature and decoration' and which allowed them to create a 'natural delicacy'.[9]

While the Morisot retrospective takes pride of place in most contemporary accounts of the show, many reviewers describe Charmy as one of the most important living women artists, and her paintings are frequently reproduced in preference to those of Laurencin.[10] For example, Fernande Olivier singles out Charmy as 'one of the most gifted, she plays delightfully with her palette, and her drawing is original, while Laurencin 'is always the same . . . childishness and charm'.[11] Although Olivier was known to have reservations about Laurencin's work, her views are echoed in several other reviews of the show. But of all those contemporary women artists exhibited, it is Laurencin's work which is now best documented. In the preceding chapters I have suggested several reasons why Laurencin has sustained a (marginal) position in many surveys of modern art. I have tried to counter

the argument that Laurencin's work is now better known simply because it has more successfully stood the test of time, citing the role of dealers, the critical perceptions of her relationship with the Cubist group, and the ease with which her work was appropriated into a critical language of difference, as crucial factors in her sustained and relative 'success'.

The current status of Valadon's work, which was also widely exhibited (after her death) during the immediate post-war years, raises some related issues. Despite problems of access, there has been a strong revival of interest in Valadon's work over the last thirty years. As I have suggested, this has been partly encouraged by the growth of feminist art history, which has identified transgressive strategies in her paintings of strong, assertive images of women and the female nude. But despite the vagaries of her financial status, Valadon sustained a reputation during the inter-war years, and the prices which her works fetched are comparable with those of Laurencin during the post-war period.[12] Both pre- and post-Second World War reviews of Valadon's work often focused on the problematic issue of a 'virile' style. Her strong, bold use of form and colour was frequently identified as 'unfeminine' or 'masculine' and therefore difficult for some critics to place, hence the description of her in Le Monde of 1946 as possessing a 'strong quasi-virile talent'.[13] As with some of Charmy's work, her painting was seen to transgress the boundaries of femininity, and in so doing its strength was implicitly derived from its imitation of 'masculine' characteristics. This association was consolidated by the 1960s when the critic Bernard Dorival saw her work as virtually bereft of 'feminine' traits, equating a concept of 'virile' painting with a notion of 'greatness' in art.[14] Valadon's greatness could thus be seen as an exception to her sex. Such critical associations also raise the possibility of a sexualised language of art criticism which, as I have argued in Chapter 4, could carry a particular currency in relation to representations of the female nude. In critical representations of Valadon's work, 'virility' is a borrowed sexual metaphor which itself defines a 'masculine' activity. Moreover, Valadon's professional independence from the work of the Fauve and Cubist avant-garde allowed that appropriation of a 'masculine' language to be safely contained within the category of l'art indépendant. Given her different technical interests, the perceived 'virility' of her art did not threaten the 'masculine' associations of avant-gardism. Although her work seems to have raised some similar critical issues to those provoked by Valadon's paintings, many of Charmy's supporters sought clearly to separate her interests from those of Valadon, sustaining the former's relationship with the 'feminine' camp. In 1963 Roland Dorgelès compared the work of the two artists, suggesting that Charmy had a more imaginative, less arid style: 'Unlike her great friend Suzanne Valadon who is tied to the representation of things in their arid simplicity, she [Charmy]

exorcizes them, marking each subject with her own subtlety'.[15] During the post-war period, then, the language of art history seems to have been no better equipped to explain what were seen to be the contradictions in Charmy's work. I would suggest that it was precisely because her work was not adequately represented for contemporaries by either the category of the 'feminine' (as was Laurencin's work) or the 'masculine' (as was Valadon's) that Charmy's work posed problems for many of the chroniclers of modern French art.

Charmy's longevity has also contributed to the ignorance and confusion which now surrounds much of her work. Her working life spanned over seventy years, and witnessed a succession of much publicised avant-garde developments. She was already approaching forty when Picasso and Braque were exhibiting their early Cubist canvases. By the 1960s, when she was in her eighties, critical interest in her work had faded. This was partly because much of her interesting and original work from the earlier Lyon and Paris periods was by then little known or inaccessible to the art consuming public. Since the Second World War the later canvases, particularly those from the fifties and sixties have been more likely to pass through the hands of French dealers. Her enduring suspicion of dealers and their contracts meant that she often sold to private buyers, and most of her best works are now hidden in private collections.

However, some of the successes which Charmy and other women artists enjoyed in the 1920s and 1930s, when they were co-opted into categories of *l'art indépendant*, prepared the ground for their subsequent demise. I have tried to show how many of the critical approaches of the 1920s, when applied to the work of a range a women artists, were easily adjusted to embrace or to signify notions of an essentially 'feminine' mode of artistic expression. The effect of this critical process was to separate off the meanings of the work of many women artists from the supposedly more profoundly 'expressive' meanings of those produced by male artists, whether they were associated with the artistic vanguard, or the more traditional School of Paris. Thus in 1922 André Gybal identified a separate role of women painters as the conservers of 'sensuality' as against the avant-gardism of contemporary male painters. He wrote: 'Art and science have joined together. But what will become of sensuality? I know what: it is the women, the women painters who conserve it, vestal guardians of the sacred fire. The male painters have become mathematicians; the women have remained women'.[16] I have suggested that despite significant changes in the educational and social opportunities available to women artists during this period, they were constantly confronting some subtly different (and shifting) structures of patronage, professionalism and display to those encountered by their male colleagues.

Strategies of masquerade and the different and sometimes more private languages of feminine artistic production – the *écriture féminine* – adopted in the work of some of these women artists could be seen as a response to some of these structures within which they worked.

In seeking to explore the artistic, professional and personal relationships which some of these women forged with the work and activities of the so-called Fauve and Cubist avant-gardes, I have tried to engage with a wide range of historical, social and artistic sources. I am well aware that I have only scratched the surface of this immense project, and there is much work still to be done. However, my study thus far suggests that it was possible for some women to engage with the artistic projects of early modernism, but that the terms of that engagement were complex, and subject to contradictions and constraints. Moreover, different women artists adopted significantly different strategies of self-representation. While Laurencin cultivated the role of a quintessentially 'feminine' modernist, Charmy's Fauve interests were qualified by her presentation of herself as an 'independent'. These issues have led me to be cautious of adopting or constructing too crude a model of art historical analysis. It is too easy to construct a trajectory of modern art which sets up a masculinist modernist discourse (of the avant-garde) as against an excluded and marginalised group of 'independent' women's art. While their work *was* often marginalised in contemporary and later art history, the artistic spaces which they occupied, and the forms of representation which artists such as Valadon, Charmy, Marval, Marevna, Blanchard or Halicka adopted are not easily accommodated by any existing art historical narratives. What I have described as a 'fragile space' was constantly subject to negotiation and redefinition.

Notes

1 For example, the journal *Cahiers d'Art* in 1927 included a series of articles by critics associated with the Cubist and Purist avant-garde, including M. Raynal and E. Tériade, which criticised Surrealist painting in these terms. For a discussion of the work of women artists associated with the Surrealist movement see Whitney Chadwick, *Women Artists and the Surrealist Movement*, London and Boston, 1985.

2 Several of Charmy's friends, including Roland Dorgelès were also made '*chevaliers*' that year. Utrillo was awarded the Légion d'Honneur in 1928.

3 Briand began his political life as a socialist, but later adopted a more centrist position. He held ministerial positions, including the post of prime minister, in the pre-war and war-time government and was foreign minister from 1926–32. After his death the government set up a subscription for a monument to Briand to be erected in the centre of Paris. In July 1932 *Le Petit Parisien* published a tribute to the politician which included a reproduction of Charmy's portrait.

4 According to Wendy Roche, who has done extensive research on Valadon's life, she consis-

tently rejected the label 'feminist'. Janine Warnod even describes 'Valadon's misogyny' in *Suzanne Valadon*, Bonfini Press, Naefels, 1981, p. 85.

5 It is likely that the gift of a flower painting (*Bouquet de Fleurs, dans un verre*) was intended as tribute to Charmy's talent in that genre. I am grateful to Wendy Roche for providing me with information on this dedication.

6 Janet Flanner, *Paris was Yesterday 1925–1939*, Angus and Robertson, London 1973, p. 82. For an excellent account of developments in French feminism during this period, see Christine Bard, *Les Filles de Marianne: Histoire des féminismes 1914–1940*, Arthème Fayard, Paris, 1995.

7 Between 1945 and 1946 there were many shows of the work of women artists in private galleries. Valadon, Marval, Charmy and Laurencin were all featured in shows, and in 1946 Charmy had a one-woman show at the Galerie Raspail.

8 Names which featured in contemporary reviews include Lily Steiner, Geneviève Capron, Andrée Joubert, Inès Barcy, Kate Munzer, Flordavid, Suzanne Tourte, Henriette Groll.

9 *Arts*, 15 Mar. 1946.

10 See, for example, review in *Arts*, 18 Jan. 1946.

11 Fernande Olivier, 'Le Salon des femmes peintres et sculpteurs', in *La Revue Moderne et de la Vie*, 1 Mar. 1946.

12 For information on the prices fetched by the work of both artists, see entries for both in E. Bénézit, *Dictionnaire des peintres, sculpteurs, dessinateurs et graveurs*, Gründ, Paris, 1976.

13 *Le Monde*, Apr. 1946.

14 Quoted in Warnod, *Suzanne Valadon*, p. 88.

15 Roland Dorgelès, introduction to catalogue *Emilie Charmy*, Galerie Paul Petridès, Paris, 1963.

16 A. Gybal, 'Le Nu féminin d'Ingres à nos jours', in *Les Hommes du Jour*, 11 Mar. 1922.

APPENDIX 1 Biographical information on *les femmes peintres*

Please note that the list of sources provided with biographical information is not intended to be comprehensive; texts cited are recommended or useful sources.

Alice BAILLY

Born Geneva, 25 February 1872; died Lausanne, 1 January 1938.

Studied at the *École des Beaux Arts* in Geneva, and obtained a grant to study in Munich, and then returned to Geneva where she took a post teaching drawing at a school. She soon left the school and took a study trip to Naples. After returning to Geneva, she left for Paris in 1904, at the age of thirty-two. She worked for ten years in Paris, based in Montparnasse. During this period she produced many coloured wood-engravings, including her *Scènes Valaisannes* which she showed at the *Salon d'Automne* of 1906. She showed again at the *Salon d'Automne* in 1908, where her *Maternité* was placed in the Salon des Fauves. Her work was influenced by Cubism, and she worked with artists including Dufy, Gleizes, Picabia, Laurencin, Gris and Lévitzka. Her adaptation of Cubist techniques is demonstrated in *Fantasie équestre de la dame en rose* in the *Salon d'Automne* (1909/10?), of which Apollinaire wrote, 'Through her modern technique Alice Bailly expresses great freshness of feeling' (Vergine, p. 71). She showed at the *Salon des Indépendants* in 1911. In 1914 she executed *Marval au bal Van Dongen* and *Le Thé*. She returned to Geneva during the war in 1916. The same year she developed a form of painting which she called *tableau laines*, which she used in around forty canvases produced up to 1922. She returned to Paris for a year in 1921–22. During her last years in Switzerland she produced eight wall panels for the foyer of the *Théatre de Lausanne*. Shortly before her death she established the Foundation Alice Bailly, designed to provide student grants for Swiss artists.

Sources: Georges Peillex, *Alice Bailly*, Editions Pierre Cailler, Geneva, 1968; Paul André Jaccard, 'Alice Bailly et l'introduction du Cubisme en Suisse', in *Études de Lettres*, Lausanne, 1975; Lea Vergine, *L'autre moitié de l'avant-garde 1910–1940*, des femmes, Paris, 1982, pp. 71–2.

Maria Gutierriez BLANCHARD

Born Santander, 1881; died Paris, 6 April 1932.

Her Spanish father was a respected amateur painter and her mother's family was half Polish, half French. A prenatal accident caused physical disabilities. At the age of eighteen she went to Madrid where she had private art tuition. In 1909 she moved to Paris to study art, thanks to a grant from Santander. She studied with Marie Vassiliev and attended the *Academy Vitii* under the Spanish painter Angalada and Van Dongen. During this period she became familiar with Cubist developments, which were to influence her later work. In 1913 she returned to Spain, where she accepted a post as professor at a school in Salamanca. Some of her canvases from this period reflect her growing mystical interests, including *La Première Communiante*, painted in Madrid in 1914, which created a stir when it was exhibited at the *Salon d'Automne* of 1921 (and bought by Paul Rosenberg). She also worked on subjects from the Madrid suburbs, still-lifes and children. She returned to Paris in 1916, where she met Picasso and a fellow Spanish painter Gris. She also became friendly with Lhôte, La Fresnaye, Metzinger and Lipchitz, who encouraged her work. She developed a close working relationship with Juan Gris, with whom she sometimes collaborated on the same canvases. During this period she produced a series of works influenced by Cubism, and became involved with the *Section d'Or group*. Her Cubist works from the years 1916–19 were all bought up by Léonce Rosenberg, without gaining public recognition. During this period she often signed her works M.G.B. She showed at the *Salon des Indépendants* between 1920 and 1922. In her later works she returned to the theme of the human figure, causing Lhôte to write, 'Her compositions reserve for the human figure, which is bannished from Cubism, a regal position' (Bénézit, vol. ii, p. 68). In 1927 the dealer Max Berger became interested in her art. She had problems supporting her sister and her two children, and Maurice Raynal wrote of her, 'Always confronting bad luck and difficulty' (Bénézit, *ibid.*). But her reputation waned in France, and she turned to religion, encouraged by Isabelle Rivière and a Dominican priest. Religious concerns and illness dominated her last days, and she died in Paris in 1932.

> **Sources:** *Maria Blanchard*, Waldemar George, Paris, 1928; *Maria Blanchard*, Isabelle Rivière, Paris, 1934. See also P. Cabanne, *L'épopée du cubisme*, Table Ronde, Paris, 1963, p. 278; Musée Municipal de Limoges, *Hommages à Maria Blanchard*, 1965; Lea Vergine, *L'Autre Moitié de l'avant-garde, 1910–1940*, des femmes, Paris, 1982, p. 73; Liliane Caffin Madaule, *Maria Blanchard: Catalogue Raisonné*, 2 vols., Editions Caffin Madaule, London, 1994; E. Bénézit, *Dictionnaire des peintres, sculpteurs, dessinateurs et graveurs*, Gründ, Paris, 1976.

Emilie CHARMY

Born, Saint-Étienne, 1878; died Paris, 1974.

She was one of three children born to a middle-class family which owned a local iron foundry. She was boarded out with a wet nurse until she was four. Orphaned in her early teens she went to live with relatives in Lyon, where she qualified to be

a teacher, and took private art lessons with a well-known local artist called Jacques
Martin. In 1902/3 she moved with her older brother Jean to Paris, where they rented
a house in Saint Cloud, and a studio for Charmy in the Place Clichy. She soon
began to exhibit at the *Salon des Indépendants* and the *Salon d'Automne*, and her
work was first noticed by Berthe Weill in 1905. She developed a brightly coloured,
freely painted style of painting closely associated with so-called Fauve techniques
and became friendly with many Fauve painters. She spent the summer of 1906 in
Corsica with Camoin. In the 1910s she exhibited regularly with Berthe Weill and
established a reputation as a 'Fauve' painter. In 1908 she and her brother moved
into central Paris, to a large apartment in the rue de Bourgogne, where she also
had studio space. Her brother soon left Paris, and this apartment remained
Charmy's home and work place throughout her life. In 1912 she first met the painter
Georges Bouche, who had seen her work and, presuming it to be painted by a man,
asked to make the artist's acquaintance. Charmy and Bouche became romantically
involved and spent the summer of that year in his farmhouse in Marnat in the hills
of the Auvergne, which still belongs to her surviving family. She gave birth to his
son, Edmond, in 1915, although the relationship with Georges had already cooled,
and the baby was sent out to live with a wet nurse in Étampes, north of Paris. By
the late 1910s Charmy's work was becoming quite well known, particularly within
those circles associated with the School of Paris, and during the 1920s it was fea-
tured in many exhibitions in left and right bank galleries. In 1927 she was made a
chevalier of the Légion d'Honneur, and in the twenties and thirties she was com-
missioned to do portraits of many well-known artists, writers and politicians,
among them Rouault, Colette and Briand. She married Georges Bouche in 1935 in
order to give Edmond legitimate status. She continued throughout her career to
produce work which was known for its thick impasto, boldly applied, but from the
1920s onwards she increasingly dissociated herself from the interests of various
'avant-garde' movements, reworking the themes for which she had been known
early in her career, in particular female nudes and flower paintings. She continued
to paint during the period after the Second World War, when she was already
approaching her seventies. She died in 1974 at the age of ninety-four.

Sources: Galeries d'Oeuvres d'Art, *Charmy: Toiles*, June 1921; Patrick Seale
Gallery, *Emilie Charmy: 1878–1974*, London, 1980; G. Perry, 'Emilie Charmy
. . . sees like a woman and paints like a man', catalogue introduction to Kunsthaus
Bühler, *Emilie Charmy 1878–1974*, Stuttgart, 1991.

Sonia DELAUNAY

Born Ukraine, 14 November 1885; died 1979.

Adopted by her maternal uncle, Henri Terck, when aged only five, she lived and
went to school in St Petersburg. In 1903 she went to Karlsruhe to study drawing,
and in 1905 she moved to Paris. Here she studied at the *Académie de la Palette*,
where her colleagues included Ozenfant, Dunoyer de Segonzac and Bousingault.
Around 1906–7 she began to paint brightly coloured Fauve type canvases influenced

by Van Gogh and Gauguin. She held her first exhibition in 1908 at the gallery of W. Uhde. In 1909 she married Uhde (a marriage of convenience to allow her to gain French citizenship) and became interested in Cubist developments in art. That year she also met Robert Delaunay, and in 1910 she divorced Uhde and married Robert. They moved to rue des Grands-Augustins where they shared a studio until 1935. In 1911 their son Charles was born, and Sonia did her first patchwork fabrics (*tissus appliqués*). Apollinaire lived with the Delaunays for several weeks at the end of 1912. Her first studies of light, including *Étude de lumière* and *Boulevard Saint-Michel*, appeared in the years 1912–13, when she also produced her first works on the laws of simultaneity, such as *Contrastes simultanés*. In 1913 she sent twenty works to the First German Autumn Salon (Erster Deutscher Herbstsalon). In 1914 she showed her *Prismes éléctriques* (COL. PL. 19) at the *Salon des Indépendants*. After Charles became seriously ill, the Delaunays decided to move to Madrid in 1914. With the outbreak of the Russian revolution in 1917, Sonia Delaunay lost her source of income and increasingly earned her living as a decorative artist, working on designs for Diaghilev in 1918. The Delaunays returned to Paris in 1920, and over the next few years she worked on clothes and fabric designs, and continued to produce paintings. In 1931 she joined the *Abstraction Création* group and in 1932 she published *Les Artistes et l'Avenir de la Mode*, advocating ready-to-wear fashion.

> **Sources:** Bibliothèque Nationale, *Sonia et Robert Delaunay*, Paris, 1977; Sonia Delaunay, *Nous irons jusqu'au soleil*, Robert Laffont, Paris, 1978; Arthur Cohen (ed.), *The New Art of Colour: The Writings of Robert and Sonia Delaunay*, Viking Press, New York, 1978; Peter-Klaus Schuster, *Delaunay und Deutschland*, Du Mont, Köln, 1985; Musée d'Art Moderne de la Ville de Paris, *Robert et Sonia Delaunay*, Paris, 1989.

Alice HALICKA

Born Krakow, Poland, 20 December 1895; died Paris, 1975.

Born into an affluent middle-class family. Her father was a doctor, and her mother died when she was seven years old. She spent part of her childhood with her maternal grandparents in southern Tyrol. After school, she went to Munich to study painting at the academy under the Hungarian painter Simon Hollosy. She was drawn to Paris, and moved there in May 1912, when she frequented the *Académie Ranson* where Maurice Denis and Paul Sérusier were teaching. At the end of 1912 she met Louis Marcoussis, also of Polish origin, whom she later married. Their home was visited by Apollinaire, Max Jacob, André Salmon, Maurice Raynal, Braque, Gris and Dufy, and subsequently by members of the Surrealist group. She participated in the *Salon des Indépendants* of 1914. Apollinaire noticed her works in his review in *Soirées de Paris*. The same year Marcoussis left for the army, returning after the armistice. During this period her work was influenced by Cubism, and included portraits of André Gide and Zborowski who later became her dealer. After his return from war Marcoussis discouraged Halicka from signing a contract with Zborowski, and from following her Cubist interests. She destroyed many of her

canvases from this period and left some others in a house in Normandy, to which she returned in her last years. In 1919 she worked on fabric designs. From 1920 she exhibited at the *Salon des Indépendants*, the *Salon d'Automne*, the *Salon des Tuileries* and the *Salon des Surindépendants*. In the early twenties she travelled to Poland and London, where she saw Roger Fry, Vanessa Bell and Duncan Grant. Following a successful show at the Galerie Druet in 1924, she wrote: 'I am forcing myself more and more to concentrate exclusively on the problems of form, colour and values (*valeurs*) in painting, without being pushed towards literature, anecdotes or popular prints, which are so much in fashion' (Vergine, p. 77). In 1924 she had her first exhibition of a collage series called *Romances capitonnées*, which included paper, material, feathers and bric-à-brac. In 1925 she illustrated *Enfantines* by Valery Larbaud and *Les enfants du ghetto* by Zangwill. Her exhibitions included Galerie Georges Petit, Paris, 1930 and 1931; Leicester Gallery, London, 1934. She was in America between 1935 and 1938, and she organised two shows in New York: M. Harriman Gallery, 1936 and Galerie Levy in 1937. She designed several ballet sets in New York, including those for the ballet *Jardin Publique* from the novel by Gide, which was performed at the Metropolitan Opera New York, and Covent Garden London.

She spent the Second World War in France. In 1945 she was in Paris preparing for an exhibition and in 1946 she published a book of memories *Hier*, which described some of her experiences in the art world. There were exhibitions of her work in France in the 1950s and 1960s.

Sources: Maurice Raynal, *Anthologie de la peinture en France – De 1906 à nos jours*, Editions Montaigne, Paris, 1927, pp. 187–90; Alice Halicka, *Hier*, Du Pavois, Paris, 1946; Jeanine Warnod, 'Alice Halicka et ses souvenirs', in *Terre Europe*, 48, May 1974, Brussels; L. Vergine, *L'Autre Moitié de l'avant-garde 1910–1940*, des femmes, Paris, 1982, pp. 76–7; Ville de Vichy, *Alice Halicka 1895–1975: Periode Cubiste (1913–20)*, Salle de la Restauration, Vichy, 1988.

Jeanne HÉBUTERNE

Born 1898; died Paris, 1920.

Studied at the *Académie Colarossi* and the *École des Arts Décoratifs*, and became interested in Fauve techniques in the 1910s. She was Modigliani's partner from 1917, and gave birth to his daughter Jeanne in November 1918. She was friendly with the artist Marevna who included Hébuterne in her retrospective group portrait, *Homage to Friends from Montparnasse* (COL. PL. 21). Her career was cut short by her premature death shortly after that of Modigliani in 1920. She threw herself off a fifth floor balcony carrying her second child fathered by Modigliani.

Source: Patrice Chaplin, *Into the Darkness Laughing: The Story of Modigliani's Last Mistress Jeanne Hébuterne*. Virago, London, 1990.

Louise HERVIEU

Born Alençon, 28 October 1878; died 11 September 1954.

Known for her paintings, drawings, illustrations and writings, she suffered from a hereditary illness. She first became known as a painter in 1910, but exhibited rarely. In 1920 and 1922 she illustrated Baudelaire's *Fleurs du Mal* and *Le Spleen de Paris*, and in 1948 she illustrated Verlaine's *Les Liturgies Intimes* with drawings of sensual nudes. She produced many albums of drawings, and illustrated her own texts, which included *Lettres à Geneviève* and *Vingt nus*. She also participated in the illustration of *L'Âme du cirque* with Bonnard, Bourdelle, Maurice Denis and Dunoyer de Segonzac. As a result of her illness she later gave up paintings for charcoal drawing, a technique for which she became renowned.

Source: René Huyghe, *Les Contemporains*, Tisné, Paris, 1949.

Marie LAURENCIN

Born in Paris, October 1883; died Paris, 8 June 1956.

Her mother, Melanie-Pauline Laurencin came from a Creole family, but Marie knew nothing about her father. After schooling at the *Lycée Lamartine*, she studied art at the *Académie Humbert*. She also studied to be a porcelain painter at the *École de Sèvres*, but in 1907 Georges Braque, a fellow pupil at the *Académie Humbert*, introduced her to Picasso's circle around the *Bateau Lavoir* and the rue Ravignon, the group commemorated in two versions of *Apollinaire et ses amis*, 1908 (one of these belonged to the writer and critic Apollinaire, and is now in the *Musée National d'Art Moderne, Paris*, COL. PL. 16). She lived with Apollinaire until 1912. Laurencin showed in the *Salon des Indépendants* of 1907, and Apollinaire mentioned her work in reviews in the following years. In 1910 he described her exhibits in the *Salon des Indépendants* as 'Cubist', and in the following year two of her works were hung in the famous Cubist exhibition in room 41. In 1912 her work was included in the *Section d'Or* show at the *Galerie La Boétie*, and in 1914 she worked on the decoration of the *Maison Cubiste* designed by Raymond Duchamp-Villon and André Mare.

Married Otto von Waetjen, a German artist and fellow student at the *Académie Humbert*, in June 1914, but the outbreak of war forced them to seek refuge in Spain. While in Madrid she co-edited the Dada magazine *391* with Picabia, Gleizes and Arthur Cravan, although her work shows no trace of this contact with Dada. After the war Laurencin spent a year in Düsseldorf, where she designed wall-papers for André Groult, and where she filed for divorce, before returning to Paris in 1920. By 1921 she was well established as an artist with a growing reputation. She developed close friendships with Nicole Groult, a dress designer (sister of Paul Poiret and wife of André Groult) and with Armand Lowengrand, who worked for the profitable art dealers the Duveen brothers. Lowengrand became a friend and companion for many years. She also became friendly with Lowengrand's uncle, the art dealer René Gimpel.

In 1923 Laurencin started work on designs for the decor and costumes of Francis Poulenc's ballet, *Les Biches*, commissioned by Diaghilev. The ballet was first performed in Monte Carlo in 1924 and was an international success. Many other

decorative commissions followed. In her paintings from the 1920s onwards she ignored contemporary avant-garde developments, and continued to produce delicately coloured portraits and still-lifes throughout her life. Despite periods of ill health, she continued painting until she was nearly 70. She died in June 1956 following a heart attack.

Sources: (there are many publications on Laurencin and her work; the following is a selection of useful sources): Roger Allain, *Marie Laurencin*, Editions de la Nouvelle Revue Française, 1921; Marcel Jouhandeau, *Marie Laurencin*, Editions Quatre Chemins, Paris, 1928; George Day, *Marie Laurencin*, Paris, 1947; René Gimpel, *Diary of an Art Dealer*, Hamish Hamilton, London 1986; Marie Laurencin, *Les Carnets des Nuits*, Geneva, 1956; Charlotte Gere, *Marie Laurencin*, Academy Editions, London, 1977; Daniel Marchesseau, Marie Laurencin: *Catalogue Raisonné de l'œuvre grave*, Kyuryodo, Tokyo, and Alan Wofsy Fine Arts, San Francisco, 1981; Daniel Marchesseau, Marie Laurencin: *Catalogue Raisonné of the Paintings*, Alan Wofsy Fine Arts, San Francisco, 1986; Flora Groult, *Marie Laurencin*, Mercure de France, Paris, 1987; Julia Fagan King, 'United on the threshold of the twentieth-century mystical ideal: Marie Laurencin's integral involvement with Guillaume Apollinaire and the inmates of the Bateau Lavoir', *Art History*, 11:1, Mar. 1988; Douglas K. S. Lyland and Heather Mcpherson, *Marie Laurencin, artist and muse*, exhibition catalogue Birmingham, Alabama, 1989; Elisabeth Coutuvier, 'Marie Laurencin: mémoires d'une jeune fille rangée', *Beaux Arts*, Dec. 1993, pp. 96–101.

MAREVNA

Born in Russia, 14 February 1892; died Ealing, London, 1984.

Born Maria Vorobëv, she was later named 'Marevna' (`Marie, daughter of the sea') by the poet Maxim Gorky. Her mother was an Israeli actress and at the age of two she was adopted by the Polish aristocrat Bronislav Stebelski, with whom she lived until the age of eighteen. She was born in the Department of Kazan and then spent several years in the Caucasus. At the age of fifteen she enrolled at the Academy of Tiflis, and at eighteen she went to Moscow where she attended the School of Decorative Arts and the Free Academy. Here she had her first contact with contemporary French painting. She travelled in Europe and was the guest of Maxim Gorky in Capri, and was first named 'Marevna'. She travelled to Rome and then Paris in 1912, where she studied at the *Académie Zuluaga*, the *Académie Colarossi* and the *Académie Russe*. With Maria Blanchard, with whom she became friendly, she was among several women artists who developed Cubist styles, and she exhibited in the 1913 *Salon des Indépendants*. After the suicide of her adopted father in 1914 which left her disturbed and without financial support, she became depressed, and left for a holiday in Italy, returning in 1915. She established strong personal and artistic relationships with many Paris-based artists, including many Russian *émigrés* who helped her sell works to the organisers of the A.A.A. (*Aide Aux Artistes*) and around 1918 became involved with the Mexican artist Diego Rivera who fathered

her daughter Marika born in 1919. Her work from this period often includes figures broken down into geometric forms, and is clearly influenced by synthetic Cubism. In 1919 she showed at the *Salon d'Automne* and at the *Tuileries.*

During this period she formed close friendships with many artists and writers living or working around Montparnasse, including Kisling, Soutine, Modigliani and his partner Jeanne Hébuterne, Max Jacob, Apollinaire, Ilya Ehrenburg, Ozenfant, Gris, Zadkine, Voloshinov, Van Dongen and Picasso, who painted Marevna's portrait and is reported to have said to her 'We will turn you into an even greater artist than Marie Laurencin' (in *Marevna and Montparnasse*, Wildenstein, London, 1992). From 1920 onwards she struggled with financial and personal problems, and moved from Cubism to Neo-Impressionism, sometimes combining both styles in her work. She exhibited at Gustav Kahn's '*Quotidien*' in 1929, and at Zborowski's in 1936. She had exhibitions in Paris in 1942 and 1953, at the Lefèvre Gallery, London, in 1952, and at New York's Guggenheim Museum in 1968. In 1947 she moved to England, where she died in 1984 at the age of 92.

> **Sources and exhibitions:** Marevna Vorobëv, *Life in Two Worlds*, Abelard-Schuman, London, 1962; *Marevna*, Georges Peillex, Musée du Petit Palais, Geneva, 1971; Marevna Vorobëv, *Life with the Painters of La Ruche*, translated from the Russian by Natalia Heseltine, Macmillan, London, 1974; Marevna Vorobëv, *Mémoires d'une nomade*, Encre, Paris, 1979; *Marevna and Montparnasse*, Wildenstein, London, 1992.

Jacqueline MARVAL

Born at Quaix near Grenoble as Marie-Josephine Vallet on 19 October 1866; died in Bichat, 28 May 1932.

Both parents were school teachers, and her father was an amateur musician and painter. In 1884 she qualified as a school teacher, and began to paint under the name Marie Jacques. In 1886 she married Albert Valentin, a travelling salesman. In 1891, after the death of her baby son, the marriage broke down. In 1895 she moved to Paris and lived in Montparnasse with the painter Jules Flandrin. Attended classes at Gustav Moreau's studio where she made friends with Matisse, Marquet and Rouault.

In 1900 she adopted the name Jacqueline Marval. Her works were rejected by the *Salon des Artistes Français*, but bought by Vollard. In 1901 she exhibited ten paintings at the *Salon des Indépendants*. In 1902 Berthe Weill showed her work in a group show with Matisse, Marquet and Flandrin. The following year Marval exhibited in the first *Salon d'Automne*, including her *Les Odalisques* 1902–3 (now in the Grenoble Museum of Art: COL. PL. 9). Exhibited in several group shows at Berthe Weill's over the next few years when her nudes attracted attention. In 1913 *Les Odalisques* was shown in the New York Armoury show. In the same year Marval worked on decorations for the *Théatre Champs Elysées* with Vuillard, Bourdelle, Denis.

In 1914 Marval and Flandrin moved into 40 rue Denfert Rochereau, next door to her friend Van Dongen. Van Dongen held his famous ball – a Parisian society

event – in the same year. During the war she spent time helping to look after children of artists at war. She moved to 19 Quai St Michel in 1917, when she participated in an exhibition of contemporary art at the Galerie Georges Petit. In 1919 she and Flandrin separated. From 1919 to 1931 she showed regularly at the *Salon d'Automne*. During this period she was also showing with Weill, Druet and Katia Granoff. She suffered from cancer during her later years, and died in the hospital at Bichat in 1932.

> **Sources and exhibitions:** Andry-Farcy, *Jacqueline Marval*, Editions Albert Morancé, Paris, 1929; Grenoble, *Jacqueline Marval, extrait du Bulletin de l'Académie Delphinale, 1944–1946*, Allier, 1948; François Roussier, *Jacqueline Marval 1866–1932*, Editions Didier Richard, Grenoble, 1987; *Jacqueline Marval (1866–1932)*, Crane Gallery, London, 1989.

Mela MUTER

Born Warsaw, 26 April 1876; died Paris, 4 May 1967.

Melania Mutermilch was born into a wealthy Jewish family in Warsaw, where she received a classical education and showed an early talent for drawing and painting. In 1901 she moved to Paris to study at the *Académie Colarossi*. She soon associated with artists around Montparnasse, and in 1902 (aged twenty-six) she was invited to participate in the *Salon National des Beaux-Arts*. In 1905 she showed for the first time at the *Salon des Indépendants* and the *Salon d'Automne*. During the pre-war period she continued to paint in a strong, boldly coloured naturalistic style, similar to that of Valadon. She painted many portraits of well-known figures, among them the musicians Erik Satie, Maurice Ravel and Albert Roussel, the writers Romain Rolland, Henri Barbusse, Georges Courteline, the poets Hindou, Sir Rabindranath Tagore and Rainer Maria Rilke, the architect Auguste Perret, political figures including her close friend the communist Paul Vaillant-Couturier, and the French President, Georges Clemenceau.

She painted Vollard's portrait in 1916. In 1927 she took French citizenship, and in March of the same year the writer Robert Rey praised her work in an article in *Arts et Décoration*. She won a gold medal at the Exposition Universelle in 1937. During the war of 1939–45 she left Paris for Avignon, where she hid for fear of being imprisoned for her Jewish origins and her left-wing political views. Apart from this period she lived all her life in Paris, where she died aged 91 in 1967.

> **Sources:** Chris Petteys, *Dictionary of Women Artists*, Boston, Mass., 1984; Petit Palais, Musée d'Art Moderne, Geneva, *Mela Muter 1876–1967*, Geneva, 1987.

Suzanne ROGER

Born in Paris, 1899; died 3 January 1986.

After a classical education, she travelled in Italy, where she was impressed with Florentine painting. She exhibited from 1920 onwards. She was a friend of Juan Gris and was influenced by Cubist developments. George Limbour said of her

painting that it reminded him of 'un Fernand Léger féminin' (Bénézit, vol. x, p. 46). Despite the Cubist influences her work remained largely figurative, often inspired by contemporary historical events, such as in her scenes of the Liberation from 1945–46, or her riot scenes of 1968. She showed at the *Salon des Surindépendants*, and with other groups. She married the painter André Baudin.

> **Sources and exhibitions:** Maurice Raynal, *Anthologie de la peinture en France – De 1906 à nos jours*, Editions Montaigne, Paris, 1927, pp. 275–8; Bernard Dorival, *Peintres Contemporaines*, Mazenod, Paris, 1964; Georges Limbour, *Suzanne Roger*, Exhibition catalogue, Galerie Louise Leiris, Paris, 1969; Chris Petteys, *Dictionary of Women Artists*, Boston, Mass., 1984.

Suzanne VALADON

Born Bessines-sur-Gartempe, 23 September 1865; died Paris, 7 April 1938.

Born Maria Clementine in Bessines in the department of Haute Vienne to Madeleine Valadon, a sewing maid, and an unknown father. Shortly after Suzanne was born, Madeleine left her poor rural background to find work in Paris. Around 1870 they settled in the boulevard Rochechouart in Montmartre, and Madeleine found work as a cleaner, sending her daughter to a convent school. Valadon left school aged eleven, and subsequently worked as a milliner's apprentice, sold vegetables at Les Halles and became a waitress in a restaurant. As a teenager she got to know many of the artists then associated with Montmartre, who introduced her to the Mollier circus, where she fell from a trapeze. She haunted many of the bars of Montmartre, and between 1880 and 1885 began working as a model, sitting for artists such as Puvis de Chavannes, Renoir, Henner, Inais, and Toulouse-Lautrec.

Her first known works, including a pastel self-portrait, date from 1883. In the same year she gave birth to her son Maurice Valadon, and in 1891 the Spanish artist and journalist Miquel Utrillo y Molins acknowledged him as his son (although other names have been suggested as Utrillo's father). Around 1890 she became friendly with Degas who encouraged her work (which was largely drawn in lead pencil, charcoal, and red chalk at this time). Her first known oil paintings are from 1893, and she submitted drawings to the *Salon de la Nationale* in 1894. In 1896 she married Paul Mousis, a well-off chief clerk, and they spent their time in the country outside Paris at Pierrefitte. Between 1896–1909 she devoted much time to painting. Utrillo began to show signs of alcoholism. Some of her work was sold by Le Barc de Boutteville and Vollard. In 1909 she met the artist André Utter, one of her son's friends. She filed for divorce and went to live with Utter. The same year she exhibited at the *Salon d'Automne*.

In 1910 she began painting large allegorical canvases influenced by Puvis de Chavannes, including *The Joy of Living*, which was shown at the *Salon d'Automne* in 1911. She also showed six works in the *Salon des Indépendants*. She had her first one-woman show at the *Galerie Clovis Sagot*. She continued to show annually at both independent Salons and married André Utter in 1914. In 1915 she had a one-woman show at the *Galerie Berthe Weill*. During the post-war period she was very

productive, painting many portraits, nudes and still-lifes, and was widely exhibited.
In 1923 she bought a castle at Saint-Bernard in the Saone valley. In 1924 she signed
a contract with Bernheim-Jeune, who bought a house in Paris for Utrillo and his
family at 12 avenue Junot in 1926. By 1928 Valadon had achieved an international
reputation. She had her most important retrospective exhibition at the Georges Petit
Gallery in 1932, but there were almost no sales. She painted less in the 1930s when
her relationship with Utter had broken down. She increasingly suffered from ill-
health, and died of a stroke on 7 April 1938.

> **Sources** (there are many publications on Valadon and her work; the following is
> a selection of useful sources): André Tabarant, 'Suzanne Valadon et ses souvenirs
> de modèle', *Bulletin de la vie artistique*, Paris, 15 Dec. 1921, pp. 626–9; Robert Ray,
> *Suzanne Valadon*, Paris, 1922; Adolf Basler, *Suzanne Valadon*, Crès, Paris, 1929;
> Suzanne Valadon and Germain Bazin, *Suzanne Valadon par elle-même*,
> Prométhée, Paris, 1939; Galerie Georges Petit, *Suzanne Valadon* (with an intro-
> duction by Edouard Herriot), Paris, 1932, John Storm, The Valadon Drama,
> E. P. Dutton & Co., New York, 1959; Paul Pétridès, *Catalogue raisonné de
> l'œuvre de Suzanne Valadon et avant propos*, Compagnie française des arts
> graphiques, Paris, 1971; Janine Warnod, *Suzanne Valadon*, Bonfini Press, Naefels,
> Switzerland, 1981; Rosemary Betterton, 'How do Women Look? The Female Nude
> in the Work of Suzanne Valadon', in R. Betterton (ed.), *Looking On: Images of
> Femininity in the Visual Arts and Media*, London and New York, 1987; Sarah
> Bayliss, *Utrillo's Mother*, Pandora, London, 1987; Patricia Matthews, 'Returning
> the Gaze: Diverse Representations of the Nude in the Art of Suzanne Valadon',
> *The Art Bulletin*, 72:3, Sep. 1991, pp. 415–30; Thérèse D. Rosinsky, *Suzanne
> Valadon*, Rizzoli, New York, 1994.

Marie VASSILIEV

Born Smolensk, February 1884; died Nogent-sur-Marne, 1957.

Studied in St Petersburg in 1902 at the Faculty of Medicine and the School of
Fine Art. In 1905 she received a grant to study in Paris, returning there in 1907. A
Russian friend who worked on the Moscow review *Zolotoe Runo* introduced her to
Matisse, with whom she studied in 1907. She exhibited in St Petersburg in 1908, and
in 1909 she founded the *Académie Vassiliev* in Paris. She associated with the circle
around the *Bateau Lavoir*, and produced many Cubist influenced works during the
period before the First World War, when she participated in many exhibitions
including the *Indépendants* and the *Salon d'Automne* of 1909.

From 1924 she worked on theatre designs, and produced costumes and decor for
the Swedish ballets of Rolf de Mare and Gaston Baty's theatre. In the 1930s she began
to introduce symbolic themes in her paintings, as in *Eve* of 1930, or *Couple* of 1934.
Died in 1957 in the Maison des Artistes in Nogent-sur-Marne. In the same year a
retrospective of her work was held in Paris.

> **Source:** Lea Vergine, *L'autre moitié de l'avant-garde 1910–1940*, des femmes, Paris,
> 1982, p. 74.

APPENDIX 2 Galerie Berthe Weill: exhibitions and artists shown 1901–26

The following list has been compiled from information in Berthe Weill's *Pan! dans l'œil! Ou trente ans dans les coulisses de la peintre contemporaine 1900–1930*, 1933, and her unpublished diary 1917–18 (see Bibliography). Women artists are shown in italics.

1901, 1 December: Inaugural exhibition of GALERIE B. WEILL (rue Victor Massé). Works by Bocquet, Paco Durio, Girieud, *Warrick* (showed sculptures), Maillol (terracotta figures), Raoul de Mathan (nothing sold).

1902, 2 January: Drawings by Abel Faivre, Cappiello, Hermann-Paul, Gose, Sancha, Sem, Roubille (sales of 600 FF).

1902, 10 February: Matisse, Marquet, *Marval, Krouglicoff*, Flandrin.

1902, 5 March: Drawings by Willette, Wély, Léandre, Depaquit, Mirande (good sales).

1902, 1 April: Picasso and Bernard Lemaire (nothing sold).

1902, 1 May: Drawings and watercolours by Braun, Camara, Gottlob, Grün, Rouveyre, Villon, Weiluc (again, more profitable than painting shows).

1902, June: 'Exposition Récapitulative' of six preceding shows, including Matisse and Flandrin.

1902, 15 October: Girieud, Launay, Picasso, Pichot (only seems to sell drawings).

1902, 18 December: Drawings by Abel Faivre, Forain, Chéret, Helleu, Sem, Steinlen, Jean Véber.

1903, 19 January: Dufy, Metzinger, Torent, Lejeune (some sales).

1903, 10 March: Abel Faivre, Bottini, Helleu, Steinlen, Jean Veber, Wély.

1903, 2 September: Auglay, Bétrix, Deltombe, Metzinger, Muller.

1903, 10 October: Drawings and watercolours by Abel Faivre, Chéret, Forain, Roubille, Vallotton, Jean Véber.

1904, 20 January: Dufy, Duparque, René Juste, Torent.

1904, 2 April: Camoin, Marquet, Manguin, Raoul de Mathan, Matisse, Jean Puy.

1904, 3 May: Drawings by Abel Faivre, Chéret, Helleu, Steinlen, Lautrec, Willette (all sold apart from Lautrec).

1904, 1 October: Drawing and watercolours by Roubille, Grass-Mick, Galanis, Leandre, Ricardo-Flores.

1904, 24 October: Dufy, Girieud, Picabia, Picasso, Thiesson.

1905, 1 January: Raoul Carre, Deltombe, Delannoy, Torent, Van Dongen.

1905, 25 February: Dufy, Lautrec, Beaufrère, Boudin, Van Dongen.

1905, 2 April: Camoin, Dufy, *Gilliard*, Marquet, Van Dongen.

1905, 12 May: Bouche, Dufrenoy, Friesz, Minaertz, Ranson.

1905, October: Paviot.

1905, end October: Matisse, Camoin, Marquet, Manguin, Derain and Vlaminck; Dufy shown in separate room.

1905, November: *Charmy*, Dufrenoy, Friesz, Girieud, Metzinger.

1906, 12 January: Guerin, Laprade, *Marval*, Rene Piot, Rouault.

1906: Matisse organises a watercolour show of Jean Biette.

1906: Lacoste and Roustan.

1906, October: Dufy.

1906, December: Baignières, Desvallières, Guérin, Laprade, Rouault.

1907, January: *Charmy*, Robert Delaunay, Halou, Metzinger, Ottman.

1907, Spring(?): Matisse, Marquet, Derain, Friesz, Dufy, Vlaminck, Camoin, Vallotton.

1907, 2 November: Camoin, Derain, Marquet, Matisse, Friesz, Dufy, Vlaminck.

1908, 6 January: *Laurencin, Marval*, Flandrin, Léon Lehmann, de Mathan.

1908, February: *Laurencin, Marval*.

1908, March: Bela Czöbel.

1908, June: Camoin, Derain, Friesz, Dufy, Marquet, Matisse, Vlaminck ('le fameux groupe').

1908, October: Léon Lehmann.

1909, March: *Charmy*, Czöbel, Girieud, Metzinger, Tarkhoff, with Dufy, Friesz, Marquet, Picasso, Girieud, Redon, Puy.

1909, May: Diriks, Evelio Torent.

1909, November: De Groux, Lehmann, Verhoeven.

1910, January: Pascin, Berne Klene, Van Rees, Schnerb.

1910, February: Bollinger, Ribemont-Dessaigne, Finklestein.

1910, March: Burgsthal, Coppenolle, Deville, Tarkhoff.

1910, April: Derain, Girieud, Mathan, Rouault, Van Dongen.

1910, Spring/summer: Lacoste, Plumet, Paviot, Van Rees.

1911, February: Drawings and watercolours by Henri Somm.

1911, March: Grass-Mick.

1912: Jean Berger (catalogue written by Charles Morice).

1912: Gleizes, Metzinger, Léger.

1913: *Charmy, Marval, Lucie Cousturier*, Camoin, Raoul Dufy, Girieud, Gleizes, Lacoste, Laprade, Lebasque, Léger, Lhote, Luce, Matisse, Metzinger, Picasso, Redon, Rouault, Van Dongen.

1913: *Lévitzka* (all sold).

1913: André Lhote.

1913: *Charmy* (sold 12 pictures).

1913, December: *Charmy, Lévitzka, Valadon*, Utter, Lacoste, Lhote, Ribemont-Dessaignes, Czöbel (poor sales).

1914, January: Jean Dufy (no sales).

1914, February: Alfred Reth.

1914: Bolliger, Buhot, Esmein, Lehmann, van Rees.

1914, April: Diego Rivera.

1914, May: M. and *Mme Galimberti* (alias Valeria Dénes who died in 1915).

1915: Utter, *Valadon*.

1916, November: *Charlotte Gardelle*.

1917: Inaugural exhibition of new gallery at 50 rue Taitbout, works of artists who had shown with Weill, including *Valadon*, Utrillo, *Charmy*(?).

1917, 3 October: Modigliani. Included several nudes. Weill asked to remove one from the window by local commissaire of police. Subsequently asked to take down the other nudes. (Only 2 drawings sold).

1918, January: *Marthe Laurens*.

1918: Bergon, Hensel.

1919: René Durey, Ortiz de Zarate.

1919: Mainssieux.

1919, April: Celli.

1919, May: *Charmy*, Chabaud, Heuzé.

1919, June: Verhoeven.

1919, November: drawings by Coubine, Derain, Dufy, Friesz, Galanis, Marquet, Matisse, L. A. Moreau, Picasso, Jean Puy, Utter, *Valadon*, Van Dongen, Vlaminck (sold well).

1919, December: decorative art exhibition.

1920, January: Bissière, Galanis, Gernez, Lhote, Lotiron, Utter.

1920, February: sketches by Luis de La Rocha and group of young painters calling themselves 'Les Veilleurs' (the Watchmen).

1920, March: Robert Diaz de Soria.

1920, April: Clairin, Jean Dufy, Farrey, Favory, G. Fornier, Portal, Riou.

1920, May: Gimmi.

1920, September: First show in new premises, 46 rue Lafitte - show of 'Les Veilleurs' organised by the poet Carlos Larronde.

1920, October: Mendes-France.

1920, November: Angibault, Archipenko, Raoul and Jean Dufy, Gernez, Gleizes (also a member of 'Les Veilleurs'), *Halicka*, Gimmi, Kars, *Lévitzka*, Lhote, Marcoussis, Robert Mortier, Survage.

1921, 21 February: 100th exhibition of gallery, followed by a review in the evening. Guest list included artists, critics, dealers and 'amateurs', including *Valadon, Charmy, Lévitzka*, Flandrin, Friesz, Jean Dufy, Clarin, Favory, Utter, L. A. Moreau, M. and Mme de La Rocha, Gimmi, Lhote, Loitron, Bissière, Galanis, Camoin, Girieud, Laprade, Mme Matisse and her two girls, Manguin, Paviot, Dufrenoy, Metzinger, Waroquier, Dr and Mme Desjardins, Pauwels, M. and Mme Coquiot, de Jouvencel, M. and Mme Dorival, M. and Mme Ebstein, M. and Mme Guillaume, Basler, Zborowski, Mainssieux.

1921, March: P. E. Clarin.

1921, April: Favory, Farrey, G. Fournier, Jean Dufy, Riou, P. E. Clarin, Portal, Utter.

1921, June: Frank-Burty, followed by group show of L. Barat, Fredureau, Gimmi, Kars, Robert Mortier.

1921, Summer: *Valadon* and Utrillo (Utrillos sold for between 1,500 and 2,000 FF).

1921, October: Hogg.

1922, February: Francis Smith.

1922, March: Zadkine (watercolours).

1922, March-April: Edy Legrand.

1922, Spring: *Valadon*, Utrillo.

1922, May: Kayser.

1922: Exhibition of poems of Pierre-Albert Birot.

1922: Hayden, Herbin, *Irène Lagut*, Metzinger, Severini, Survage (groupe Léonce Rosenberg).

1922, Summer: *Valadon*, Utrillo.

1922, Autumn(?): Utrillo (excellent sales).

1922, November: *Halicka* (paintings and gouaches, including a gouache series *The Ghetto at Krakow*) (quite good sales).

1922, December: Dubreuil, Favory, Gimmi, Kars, Kisling, Portal, Sabbagh, Utter.

1922, December: Eberl.

1923, January: Eisenschitz.

1923, February: Billette, Frelaut, *Hermine David*, Kayser, Leopold Levu, Pascin, Per Krohg, Verge-Sarrat, Despiau.

1923, March: Pierre Dubreuil.

1923, April: *Hermine David* (paintings and watercolours).

1923, April: Utrillo.

1923, May: Edy Legrand.

1923, June: Bissière, Raoul Dufy, Gernrez, Gimmi, Lhote, Simon Levy.

1923, October: Coubine.

1923, November: Marcel Mouillot, Widhopff.

1923, November: *Charmy*, Favory.

1923, January: *Valentine Prax*.

1923, February: Kayser.

1923, March: Dubreuil, Gromaire, Makowski, Pascin, Per Krohg.

1923, April: *Odette des Garets*.

1923, April: Verge-Sarrat.

1923, May: Eisenschitz, *Claire Bertrand*.

1923, June: Francis Smith.

1924, July: Bosshard, Raoul Dufy, *Hermine David*, Kisling, Lurcat, Marcoussis, Zamoyski (sculptor).

1924, October: Barat-Levraux, Eberl, Goerg, Ramey, Savin.

1924, Autumn: *Lévitzka*.

1924, Autumn: *Hermine David*.

1924, December-January 1925: Group show 'La Fleur' of artists who had shown with Weill since 1901.

1925, February: Girieud.

1925, February: *Jeanne Rosoy*.

1925, March: Dubreuil, Goerg, Gromaire, Makowski, Pascin, Per Krohg.

1925, Spring: Kayser.

1925, Spring(?): Verge-Sarrat.

1925, Summer: Georges Capon.

1925, June: Sepia drawings by *Berthe Martinie*.

1925, July: Raoul Dufy, Laglenne, Lurcat, Marcoussis.

1925, Autumn: Simon Levy.

1925, December-January 1926: Annual group show 'Fleurs animées'.

1926, February: Eberl.

1926, February: Quelvée.

1926, February(?): Tcherniawsky.

1926, Spring: Dubreuil, Goerg, Gromaire, Makowski, Pascin, Per Krohg.

1926, Spring: Maurice Savin.

1926, April: Verge-Sarrat.

1926, June: Georges Capon.

1926, Summer: Grillon.

1926, October: Joseph Hecht (paintings and engravings).

1926, November: Fernand Simeon.

1926, November: Georges Cyr.

1926, December-January 1927: Annual group show, 'Fenêtres Fleuries' (including flower paintings by many women artists?). Celebrates 25 years of exhibitions.

APPENDIX 3 Extracts from Marevna Vorobëv, *Life in Two Worlds**

Extract from Part 2, Chapter 9, Paris, 1912

One day I went to the Rotonde, the café where all the painters in Paris used to meet. It was more than a social meeting place: they almost lived there, and came together like one big family. I wanted to find out the address of the Russian Academy, of which I had heard well at Capri. In this little café-bar, at the well-known crossing of the boulevards Raspail and Montparnasse, an artist newly arrived in Paris would get all the necessary directions. It was very different from what it later became. M. Leblanc, the *patron*, who was a butcher, and whose shop stood next door to this international resort, had just acquired it. He had very soon become a kind of father to favourites and chosen neophytes whom he spotted among this little world of artists, always hard up and always looking for moral support. For the majority of French artists, and more so for foreign ones, life in Paris was harsh and pitiless, often lonely and bounded on every side by sheer destitution. Père Leblanc treated them to *café-crème*, hot *croissants* and *sauerkraut* on credit, which was never paid off; but the good man was glad to accept a few sketches or a canvas as compensation for his expenses. This is how he began to make a collection of pictures which grew from day to day, among which were canvases by Modigliani, Kisling, Soutine, Krémègne, Ortis and others, and even one of mine. His good humour and his fatherly advice were a valued comfort to us all. I had occasion, later on, to appreciate deeply the big fellow's friendliness, considerateness and benevolence.

It was at the Rotonde, then, that I discovered without any difficulty the address of the Russian Academy.

The student in charge, Bulakovsky, was a Russian sculptor; his predecessor had been a painter called Marie Vasilev, who was said to be very gifted. She had left after numerous rows for which she had been responsible, and she had been asked to resign. When I arrived I heard that she had opened a canteen for artists in her studio in the avenue du Maine. (The canteen became celebrated during the 1914 war.) I had the opportunity afterwards of making her acquaintance in very different circumstances, sometimes amusing, often embarrassing.

The Academy, where I soon began work, was frequented by many Russian artists,

*Abelard-Schuman, London, 1962, reproduced with kind permission of Marika Rivera Phillips.

among them Anna Orlov, who later made a name for herself as a sculptor, and Zadkine, with a fringe of hair on his forehead and his very marked Semitic charm. He was very talented, a sort of stormy *Jupiter tonans*, full of gaiety and wit, especially when he had a few glasses of wine inside him. He had hewn out for himself the place he occupied among the sculptors of the world. There were also the coming painters like Krémègne, and the shy Soutine, always melancholy, who was likewise to become celebrated. I shall talk of him later.

On the evenings devoted to sketching the little hall was always full to overflowing, and it was difficult to find room at a bench or on anything that might serve as a seat; but our passion for work was such that we willingly put up with discomfort. I met Willi and his Russian wife, Olga Sakharov, whose talent for painting was already recognised. I had known them rather vaguely at Capri. I liked the atmosphere of the academy and I used to go every day to paint and to study models from the life.

One evening, however, it happened that I had gone to work at drawing at the Colarossi Academy, in the rue de la grande Chaumière. The crowd there was thicker still: the building was filled with a whole army of young students of all nationalities, and all the rooms were packed. In the one where we were drawing from the nude the air was stifling, because of an overheated stove. We were positively melting in an inferno permeated by the strong smell of perspiring bodies mixed with scent, fresh paint, damp waterproofs and dirty feet; all this was intensified by the thick smoke from cigarettes and the strong tobacco of pipe smokers. The model under the electric light was perspiring heavily and looked at times like a swimmer coming up out of the sea. The pose was altered every five minutes, and the enthusiasm and industry with which we all worked had to be seen to be believed.

The clothed models, men, women and children, were often Italian, dressed in the Neapolitan fashion. They looked as though they had recently disembarked from a voyage from Naples and were completely out of their element in the chilly fog of Paris.

Besides our work we had the daily business of going to the museums and exhibitions. I wrote excited letters to Father, that I was making good use of my time and hoped soon to be in a position to earn my living. The last words were intended to encourage him, for he was sending me at the end of every month a substantial sum, and providing me with everything I could wish for. His generosity allowed me to live a carefree life and to pass for a very fortunate girl in the eyes of my companions. He never mentioned in his letters what might be going on at home, but spoke of an early meeting with me (probably in Poland). He seemed to me to be much preoccupied with the events unfolding themselves at Tiflis, where all was not well, for the attitudes to each other of the Russian, Armenian and Tatar governments were becoming more and more strained.

Gradually I forsook my Russian friends from Capri and only saw my compatriots at charity balls, organised either for the benefit of needy artists or to provide aid for the Russian colony. I was always invited to these affairs, and I played my part energetically, helping at the buffet or moving about among the gathering,

selling glasses of vodka and hot honey. I was usually dressed as a young *muzhik*, wearing wide, baggy trousers, boots, and the traditional shirt embroidered in red. On my fair, curly head I wore a magnificent astrakhan *papakha*, a present from my father. This disguise allowed me to be more comfortable, and I enjoyed playing the clown, leaping and dancing. Everyone liked me, and the thirsty dancers enjoyed buying my perfumed liquers, calling me 'Stepka' and asking me to drink with them to the health of our venerable Russia.

Those first balls were a novelty for me, and I enjoyed them madly. They had begun to be held in 1911 and were organised in the great picturesque halls of the 'Moulin de la Galette', and also in a big *brasserie*, called 'La Closerie des Lilas', and in the 'Salle Bullier', which was very well known at that time and perhaps the best regarded. The people who came to them were a very mixed lot. The upper crust of the Russian colony might be seen there, people belonging to French society, and the representatives of industrial, literary and medical circles who were amateurs and patrons of modern painting. Journalists and art-critics were there in plenty, and, lastly, the artists themselves.

At these entertainments I used later to meet Lunacharski and his wife, who only knew me by the surname 'Marevna', given me by Gorki, which I have retained.

Extract from Part 2, Chapter 20, 1915 onwards

Back in Paris I began to see more and more of Rivera from force of circumstances, for all my friends used to go and see him. I posed for him at this time and could watch him at work. Many artists visited him, to talk about painting, especially about cubism, construction and Cézanne, whose work he had a passion for. Among others André Lhôte came, who was very curious about modern theories, and Diego gave him long explanations of his work, and his principles; Matisse, too, who refused to accept the doctrines of cubism and futurism but wanted to understand Cézanne. I was passionately interested in the discussions of these men and, under Rivera's influence, I also learned to see nature and objects from a different angle. My love of art became deeper and more complete.

Picasso, 'the mysterious and diabolical Picasso', as the Russians called him: it was at Rivera's that I met him, as I did Cocteau, Max Jacob, Apollinaire, Larinov, Goncharova, Blanchard, Favorit, Matisse, Juan Gris, Friesz and so many others.

Picasso was rather short, wiry and well proportioned. His hair was very black with blue lights in it; his eyes, too, were very black and shone with an extraordinary brilliance, which they have kept to this day. I could realise his presence in the middle of a crowd merely by the brilliance of his glance which seemed literally to spring out of the mass of other faces with some fascinating, hypnotic effect.

When he was young he wore black, striped trousers, a short jacket, also black, wide open and displaying a broad, pink girdle wrapped round his waist in the pure toreador style.

All the pretty models and actresses and dressmakers from the big fashion houses were mad about him, to say nothing of the women of the world and the

demi-monde. Later, during his cubist period, he wore a red tie, a cap and an ample, checked cloak, which made him look rather like a character from the circus.

Everything has already been said and said again about this extraordinary being, this extraordinary painter. I remember Rivera's telling me that when Picasso arrived in Paris from Barcelona he was extremely poor, and used to sell pipes which he made, carved and decorated himself – for five francs apiece!

His first dealings with Apollinaire and Max Jacob turned into a solid friendship, and the two great French poets played a great part in the artistic and spiritual development of the painter; but he owes the beginnings of his fame to an American, a great lover of painting, Leo Stein. It was he who first bought Picasso's pictures (and Matisse's and Friesz's too) in 1912. This was, besides, the Spanish painter's best period, in my opinion; his blue period, inspired by El Greco.

I made his acquaintance at the time of Negro art, of the beginnings of cubism and of *collages.* Morozov, in Moscow, was already buying pictures by Picasso for his gallery, and the Russians called the painter *'le diabolique'* . . . which flattered him, I think. His second wife was a Russian dancer from Diaghilev's Ballet. The unfortunate woman had had to give up dancing after breaking a toe. She presented Pablo with a son. They were divorced after twenty years of marriage. He also had a son by a foreign artist; and it is well known that he has recently married a charming young French girl, by whom he has had a boy, Claude, whom he worships, and a little girl, Paloma.

He has always been much talked of, most often disparagingly. That is the price that the great have to pay. I myself have always liked him as a painter and esteemed him as a man. He earns big money nowadays, but he gives generously to the cause he has adopted. He helps those compatriots of his who have talent and whom he considers worthy of succour. He supports three families over and above his own. His son is now married and continues to live peacefully in the shadow of his gigantic father.

I remember that one day Voloshin, Ehrenburg, Katya, Savinkov and I decided to go and visit Picasso. He had them moved from Montmartre to live opposite the Montparnasse cemetery – in the rue Froidevaux, if I remember rightly. (He moved again after that to Montrouge, where his studio was burgled.) We were at his door at eleven o'clock: he opened it himself, wearing a blue-and-white striped bathing-dress and a bowler hat. He made us look into all the rooms – and there were plenty of them, all arranged to serve as backgrounds for his still-lifes and portraits. There was nothing but drawings everywhere, and canvases, and piles of books cluttering up the tables and chairs. The floor was strewn with stained painting rags, cigarette-ends and a heap of newspapers. On a big easel there was prepared a canvas, big and mysterious . . . No one at first risked asking what it represented, for fear of blundering. There we stood, respectful, silent, stupefied and amazed in spite of ourselves by the power and imagination of it. Picasso, who had already astonished us with his striped bathing-dress, was continuing his efforts in the same line. It was Voloshin, finally, who could not restrain a poet's curiosity and asked: 'What does the picture represent, *maître?*'

'Oh, nothing much you know', Picasso answered, smiling. 'Between our-selves . . . it's some dung – good for idiots'.

'Thank you, thank you', said Voloshin and Ehrenburg.

'Don't think it's for your sake that I said that, *chers messieurs*', Picasso went on. 'You're different . . . only I often have to work for fools who are ignorant about art, and my dealer is always asking me to do something to astonish the public'. Now, was Picasso being sincere?

He was not very talkative on that day; perhaps our visit was preventing his aban-doning himself, in his bathroom and his fine bathing-dress, to a spell of swimming. He saw us to the door as nicely and pleasantly as possible. Later on he felt a simple comradeship for me, and half-jokingly invited me to come one day and have a bathe at his house – 'only give me notice because my bathroom is always dirty'. About the same time Voloshin was preparing to leave for Russia, and asked me to go with him. Picasso said to me: 'Don't go! What the blazes! Here we shall make an artist of you, someone even greater than Marie' (Marie Laurencin). Rivera said nothing, but he looked at me oddly and I understood that he, too, wanted me to stay.

One day Rivera showed my pictures to Matisse, who thought them very inter-esting: they were cubist pictures. Somewhat later Diego brought to my studio in the rue Asseline Paul Rosenberg, with whom he had just signed a contract. It was very cold at my place: there was no fire and I was wearing a cloak, and a *bashlyk*, a Caucasian fur hood, on my head. Rosenberg was struck by the look of my studio, which was very long, with a low ceiling, and in the winter was dark – and also somewhat, perhaps, by the sight of me. He bought two canvases and Rivera con-fided to me that he might possibly offer me a contract. I was in the seventh heaven, but unfortunately they parted soon afterwards and cancelled their contract.

Rivera was determined to be free to work as he wished. He wanted to give up cubism gradually and continue freely with his constructivst experiments, but in a more discrete form, less uniformly flat. The pictures that he painted thenceforward bore the impress of the influence of Rousseau, Renoir, Gauguin and Cézanne (whom he admired most of them all). He showed me, setting them close to each other, several tracings of pictures by Cézanne and by artists of the Flemish school; and I could see that Cézanne himself had been seeking to construct his works on something of the same system.

While Rivera was still working for Rosenberg Picasso used to come and see him at any hour, to talk and to look at his pictures, for he was always curious about all artists, their methods of working, and anything that might be new and interesting. Rivera was furious each time and said to me more than once: 'He sickens me, Pablo does. If he pinches something from me it'll always be Picasso, Picasso, but as for me, they'll say I copy him. One of these days I shall chuck him out, or *I* shall shove off to Mexico'.

When I was at Èze I had a letter in which he told me that Picasso had come to see him in his studio in the rue du Départ and, as he usually did, had started turn-ing the pictures over to look at them. Diego had abused him and they had nearly come to blows – 'He left when he saw me pick up my Mexican stick and when

I threatened to break his skull'. I never knew the exact truth about this incident but I know that for a good long time there was a coolness between Picasso and Rivera. I am sure that if Rivera finally bade farewell to cubism, and later to France, it was to free himself once and for all from Picasso and his influence. He did not wish to follow in the great Spaniard's wake; his immense pride would not permit it to be said: 'Rivera's style is Picasso's'; 'Rivera is influenced by Picasso.'

There was a time when a whole troupe of young French painters assembled round Diego, and he thought of forming from them a 'Cézanne' school; it was in this way that I met with him Metzinger, Favorit (who was gassed in the war and died later in hospital), Duret, Fournier, Cornaud, Lhôte, Marie Blanchard . . . Some years later, however, Rivera told me: 'None of those painters is fit to be called a pupil of Cézanne. It'll be Soutine who succeeds to his place, you'll see – after Modigliani: he's a great artist'.

I remember, in fact, that Rivera's friend Dr Faure was afterwards to write two books, one on Rivera himself and the other on Soutine. Dr Faure could see in those two very different men the same passion, a single true love: painting.

Extract from Part 2, Chapter 26, 1918

We became lovers. When Angelina[1] came back to the apartment Diego told me that he and I would go and live in the studio. I did not care for the idea of having Angelina and the baby so close to us, and I was right, as I found out later on.

It was a hard winter. We were short of coal and I shivered in the enormous studio. One day Rivera came home with two presents for me. The first was a pair of little Siamese cats; the second was a parcel which made me blush hotly when I opened it: it contained a hygienic device in splendid, pink india-rubber.

'It's a very prosaic present, *milaya*', said Rivera.

Clearly he did not want any more children; but I told myself that very day: I shall have one too, and it shall be more beautiful than the other! Otherwise, what's the use? . . .

The little cats kept us warm at night but they soon fell ill because of the cold and in spite of all my care they died one after the other. I was greatly grieved.

Our life became orderly. I painted, like Diego, in the studio or in the little room behind; sometimes we ate together, sometimes he ate with Angelina, I could feel the hostility of some of Rivera's friends. I did not set foot in the S.s' house again: Madame was furious at my conduct and now invited only Diego and Angelina, though Diego sometimes accompanied Angelina only 'reluctantly', he told me. On those evenings the baby was left alone, and Marie Blanchard came to look after him. She was a painter of mixed Polish, Spanish and French blood, with a hump on her back and in front; with her bony face, long nose and piercing eyes she looked like a witch. She had pretty feet and a pretty talent: among the women artists she was thought to be one of the most gifted. She was very fond of Rivera, and he often told me with a laugh that it depended only on him whether he had a child by Marie: she was longing for it.

'Why don't you do it then? I'm sure she'd bring it up admirably',

'I'm not so sure', he answered. 'It's myself she loves. She'd like to go to bed with me, if only once. But I feel quite incapable of it.'

She was an old friend of Diego's and Angelina's and had known them in Spain. She did not like me: she was jealous.

I sometimes used to go up and see the baby, and now I was pestered by the idea of having one of my own. I was twenty-five and with Diego I had learned the keen joy of being really a woman; and my maternal instinct had been roused together with my senses.

'Think of your painting and the splendid career that's waiting for you,' said Diego. 'You're madly gifted; you can be a good painter. There's nothing to stop you loving my child as if he were your own.'

[. . .]

We were still very poor: Diego gave nearly all his money to Angelina, who needed it for herself and the child. When we ate at the studio it was always very scantily, and I resolved to ask Yura for help: he sent me several dozen roubles at once. I made some money too, by painting portraits from photographs of great Jewish poets, for a Russian *émigré* who had a printing press. I used the money to improve our dinners and to buy some coal.

Diego was very suspicious of my coming back late, and with money, and was jealous, although he was often out and was satisfied with telling me the reason was the big portrait of Mme S. that he was painting. One evening he asked me where I had been and when I told him I was doing some enlargements, which brought in money, he became absolutely furious: I have never been able to tell why. I thought he would strangle me, and then I realised that he was having one of his fits. He stammered incoherently, and all I could guess at was that he was convinced that I was deceiving him and that was where the money came from.

[. . .]

We were walking in Montparnasse and, among the crowds, we met Picasso, who always paid compliments to women: this time he touched my breasts and said how beautiful he thought they were. This is a customary gesture of his: he did the same to my daughter in the summer of 1948, and I laughed when she angrily told me what had happened – Picasso is always the same! But I was myself so untamed, such a *nedotroga* ('touch-me-not') that I stepped back, very angry, and had to restrain myself from boxing his ears.

Diego went white and foamed with anger. At home he said: 'If he touches your breasts so unceremoniously it must mean that you're sleeping with him. Come on: confess!'

I only laughed.

'What do you mean?' he went on. 'I saw a sketch of a nude at his place. I recognised at once that it was a drawing of you.'

'And you asked him whether it was?'

'No. He wouldn't have told the truth. But I know what you look like so well that I didn't have to enquire.'

'Oh, lots of woman may look alike in nude sketches, you know; but I've told you already that I've never been at his house alone – to my great regret.'

The words brought him to the pitch of fury. His lips were white with foam and his eyes were upturned. With one hand he twisted my arms behind my back and with the other he seized and opened a *navaja* (clasp-knife) which was lying on the table. I begged him in a faint voice to have pity on his loving, faithful Marevna. He was shivering and shaking as much as I was. The knife grazed my throat: I fainted and he must have let go of me and let me fall, because when I came to I was lying on the floor, with the open knife not far away. I felt my neck stinging, and I was covered with blood. I staggered as far as the looking glass: I was not a pretty sight! I washed myself and made a dressing with a handkerchief and a towel.

I felt pains all over, and my legs would not support me. I lay down and wondered why Diego had behaved as he had. Was it to frighten me into leaving him? Was he sorry? What was I to do? It was a nightmare. Above all no one must know: I must clean the knife and hide it in the coal scuttle.

When Diego came back he asked me to forgive him:

'I didn't know what I was doing, Marevna. I'm mad! I'm jealous of all the men who knew you before me . . . Tell me truly that Ilya has never been your lover! Swear it!'

I swore, feeling that he did not believe me, and he swore not to belong to Angelina. The days that followed were perfectly happy. Mme S. had bought several of his canvases and two cubist pictures of mine, so life was fine. We went to hear a series of lectures by André Lhôte in the rue Huyghens. Rivera would burst out laughing.

'That Lhôte!' he said. 'He understands nothing about real cubism, any more than he does about constructivism. He comes and picks up whatever I may tell him and then makes the round of Gris, Braque and Pablo, and makes a fine omelette out of it all. You've only to look at his pictures!'

And he laughed as only he could laugh, showing his teeth and his pink gums.

'But apart from that', he went on, 'he's a good chap: like a Marseilles barber who's got bitten by painting and wants to show everybody that he understands it and that he he's become a great painter.'

I knew Lhôte, who was charming. He often came to the studio to 'talk painting' with Diego. Diego could talk for hours, drawing, explaining, turning pale and getting more and more agitated. Sometimes Matisse would happen to drop in, and Diego addressed the two of them by turns or both together, showing them his pictures and proving that each line, each angle, each cubic form was the result not of pure chance but of extensive knowledge and careful study. I listened eagerly, trying to understand in such a way that I could use what I heard in my own work. Sometimes the impressive Diaghilev called: he would look at the work of Diego, who showed him mine, which was nice of him. Crowds of people came who were interested in modern painting and in that of Diego himself. I saw his growing importance among the artists, his energy, his intelligence and his goodness to his comrades. Sometimes, it is true, he would tell me that he did not want to see

so-and-so any more – 'I'm sick of him!' But after some time he would re-admit the person in question to his friendship – or would appear to – perhaps in obedience to some compulsion. His friendship was changeable and uncertain.

I thought that little by little I was beginning to understand and know him; but my youthfulness, my high spirits, my love prevented my having with him the necessary patience and composure. Moreover – unhappily for me – I burned with passion for him, and to this was added great fondness. And I was sincere: during the whole of our liaison, from 1915[2] until he left for Mexico in 1921, I was faithful to him, body and soul. Of course I was slandered to him during that time by people trying to slacken the bonds that united us, and even to detach him from me. The jealousies of women and men! If he happened to find a man sitting for his portrait in my studio in the rue Asseline he would rush away, and if I went with him to the landing he would throw me a curse and not come back for a day or two. He wanted me to work only at my own painting; but he never gave me the money which would have allowed me to live honestly. But Rivera did not believe any of this, chiefly because the women he had known were usually rather flighty: he accepted my standpoint only reluctantly and refused to believe that I could remain faithful in the midst of so many men who were making up to me. He sometimes said that Angelina disliked our living near her: I said I was ready to go, but he would not hear of that, alleging that I should fall ill at my studio in the rue Asseline, with no coal and no one to look after me. I saw that he was torn between his love for me and his duty to Angelina and the baby. I think his weakness of character had something to do with it too: he was wondering how he could go on arranging our life. Perhaps he would have liked to live differently, but he had not the money to support two households.

Notes

1 Angelina was Rivera's mistress with whom he had a son during the same year that he began his relationship with Marevna.
2 According to Marevna, the first period of their relationship was platonic.

Selected bibliography

For bibliographical references on individual women artists please see biographical information in Appendix 1. Please note that some of the detailed references given in footnotes are not included in the following *selected* bibliography.

Adler, Kathleen, and Tamar Garb, *Berthe Morisot*, Phaidon, London, 1987.

Adler, Kathleen, and Marcia Pointon, *The Body Imaged: The Human Form and Visual Culture since the Renaissance*, Cambridge University Press, Cambridge, 1993.

Anscombe, Isabelle, *A Woman's Touch: Women in Design from 1860 to the Present Day*, Virago, London, 1984.

Bailey, Anna, *A Time of Transition: Female Representation in France 1914–1924*, M.A. thesis, Courtauld Institute of Art, London, 1991.

Bard, Christine, *Les Filles de Marianne: Histoire des féminismes 1914–1940*, Arthème Fayard, Paris, 1995.

Basler, Adolf, and Charles Kunstler, *La Peinture indépendante en France: vol. i De Monet à Bonnard; vol. ii De Matisse à Segonzac*, G. Crès & Cie, Paris, 1929.

Bayard, Émile, *Les Arts de la femme encyclopédie pratique*, Librairie Delagrave, Paris, 1904.

Bénézit, E., *Dictionnaire des peintres, sculpteurs, dessinateurs et graveurs*, Gründ, Paris, 1976.

Benstock, Shari, *Women of the Left Bank: Paris 1900–1940*, Virago, London, 1987.

Betterton, Rosemary (ed.), *Looking On: Images of Femininity in the Visual Arts and Media*, Pandora, London, 1987.

Broude, Norma, and Mary D. Garrard (eds.), *Feminism and Art History: Questioning the Litany*, Harper and Row, New York, 1982.

Broude, Norma, and Mary D. Garrard (eds.), *The Expanding Discourse: Feminism and Art History*, Icon/Harper Collins, New York, 1992.

Butin, Jean, and Henri Béraud, *Sa longue marche de la Gerbe d'or au Pain Noir*, Éditions Horivath, Paris, 1979.

Caffin Madaule, Liliane, *Maria Blanchard: Catalogue Raisonné*, 2 vols., Éditions Caffin Madaule, London, 1994.

Cahm, Eric, *Politics and Society in Contemporary France 1781–1971*, Harrap, London, 1972.

Carco, Francis, *Le Nu dans la peinture moderne*, Éditions Crès, Paris, 1924.

Caufeynon, Dr, *Histoire de la femme (son corps, ses organes . . . ses vices, ses aberrations sexuelles etc.)*, Côté femmes, Paris, 1989.

Chadwick, Whitney, *Women Artists and the Surrealist Movement*, London and Boston, 1985.

Chadwick, Whitney, *Women Art and Society*, Thames and Hudson, London, 1990.

Chadwick, Whitney, and Isabelle Courtivron (eds.), *Significant Others: Creativity and Intimate Partnership*, Thames and Hudson, London, 1993.

Chaplin, Patrice, *Into the Darkness Laughing: The Story of Modigliani's Last Mistress, Jeanne Hébuterne*, Virago, London, 1990.

Clark, Francis I., *The Position of Women in Contemporary France*, P. S. King and Son, London, 1937.

Colette, *Quelques Toiles de Charmy – Quelques Pages de Colette*, Galerie d'Art Ancien et Moderne, Paris, 1926.

Copley, Antony, *Sexual Moralities in France 1780–1980: New Ideas on the Family, Divorce and Homosexuality. An Essay In Moral Change*, Routledge, London, 1989.

Crane Gallery, *Jacqueline Marval 1866–1932*, London, 1989.

Crespelle, Jean, *Montparnasse vivant*, Hachette, Paris, 1962.

Delaunay, Charles, *Delaunay's Dilemma: De la peinture au jazz*, Editions W., Mâcon, 1985.

Delaunay, Sonia, *Nous irons jusqu'au soleil*, Robert Laffont, Paris, 1978.

Distel, Anne, *A. Dunouer de Segonzac*, Bonfini Press, Naefels, 1980.

Dorgelès, Roland, *Bouquet de bohème*, Albin Michel, Paris, 1947.

Dorgelès, Roland, *Images*, Albin Michel, Paris, 1975.

Dorival, Bernard, *Les Étapes de la peinture française contemporaine*, vol. ii, *Le Fauvisme et le cubisme, 1905–1911*, Gallimard, Paris, 1944.

Dorival, Bernard, *The School of Paris in the Musée d'Art Moderne*, Harry N. Abrams, New York, 1962.

Dubesset, Mathilde, and Michelle Zancarini-Fournel, *Parcours de femmes: Realités et representations, St-Étienne 1880–1950*, Presses Universitaires de Lyon, Lyon, 1993.

Edelstein, T. J., (ed.), *Perspectives on Morisot*, Hudson Hills, New York, 1990.

Faure, Jacques-Elie-Paul, *Histoire de l'art*, vol. iv, *L'Art moderne 1909–1921*, Paris, 1921.

Elliot, Bridgett, and Jo-Ann Wallace, *Women Artists and Writers: Modernist (im)positionings*, Routledge, London, New York, 1994.

Flanner, Janet, *Paris was Yesterday*, Angus and Robertson, New York, 1973.

Focillon, Henri, *La Peinture française aux XIX et XXé siècles*, Librairie Renouard-Laurens, Paris, 1928.

Garb, Tamar, *Women Impressionists*, Phaidon, London, 1986.

Garb, Tamar, *Sisters of the Brush: Women's Artistic Culture in Late Nineteenth-Century Paris*, Yale University Press, London and New Haven, 1994.

Garb, Tamar, '"Unpicking the Seams of her Disguise": Self Representation in the Case of Marie Bashkirtseff', *Block*, 13, Winter 1987/8, pp. 79–86.

Garb, Tamar, '"L'Art Féminin": The Formation of a Critical Category in Late Nineteenth-Century France', *Art History*, 12:1, Mar. 1989, pp. 39–65.

Garb, Tamar, 'The Forbidden Gaze: Women Artists and the Male Nude in Late Nineteenth-Century France', in K. Adler and M. Pointon, *The Body Imaged*.

Garb, Tamar, 'Berthe Morisot and the Feminizing of Impressionism', in T. J. Edelstein (ed.), *Perspectives on Morisot*.

Gee, Malcolm, *Dealers, Critics and Collectors of Modern Painting: Aspects of the Parisian Art Market between 1910 and 1930*, Garland, New York, London, 1981.

Gimpel, René, *Diary of an Art Dealer*, Hamish Hamilton, London, 1986.

Giraudy, Danielle, *Camoin: Sa vie, son œuvre*, Lausanne, 1972.

Granoff, Katia, *Bouche*, Place Beauvau (undated catalogue).

Green, Christopher, *Cubism and its Enemies: Modern Movements and Reaction in French Art, 1916–28*, Yale University Press, New Haven and London, 1987.

Herbert, James, *Fauve Painting: The Making of Cultural Politics*, Yale University Press, New Haven and London, 1993.

Higonnet, Anne, *Berthe Morisot's Images of Women*, Harvard University Press, Cambridge, Mass., 1992.

Huyghe, René, *Les Contemporains*, Tisne, Paris, 1949.

Labaud, Valery, *Les Enfantines*, Gallimard, Paris, 1926 (with illustrations by Jeanne Rosoy, Germaine Labaye, Alice Halicka and Hermine David).

Marchesseau, Daniel, *Marie Laurencin: Catalogue Raisonné of the Paintings*, Alan Wofsy Fine Arts, San Francisco, 1986.

Margueritte, Victor, *La Garçonne*, Paris, 1922; reprinted Flammarion, Paris, 1978.

Mulvey, Laura, *Visual and Other Pleasures*, Macmillan, London, 1989.

Musée Nationale d'Art Moderne de la Ville de Paris, *Robert et Sonia Delaunay: Inventaires des collections publiques françaises*, Paris, 1989.

Musée d'Art Moderne de la Ville de Paris, *Kees Van Dongen*, Paris-Musées, 1990.

Nadel, Victor, *Le Nu au Salon*, 2 vols. Paris, 1905.

Nead, Lynda, *The Female Nude: Art, Obscenity and Sexuality*, Routledge, London, 1993.

Nesbit, Molly, *Atget's Six Albums*, Yale University Press, London and New Haven, 1992.

Nochlin, Linda, *Women, Art and Power and Other Essays*, Thames and Hudson, London, 1989.

Olivier, Fernande, *Picasso et ses amis*, Paris, 1914.

Oppler, Ellen C., *Fauvism Reexamined*, Garland Publishing, New York and London, 1976.

Parker, Rosika, and Griselda Pollock, *Old Mistresses: Women, Art and Ideology*, Routledge and Kegan Paul, London, 1981.

Pernoud, R., *Histoire de la bourgeoisie en France*, vol. ii, *Les Temps modernes*, Editions du Seuil, Paris, 1962.

Petteys, Chris, *Dictionary of Women Artists*, Boston, Mass., 1985.

Pollock, Griselda, *Vision and Difference: Femininity, feminism and histories of art*, Routledge, London and New York, 1988.

Radycki, Diane, 'The Life of Lady Art Students: Changing Art Education at the Turn of the Century', *Art Journal*, Spring, 1982.

Raynal, Maurice, *Anthologie de la peinture en France – De 1906 à nos jours*, Editions Montaigne, Paris, 1927.

Richardson, John, *A Life of Picasso; vol. i, 1881–1906*, Pimlico, London, 1991.

Rifkin, Adrian, *Street Noises: Parisian Pleasure 1900–40*, Manchester University Press, Manchester and New York, 1993.

Rose, Jean, *Modigliani: The Pure Bohemian*, Constable, London, 1990.

Rosinsky, Thérèse D., *Suzanne Valadon*, Universe Series, Rizzoli, New York, 1994.

Roussier, François, *Jacqueline Marval, 1866–1932*, Didier Richard, Grenoble, 1987.

Salmon, André, *La Jeune Peinture française*, Albert Messein, Paris, 1912.

Silver, Kenneth, *Esprit de Corps: The Art of the Parisian Avant-Garde and the First World War, 1914–25*, Thames and Hudson, London, 1989.

Stein, Gertrude, *The Autobiography of Alice B. Toklas*, Penguin, London, 1966.

Uzanne, Octave, *Parisiennes de ce temps*, Paris, 1910.

Louis Vauxcelles, *L'Histoire générale de l'art français de la Révolution à nos jours*, Librairie de France, Paris, 1922–25.

Vergine, Lea, *L'Autre Moitié de l'avant-garde 1910–1940*, des femmes, Paris, 1982 (translated from the Italian by Mireille Zanuttini; first published Milan, 1980).

Ville de Vichy, *Alice Halicka 1895–1975: Période Cubiste (1913–1920)*, Salle de la Restauration, Vichy, 1988.

Vollard, Ambroise, *Recollections of a Picture Dealer* (trans. V. M. Macdonald), Dover Inc, New York, 1978.

Vlaminck, Maurice, *Portraits avant décès*, Flammarion, Paris, 1943.

Warnod, André, and Albin Michel, *Les Berceaux de la jeune peinture: l'École de Paris*, Albin-Michel, Paris, 1925.

Warnód, Jeanine, *Suzanne Valadon*, Bonfini Press, Naefels, 1981.

Weill, Berthe, *Pan! dans l'œil! Ou trente ans dans les coulisses de la peinture contemporaine 1900–1930*, Lipschutz, Paris, 1933.

Weill, Berthe, Unpublished diary from 1917, now in the Bouche family collection.

Weill, Berthe, Unpublished correspondence in the Bouche family collection.

Wheeler, Kenneth W., and Virginia Lee Lussier, *Women, the Arts and the 1920s in Paris and New York*, New Brunswick, New Jersey and London, 1982.

Wollen, Peter, 'Fashion/Orientalism/the Body', *New Formations*, 1, Spring, 1987.

Periodicals, journals and newspapers consulted

References to specific articles and dates are given in relevant footnotes

L'Amour de l'Art
Art et Décoration
Arts
Les Arts à Paris
L'Art Vivant
L'Art et les Artistes
Aux Écoutes
Avenir
Bonsoir
Bulletin de la vie artistique
Bulletin de l'Effort Moderne
Cahiers d'Art
Crapouillot
Comoedia
Eclair
Europe Nouvelle
L'Esprit Nouveau
L'Événement
Figaro
Le Gaulois
Gazette des Beaux-Arts
Gil-Blas
La Grande Dame
Les Hommes du Jour
L'Intransigeant
Journal des Débats
Journal des Femmes
Mercure de France

Mondes
Le Monde
Le Monde Illustré
Le Monde Artistique
Noir et Blanc
Les Nouvelles Littéraires
Paris Journal
Paris Midi
Paris Soir
Le Parisien
Petit Journal
Le Petit Bleu
Le Petit Parisien
La Plume
La Revue des Deux Mondes
La Revue des Arts et de la Vie
La Revue de France
Le Temps
La Vie Parisienne
La Vie

Index

Black and white plates are indicated by italicised page numbers